MONET

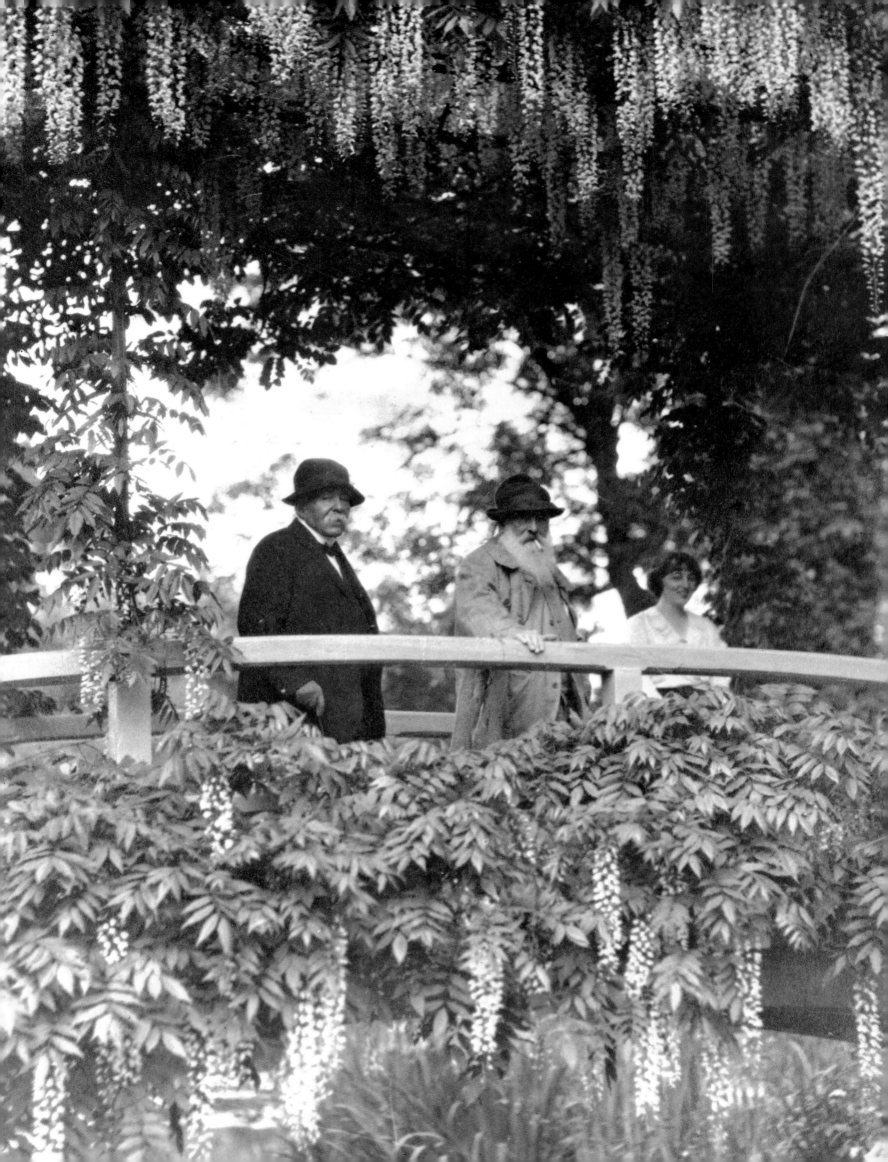

SOPHIE FOURNY-DARGERE

MONET

KONECKY&KONECKY

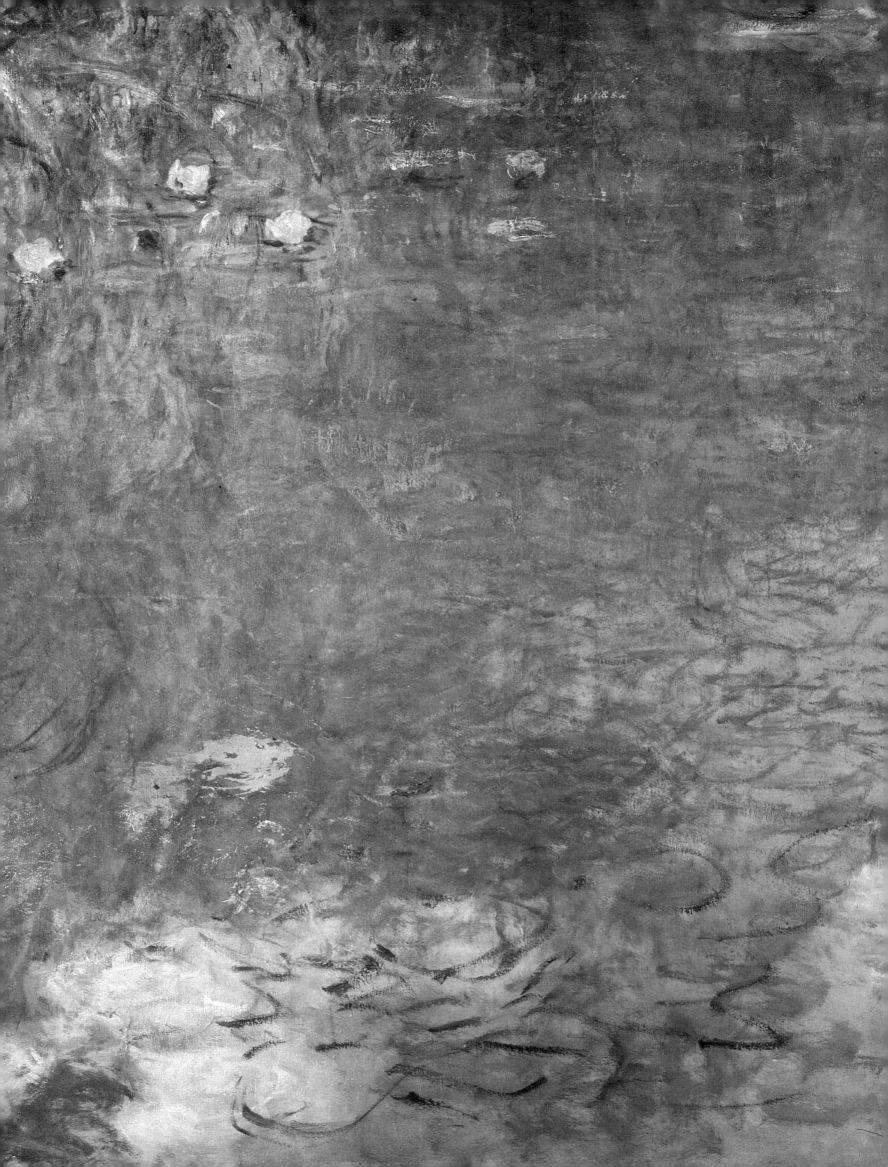

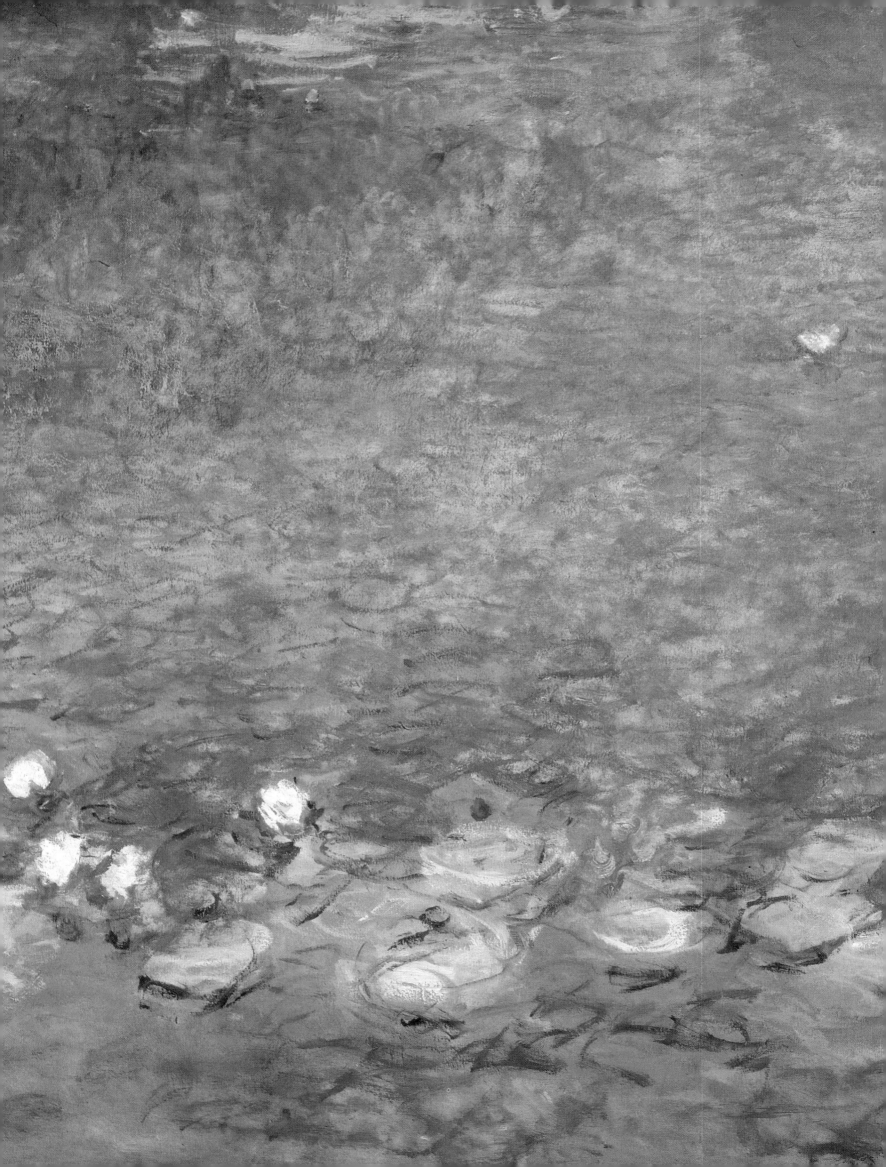

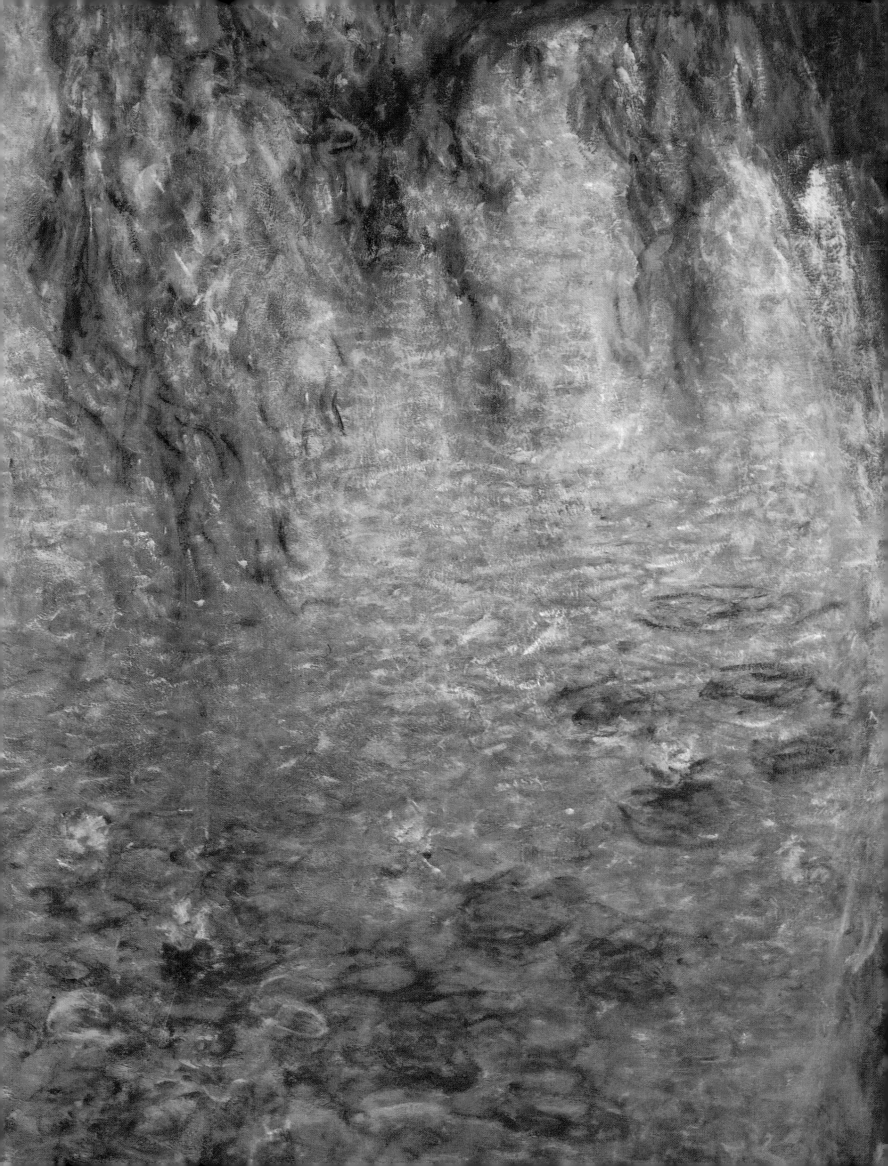

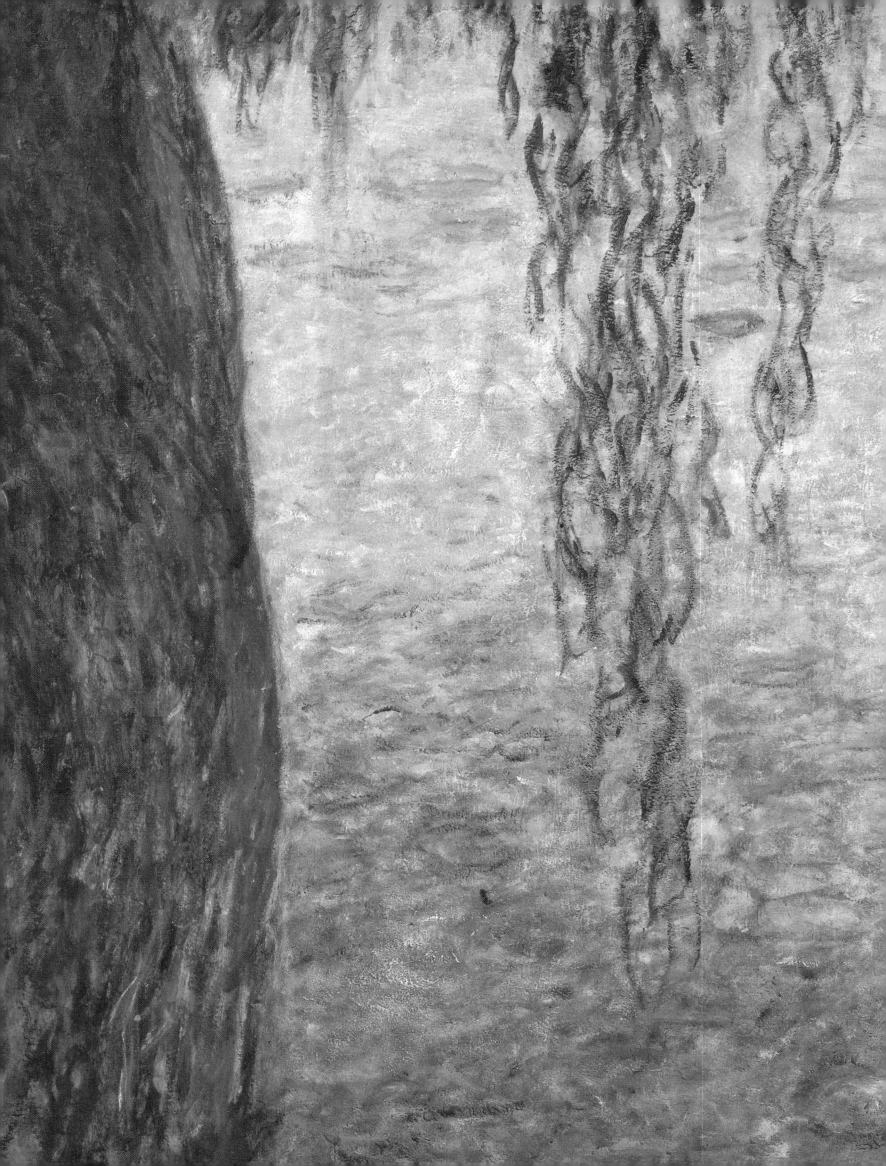

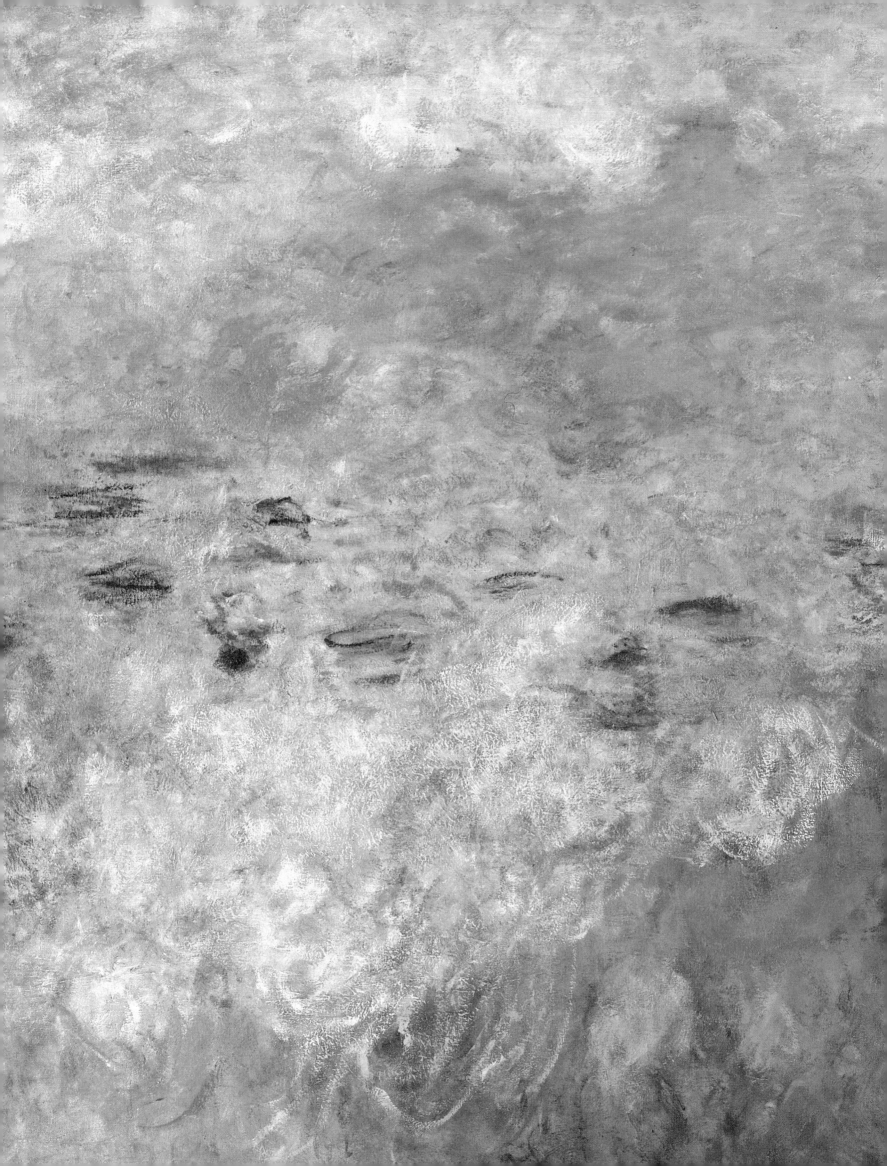

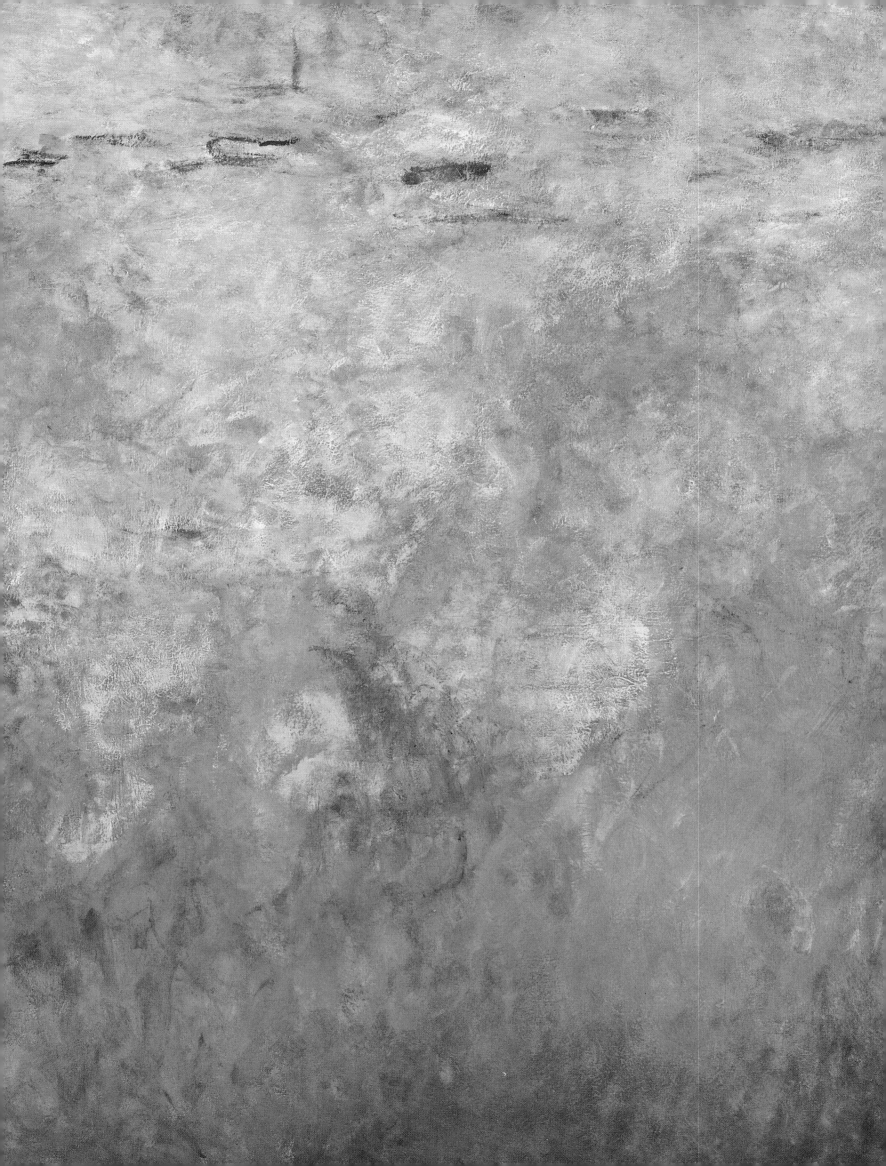

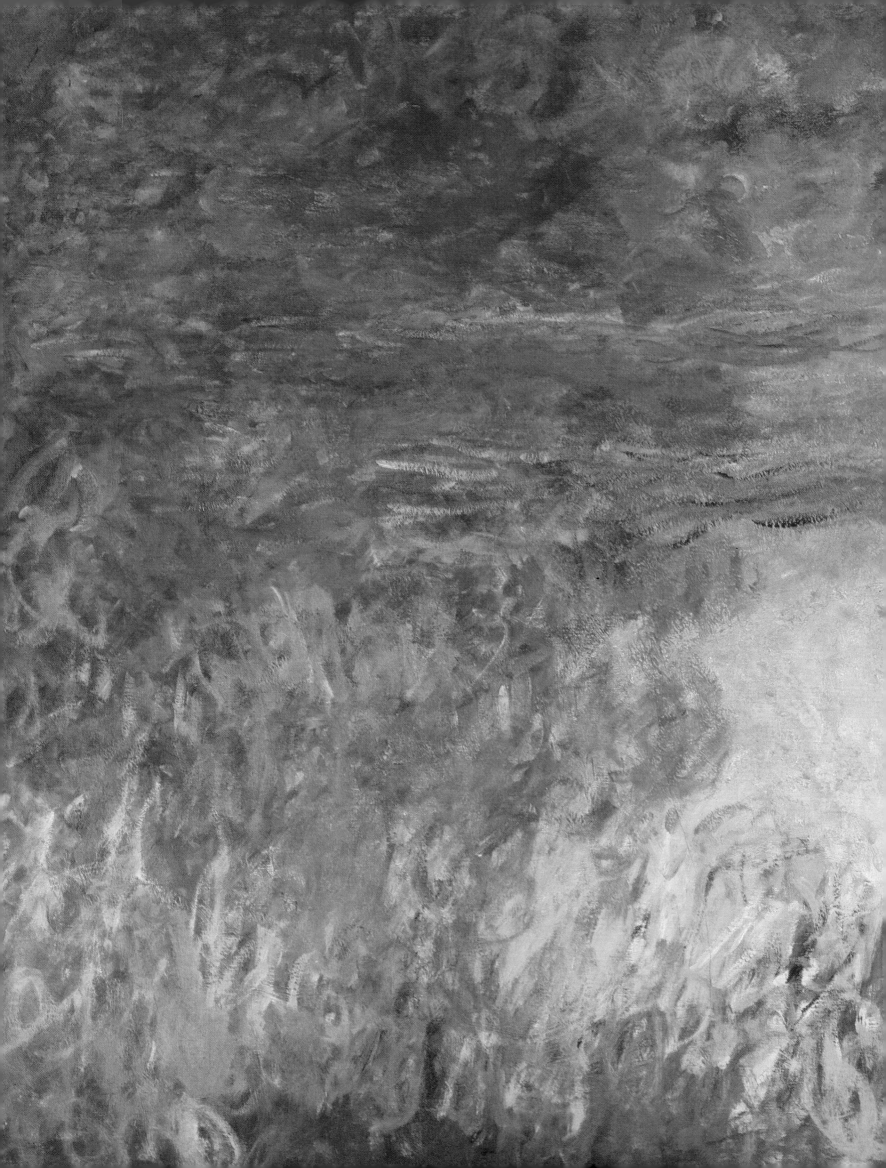

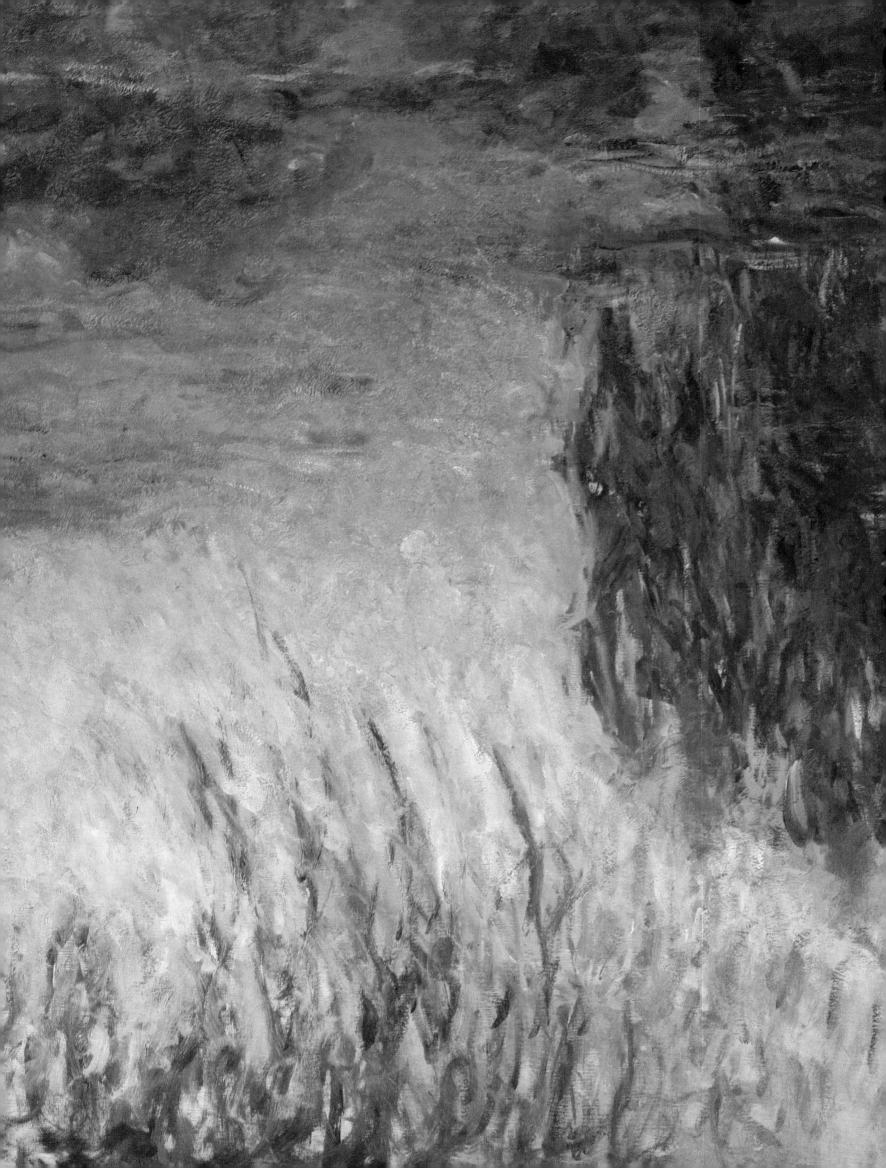

Cover:
Woman and an umbrella, Mme Monet and her son, 1875
Oil on canvas. 100 x 81 cm (39½ x 32 in)
National Gallery of Art, Washington.

Pages 4-5:
Water Lilies, Study of Water, Morning No. 2, 1914–18
Length: 12.77 m (41 ft 11 in).
Musée de l'Orangerie, Paris. RMN.

Pages 6–7:
Water Lilies, Study of Water, Morning, 1914–18
Length: 12.11 m (39 ft 9 in). Right part.
Musée de l'Orangerie, Paris. RMN.

Pages 8–9:
Water Lilies, Study of Water, Clouds, 1914–18
Length: 241 cm (7 ft 10½ in). Central part.
Musée de l'Orangerie, Paris. RMN.

Pages 10–11:
Water Lilies, Study of Water, Setting Sun, 1914–18
Detail of central part
Musée de l'Orangerie, Paris. RMN.

Konecky and Konecky
150 Fifth Avenue
New York, New York 10011

English translation: Rosetta Translations
Translation © W. S. Konecky Associates Inc.
All rights reserved

ISBN: 1-56852-248-7

Art direction
and design by Peter Knapp,
assisted by Christine Sahuc.

Research, commentaries
and captions by Emmanuel Lévy.

Created by Raymond Lévy
assisted by Sandrine Vieille and Zadia Zennir.

© 1992, Sté Nouvelle des Editions du Chêne
Printed and bound in Italy

Monet

The Man
The Head of the Family

Always critical of himself and others and invariably rejecting compromise, Claude Monet had a difficult life and an erratic career. Before he came to enjoy the success of recognition from 1890 onwards, he only had brief periods of satisfaction, or of domestic and material comfort.

The apotheosis of his work is traditionally identified with the *Water Lilies*, the great decorations that he painted for the French nation at the end of his life at Giverny. These conclusively reflected a period of great success. Indeed, Monet's paintings were unusually varied during the forty years that he spent at Giverny. He showed a renewed interest in the human figure, he developed his research into "series" paintings, and he continued to travel in countries including Italy, Norway, and England. But with the *Water Lilies*, his last struggle with himself, he moved further and further away from Impressionism.

Meanwhile, the "outsider" of 1883 had become a wealthy man, the owner of three studios, and a respected patriarch, ruling over a united family that was a veritable clan. The death of his eldest son and the fact that his second son had no children meant that there were no heirs to his name. There were however heirs on his wife's side, the Hoschedé family. Monet died on December 6, 1926, very much aware that only his work would survive him, and that is what mattered most to him. His correspondence reveals that his constant concern was that all his work should be well executed, placing this great man close to the realm of the craftsman.

For more than twenty years, critics had never spared him. He suffered from them more than other artists, being torn between the absolute ideal of the painter and the hard reality of life facing a man who had to feed a large family. Unlike Van Gogh, Gauguin, or his friend Cézanne, Monet never cut himself off from his family. Paradoxically, from the very start he tried to live a very bourgeois life. He was capable of asking Durand-Ruel for help when he could not afford to heat his house, yet at the same time asking for the address of a good wine merchant. Monet was always very human in his behavior. Legend may see him only as a churlish character who never left his property, which he had turned into some forbidden territory, a man who sold his paintings for exorbitant prices, and who terrorized his domestic staff. But to see him so is to forget the man as he was when he arrived in Paris in 1883.

Monet invested all his hopes and expectations in the village of Giverny, which had attracted him with its charming subjects. The house was rented from a rich owner and it did not yet have all the comforts that tourists today are so eager to see. The eight children were crowded into a few bedrooms with several of them having to share. Alice Hoschedé followed him in this final move just as she had followed him in his move from Vétheuil to Poissy. There is no doubt that the feelings of friendship, generosity and common sense that had prompted Madame Hoschedé to follow the painter to Vétheuil so that she could help him look after his two young children after Camille Monet's death in 1879

Camille or The Lady in the Green Dress

gradually developed into something stronger. It is not our place here to dwell on or judge the relationship that existed between Monet and Alice Hoschedé, who was married to Ernest Hoschedé, an art collector and friend of Monet. Although Hoschedé's bankruptcy was unavoidable, Alice Hoschedé's decision was a courageous one. Monet's financial situation in Vétheuil was as worrying as ever, and the hurried move to Poissy did not help as much as the painter had expected. Giverny embodied all the painter's hopes, but for the head of the family it also meant being further indebted to Durand-Ruel. In addition, his situation vis-à-vis Ernest Hoschedé, who was exercising his rights as a husband, only added to his anxiety.

Claude Monet was not in a position to hold his head high when he arrived in Giverny and the villagers were quick to treat him scornfully. A dutiful man, the painter never forgot his family when he traveled abroad. He sent sea birds and butter from Brittany and fruit from Italy; he scolded his son Jean for the many mistakes he made when writing letters; he worried about the rhinopharyngitis of the younger children who were prone to it in the Normandy climate, and he encouraged Blanche Hoschedé, the youngest of the family, to paint. Every member of the double family could be confident of his affection.

Indeed, it seemed that Monet found renewed energy every time he thought of his home and family in Giverny. Throughout his life he remained loyal, attentive and generous towards his double family as he attempted to maintain the balance between the man and the artist within him. There is no doubt that the Hoschedé children as well as his own benefited greatly from Monet's

success. Unlike the Pissarro family, only Blanche Hoschedé became a painter. Jean Monet became involved in the chemical industry where he worked with his uncle for several years. Thanks to his father's money, Michel Monet was able to give free rein to his passion for automobiles and he even crossed the Sahara in one. However, it was only after his father died that he married Gabrielle Bonaventure, in 1931. Monet would have never accepted that his own son should marry a former model, and he did everything in his power to break up any love affair between the Hoschedé daughters and several American artists who came to settle in the village. Only Suzanne was able to persuade him to change his mind, marrying the painter Theodore Earl-Butler (1861–1936) in 1892. She was helped and supported in her decision by Theodore Robinson, the only one of the Americans to earn the friendship of the "master of Giverny" when he came and settled in the village.

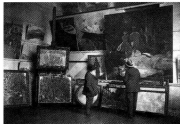
Monet and the Duke of Treviso

Both as an artist and even more as head of the family, Monet was conscientious. So when his step-daughter and favorite model became engaged to Theodore Earl-Butler, he was prompted to marry Alice Hoschedé, who had been widowed since 1891. Conscious of his obligations towards his partner's children, who had shared his financial problems, Monet saw it as his duty to give away his step-daughter like a real father. Although a committed atheist, he decided to regularize his situation four days before the wedding, which did not make life easy for the poor town clerk of Giverny!

From 1900 onward, Monet was constantly asked for help by various members of his family, especially the boys, whose life in the army he was trying to make more comfortable by helping out financially. By 1912 the painter was beginning to have doubts about himself and his abilities to develop his work, which he now found quite unsatisfactory. The reason became clear when in that year doctors diagnosed a double cataract in his right eye. He also discovered that his son Jean, married to Blanche Hoschedé since

1897, had serious health problems. To help him, Monet put his brushes aside for a time and bought him a small house in Giverny: the Villa des Pinsons. He took over the negotiations through which Jean disposed of his share in the fish-breeding business he had set up near Beaumont-le-Roger. Monet was by then over seventy years old, an age when he might have expected some well-deserved rest, free from domestic worries. But he still had to shoulder the entire responsibility for the family, solving their problems and financial burdens, and he displayed amazing energy in dealing with it all. The Registry Office at the Giverny Town Hall records the death of "Jean Monet, person of independent means…" on February 9, 1914. Madame Jean Monet (Blanche Hoschedé) did not remain long at the villa des Pinsons, which was subsequently inhabited by her younger sister. She herself moved back to the house of the great painter. Gradually, by her presence which evoked the memory of the shared sittings in front of haystacks or the poplars in the period 1890–91, Madame Jean Monet enabled the old man once again to become the great painter that he was.

Monet died on December 5, 1926, and his daughter-in-law continued to live in the big pink house with the green shutters until her own death in 1947. Then Jean-Pierre Hoschedé and subsequently Michel Monet tried to go on looking after the garden. But after Michel Monet's death in a road accident near the Pont de Vernon returning from visiting his father's house, Monet's house was bequeathed to the Musée Marmottan (Paris), as sole heir of the estate.

The painter and his refusal to make concessions

More than once, in describing himself, Monet used the words "fiercely stubborn" and "obstinate"… The amazing perseverance that was also his real strength was based on his almost complete refusal to compromise. This is not to say that Monet confined himself to a single theory, nor did he decide to work in only one field. He was probably a landscape painter at heart but he did not forsake still life or portraiture. It is true that his work was not very homogeneous in the first decades of his life, but Monet was slow. This slowness exasperated him, particularly since he was often accused by his contemporaries of "doing" a painting in a single afternoon. They did not appreciate the difficulty he had in getting into the subject, in seizing it quickly enough to extract its essence and then, in

a single spurt of combined inspiration and technique, translate it onto the canvas…

From 1883 onward, the artist, and probably the man too, was beginning to feel exhausted by the many moves in his life. He longed to settle down. The seaside in particular, whether in Normandy or abroad, made him realize that he was unable systematically to capture on canvas the conflicts between moving elements such as air, water, space and light. But Monet did not give up; he found a solution in a remarkable invention, the "series". These series paintings were like a picture book whose pages are turned over one after the other.

Monet was never a pupil of another painter and he always maintained his status as an independent artist, thus winning Renoir's admiration. The important event for the artist's family was of course the Salon. But by refusing to be anyone's pupil, Monet clearly expressed his feelings towards that institution. Happily, two landscapes: *The Mouth of the Seine at Honfleur* and *The Pointe de la Hève at Low Tide* were accepted in 1865. The next challenge he had set himself was *Women in the Garden*, a picture painted out of doors whose subject was based on life-sized characters, so that he had to make a special construction to manipulate it. Unlike the vast project of *Le Déjeuner sur l'herbe*, the *Women in the Garden* was completed, but it was rejected by the 1867 Salon. However, its completion gave Monet some satisfaction, since he had been forced to abandon *Le Déjeuner sur l'herbe* through lack of

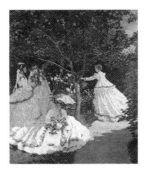
Women in the Garden

money. Being a much larger canvas, it required large amounts of paint and an enormous workshop in which to paint it. In *L'Événement illustré* of May 24, 1868, Émile Zola complimented Monet for concentrating in his paintings on the effects of light.

Monet was rejected again by the 1870

Salon when he submitted canvases painted at La Grenouillère. In these he had made no concession at all to the human figure, while Renoir's paintings on the same theme showed characters with attractive faces. His failure at the Salon clearly showed that neither the jury, the critics or the public were able to understand Monet's concept of painting.

His involuntary stay in London in 1870 marked a pause. Monet and Pissarro met up in London and visited the museums together. The landscapes of Constable and Turner simply served to strengthen Monet in his conviction that landscapes were best conveyed by a play of light and shade.

The Commune insurrection and the subsequent fierce repression imposed by the Thiers government were not calculated to attract the artist back to his country. From England, Monet went to Holland where he found some interesting subjects, perhaps suggested by Daubigny who was also living there in 1871. The *View of Zaandam*, now in the Musée d'Orsay, clearly foreshadows the Argenteuil canvases. The old "master" Eugène Boudin was delighted by the twenty or so studies that Monet brought back with him.

Argenteuil

The magic name of Argenteuil marks a golden age of Impressionism, a very creative period in Monet's career, and the best days of his friendship with Renoir and Manet. Through them, Monet found a house to rent in Argenteuil in December 1871. This little town on the Seine had a railway bridge and a road, promenades, and a fairground where many of the public festivities that livened up towns of the time were held. All these proved excellent subjects for Monet.

From 1872 onward Monet began earning significant sums of money. Buyers of his paintings included the dealer Paul Durand-Ruel, the merchant Latouche, the critic Théodore Duret and even the artist's brother, Léon Monet, who was one of the Rouen bourgeoisie. Encouraged by this success, Monet, Pissarro, and Sisley (but not Renoir) decided to abandon the Salon. Encouraged by his small circle of admirers, Monet worked harder and harder. Some of these paintings were so spontaneous that they are more like sketches. They also provided a basis for future developments: *Regatta at Argenteuil* (page 70, detail). Others like *The Bridge at Argenteuil* at the Musée d'Orsay (page 64) reveal the new level achieved by Monet in his research. The dialogue between air and water has been initiated but it has not yet

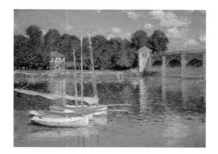
The Bridge at Argenteuil

become the painter's exclusive preoccupation. On the contrary, this Argenteuil period (1871–78) is marked by the great diversity of his themes and techniques. This varied production reflects the various stages in Monet's development, all of which the painter would take up again later. Thus, the subjects of characters in a garden or in regattas would appear later in the poppy fields at Vétheuil, at Giverny and in boats gliding on the river Epte. Of the latter he confirmed: "Yet again I have taken on an impossible task by choosing the subjects of grass and water."

At Argenteuil, his decision to buy a boat as a floating studio was entirely prompted by his desire to enter his subject directly. He was no longer a spectator, a voyeur on the bank of the Seine; he was on the water, surrounded by air, directly "inside" his subject. It is reminiscent of the strange wish Monet had expressed when he was young, of being buried in a life buoy so that he could float between two elements.

Monet spent many unforgettable hours on his studio-boat with his first wife, Camille Doncieux. Sometimes Manet, who lived nearby, would join him, as evidenced by his painting: *Monet Painting in his Studio-Boat* (page 72). Always rejecting easy solutions, Monet also worked on different subjects that forced him to change his technique. In the

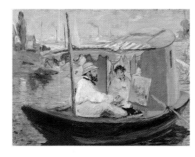
Monet Painting in his Studio-Boat, by Manet

course of 1873 he painted landscapes in the snow, still lifes in his garden, boats on the Seine during an expedition to Rouen, and family scenes such as *The Luncheon* (pages 74–75) now in the Musée d'Orsay. This

marvelous painting of this period has just two characters, one of them his son Jean, facing each other diagonally in the shadows. The laid table in the foreground is suggested and partially shaded, while the sun lights up the empty center of the painting, and, on the left, a mass of plants covered with bright red splashes of color. Bought by Caillebotte in 1876, the picture was part of the legacy left to the Musée du Luxembourg in 1896.

In some of the views of the Seine at Argenteuil, the river banks and trees are used to define the various planes. Similarly, in the first canvases painted by Monet in his garden, the masses of flowers occupy almost all the canvas, at the expense of the sky or any architecture that might have been included, a striking foreshadowing of the corners of the Giverny garden where spatial references are completely non-existent. His multiplicity of treatments of open air subjects also influenced his use of paint. Fluid, diffuse, thick, and juxtaposed, his brushstrokes helped to create the impression while also controlling the play of light.

However, the Argenteuil period also includes views of the great Parisian boulevards painted in a completely different style. It is as if Monet wanted to produce a counterpoint to the joyful Impressionist mood of the other paintings, which he accomplished using a clear palette, pleasing to the eye, and by choosing pleasant themes. Fascinated by the atmosphere of the big city, he painted *The Boulevard des Capucines* (page 79). The subject was no innovation; like most of the Impressionists, Pissarro, Renoir and Caillebotte all treated this theme at some point in their painting careers. Monet's painting was exhibited at the first Impressionist Exhibition in Paris in 1874, the event organized by the "Société anonyme dés artistes, peintres, sculpteurs, graveurs" ("Association of Artists, Painters and Engravers")

It was Bazille who had the idea of a regular exhibition independent of the Salon, but in 1867 the project was dropped through lack of funds. This time, after much discussion and not without difficulty, the former members of the Gleyre studio succeeded in drawing up the regulations of the association. Nadar had just moved out of his studio in the Boulevard des Capucines, the same one where Monet had worked on his painting of the same name, and the exhibition was held there. It opened on April 15, 1874, before the official Salon, so that the critics would

be able to see it. Monet showed five very dissimilar paintings, including another called *The Luncheon* (page 49) of 1868, which had been rejected by the 1870 salon. One of the others was *The Boulevard des Capucines*, a painting that marked an important stage in Monet's development, and one in which he strictly applied the Impressionist principles.

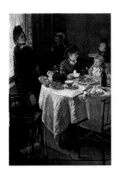

The Luncheon

It is the evocation of a sensation, a view glimpsed through a window, a street crowded with people on a winter's day. There is no foreground, the eye is not attracted to any particular point, and the whole view consists of the crowd itself. The roughly sketched carriages and the waves of characters in simple silhouette all help to create the impression of an animated crowd.

Unfortunately, all that the journal *Charivari*'s critic Louis Leroy could see in this amazingly lively representation of a milling crowd was a mass of black dots. He was even more inflamed by another painting: *Impression, Sunrise* (pages 62–63), dated 1872 but in fact painted at Le Havre in 1873. Today this is one of the most famous paintings because it gave its name to the Impressionist movement, but this remarkable canvas, entitled simply *Impression*, roused Leroy's anger. In his view, shared by most of the other journalists present, Monet was merely making fun of everyone by exhibiting a simple sketch. In it, the characters were again reduced to a few brushstokes, and there was no attempt to color the background completely.

Determined in his refusal to make concessions, Monet was not trying to seduce the viewer. What *Impression, Sunrise* and *The Boulevard des Capucines* have in common is the fact that they both represent a fleeting moment. The impression does not last; otherwise it would have been necessary to stop the passer-by to study his features or pierce through the mist and smoke to observe the

details of the cranes and wharfs, for example. Similarly, *The Poppy Field at Argenteuil* (page 76), *The Luncheon* (page 76), and *Fishing Boats Leaving the Harbor of Le Havre* offered yet more themes and treatments.

Monet seemed like an innovator, and this disturbed the critics. The year 1874, when Monet was able to establish himself and to declare his future objectives, was equally remarkable in the history of the little group. Monet's garden at Argenteuil was visited by Renoir and Manet together. The pleasure of these meetings was conveyed in paintings that are of particular interest to art historians, showing one artist recording another artist's private life. As well as Manet, Renoir painted Monet's wife and son. His well-known *Madame Monet and her Son* (page 77) is reminiscent of Manet's painting of *The Monet Family in the Garden* (page 76).

Some people think that these paintings are too close to one another because they often have the same subject, thus revealing the limitations of the movement. This is a hasty judgement, since the personality of each of the three painters comes through quite clearly. Renoir's composition shows Camille Doncieux and her son Jean in close-up, while Manet arranged his composition by defining planes, using contrasting colors and broad, decisive brushstrokes, techniques that are never found in Renoir's work.

Other paintings would follow, revealing future directions. *The Road in the Long Grass* (1875) by Renoir was painted after *Poppy Field at Argenteuil* (page 76) by Monet, but the challenge was the same: the insertion of the human figure in the landscape. Renoir makes the character stand out, enveloped in a luminous halo, while Monet so integrates

The Poppy Field at Argenteuil

the character in the landscape that it almost disappears within it.

In order to break with these images of careless happiness, Monet went in search of other subjects. The Argenteuil period also

saw his methodical exploration of the theme of railways. Monet was fascinated by the clouds of steam, and the often extreme contrasts at certain times of the day between the light inside of the station and that outside. Naturally he remembered Turner's paintings which he had seen when he stayed in London in 1870. His friend Manet had already used this theme in a memorable *Railway* (1872–73) which he bravely exhibited at the 1874 Salon. Monet was more interested in the problems of perception, vision, and light than in the subject itself, which was merely a social statement. Being a man of his own time, Monet only used from his surroundings what appeared essential to his work. There again, he made no concession to trends or to the observations of some critics who saw it as a return to realism.

In *The Pont de l'Europe, Gare Saint-Lazare* (page 83) at the Musée Marmottan, the railway itself is no longer the real subject, and

The Pont de l'Europe at Gare Saint-Lazare

the locomotive has been pushed to the far left of the canvas. The transformation of colors and perspectives caused by the spirals of smoke and steam is the real subject. Most of these paintings could not be painted at the location of the subject, in spite of the requests made by Monet to the railway administrative, so sketches and notes completed the record of impressions that contributed to the richness of the analysis. When, several years later, Émile Zola published *La Bête humaine* in March 1890, critics saw a parallel. But the writer was creating a decription of catastrophe. The murder of Barrême, the head of the *département* of the Eure, in a train compartment on the Paris-Rouen line provided the first elements in 1886. Zola used the atmosphere of stations and depots for nightmarish ends, precisely because the world of railway stations was part of everyday life. In fact, the writer admired Monet's canvases shown at the Third Impressionist Exhibition of painters in the spring of 1877: "This year he

(Monet) is exhibiting some magnificent interiors of railway stations. One can almost hear the roaring of trains rushing into the station, and see the billowing smoke hovering beneath the roof…" The *Station* paintings were a great success with Monet's loyal admirers, but the exhibition as a whole was a failure. Monet's friend, the collector Ernest Hoschedé, purchased three of the paintings anonymously, but his bankruptcy meant this did not help Monet's situation.

The Argenteuil period was important because of the various subjects treated, some of them already forerunners of the great series paintings that were to come. But paradoxically it also saw a deterioration in the financial situation of the Monet family, now including an extra member with the birth of a second son, Michel on March 17, 1878.

After producing some magnificent views of urban landscapes such as *The Rue Saint-Denis on June 30, 1878* (Musée des Beaux-Arts, Rouen), the Monet family moved to Vétheuil, once again with the help of his friend Caillebotte, the collector Bellio and a generous advance from Édouard Manet .

The stay at Vétheuil (1878) followed by a similar one at Poissy (1879) were not promising for the painter's future prospects. The future remained gloomy with the unfavorable economic situation. The ruined collector Hoschedé had left the Château of Rottenbourg at Montgeron in the Essone, for which Monet had painted four large works: *The White Turkeys, Corner of the Garden at Montgeron, The Pond at Montgeron,* and *The Hunt*. These were separated when sold at auction.

In order to economize, the Hoschedé family left Paris for Vétheuil where rents were

The White Turkeys

more affordable. Ernest Hoschedé rented another, more spacious house on the outskirts of the village in which the two families were reunited. Monet found it hard to live with this situation, which made him

wholly dependent on his former patron. His wife Camille was ill more and more often, having never properly recovered from the birth of their second son, and as was usual when his morale was low, his work suffered. The family situation and everyday life were becoming increasingly difficult for the painter.

On September 5, 1879, Camille Doncieux died, something of a release after months of anxiety. Monet the man was in a state of shock and Monet the artist insidiously took over, succumbing to a compelling urge to fix Camille's features on canvas. Slowly, the artist's spirit triumphed over the man's distress. The canvases painted during the winter of 1879–80 show that he remained faithful to his concept of open air landscape, and the sadness of some of the views of Vétheuil or Lavacourt was probably due more to the rigors of that particularly harsh winter than to the painter's low spirits.

Hoar-Frost (1880) at the Musée d'Orsay show the care and concentration used by the artist to convey the diffuse scintillation of light, the absence of reference points, and the immaterial quality of the landscape. *Impression, Sunrise* (1873), where the dark boat is used to define the foreground, is similar in that it too has no spatial reference points. *Hoar-frost* revealed Monet's determination and his absolute refusal to compromise by producing more conventional landscapes. Exhibited in 1880 in the offices of the magazine *La Vie moderne* (launched by the wife of the publisher Charpentier), under the title *Hoar-frost, Effect of Sunlight*, it was bought by Monet's loyal admirer, Caillebotte.

The publisher Charpentier, had contributed greatly to Renoir's triumph at the Salon with his superb *Portrait of Madame G. C. and her children*. Renoir saw himself as the publisher's "usual painter," and it was probably through his intervention that Monet was able to exhibit on his premises.

Although the group of Impressionists experienced increasing friction within itself, Monet remained a committed Impressionist and a close friend of Renoir. It was probably under Renoir's influence that he resumed his contacts with the Salon in 1880. *Icefloes* was rejected, but *Lavacourt* was accepted. According to Monet, the painting was completely conventional and likely to please the bourgeoisie. Indeed, at the Seventh Impressionist Exhibition in 1882, Monet appeared to disown it by refusing to exhibit it! Instead

The Frost

he sent instead *Sunset over the Seine, Effect of Winter*, which clearly revealed his continuing adherence and loyalty to the Impressionist movement.

Of *Lavacourt*, Émile Zola wrote that "it adds an exquisite note of light and open air, all the more so because it was surrounded by tarry canvases of depressing mediocrity." The writer was still puzzled by the artist's hesitant approach and stated harshly: "It is study that produces solid work. M. Monet is now paying the penalty for his haste, for his need to sell."

Unfortunately Émile Zola was not the only one to judge some views of Vétheuil insufficiently finished. Monet responded to this accusation in 1884 in a letter to Durand-Ruel: "I can assure you that I try very hard and anyone who believes that I produce my paintings without care or effort is quite wrong. Finally, I do what I think." A few weeks later he was even more determined: "As for the finish, or rather the over-polished look, because that is what the public wants, I shall never agree with it." Monet refused to make any concession that would help the sale of his paintings by Durand-Ruel. The dealer had already reserved a large number of paintings through an informal agreement by which the painter received regular payments against future paintings. Monet was well aware that he was indebted to the dealer, indeed being almost a paid employee. But far from being conciliatory, he became even more intransigent both with himself and others.

Giverny

In December 1881, when Alice Hoschedé decided to follow Monet to Poissy with her children, it was not the start of period of hope and prosperity but the beginning of a very tense situation with the Hoschedé family. The crash of the Union Générale Bank in January 1882 put a sudden end to Durand-Ruel's projects. But nonetheless it was thanks to him that Monet was able to consider the move to Giverny. The painter had fallen in love with

the village and the many subjects that were there. While Poissy had only been a interlude, Giverny was to coincide with a period of improving fortunes during which Monet would consolidate his artistic attainment, while gradually distancing himself from the Impressionists. Curiously enough, it was the very dispersion of the group that reinforced Monet's and Renoir's positions, thus rewarding their mutual loyalty and friendship. The Giverny period (1883–1926) was therefore a new era in the career of the artist and the life of the man, even though the early years there were still affected by the critics' adverse reaction to his work.

Soon after moving to Giverny, Monet accepted an invitation to join Renoir on a study trip to the Riviera. Fascinated by the multitude of subjects discovered during this two-week tour, Monet decided to return on his own in January 1884, delicately expressing his preference for traveling without Renoir: "As much as I enjoyed traveling with Renoir as a tourist, I would find traveling and working together difficult. I have always preferred working alone." In spite of his lifelong friendship for Renoir, he feared that his company might influence his impressions, and that perhaps even the spontaneous choice of subjects might escape him. Work always took precedence over friends, and the correspondence of the artist published by G. Wildenstein clearly reveals the regret, or even the confused remorse, that beset the man when the artist had to close the door to his friends.

In 1884 Monet was enchanted by the new subjects (the lush vegetation) and the unusual colors (the blue or pink sky) he discovered in Bordighera, but he also knew that the very discovery of new elements and unfamiliar landscapes demanded much concentration on his part. "The man of lonely trees and wide open spaces," as he called himself at the time, was completely overcome by the lushness and abundance of vegetation in Italy. He worked frantically and prolonged his stay because he was not satisfied with the results of his work. Monet always experienced this uncertainty towards a subject whenever he tackled a new theme.

This feeling of uncertainty reached its peak during a journey to Norway where he arrived on January 28, 1895, yet was unable to work until mid-February, overcome by the novelty and vastness of this landscape buried beneath the snow. Full of nostalgia at the thought of the subjects at Giverny, Monet, the eternal traveler, suddenly had the curious sensation that he was attached to one place, one site.

A Serene Strength

In July 1890, Octave Mirbeau wrote to Monet: "…in temperaments like yours, everything grows, widens and becomes stronger with time." At the time the painter was working on his *Poplar* series, and though the work seems so successful and rich today, it drained Monet mentally and physically. This period of 1890 heralded the beginning of the final recognition of Monet the artist. Eternally dissatisfied and uncertain, Monet continued to pursue his ideals without yet being able to define them clearly. He derived his strength from his perseverance, and also from the long experience he had gained from his close contact with nature. In fact, he was so close to nature that he could afford to finish all his canvases in his studio, contrary to the story of his stepson Pierre Hoschedé published in 1960, *Monet, ce mal connu.*

Renoir was going through a period of crisis in the years 1881 to 1890 after a brutal realization: "I had gone to the very end of Impressionism and I realized I could neither paint, nor draw. In other words, I found myself in a dilemma." But unlike his friend, Monet remained unchanged. Although he sometimes questioned the present moment, his research always stemmed from the same approach: nature, atmosphere, light, then water. His subject became increasingly condensed. In the meantime, the public had begun to accept Impressionist paintings, largely because the subjects were far more fascinating than the traditional large historical landscapes. Art criticism had also devel-

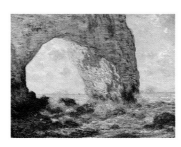

The Manneporte

oped. By 1884 it had become apparent that Impressionism was an irreversible, permanent phenomenon, contrary to what the critics had forecast. At the sale of Édouard

Manet's *atelier* after his death, the difference in price between a Meissonnier and a Monet was still significant, but it was also true that the painter's canvases had increased tenfold in price between 1880 and 1890. In spite of the interest of the critics in Symbolism, Monet remained a committed Impressionist whose only concern was to translate the ephemeral, fleeting effects of light.

This kind of serene strength which was to characterize the painter from now on already existed in a latent state in the canvases painted in Etretat in 1885. Full of life and intensity, the *Manneporte* paintings in particular no longer displayed the relative classicism of the earlier Etretat seascapes; rather they looked forward to the Belle-Ile paintings of 1886 and those of the Creuse in 1889. Nothing seemed able to stop Monet in his efforts to express the effects of nature, and above all, to understand and absorb it. Without making any concessions to the taste of the public or the dealers, Monet framed the rocks, cliffs and ravines in close-up, taking over the space usually reserved for the sky and painting the subjects in all their ruggedness beneath the elements.

Octave Mirbeau discovered the painter through Durand-Ruel in 1884, and he was thrilled by the canvases painted in Belle-Ile. Never had an Impressionist painter gone so far. A fervent admirer and quite overcome, he expressed himself clearly to Rodin: [this is] "a terrifying, formidable Monet, unknown until now, but his work will be less popular with the bourgeoisie!"

The series of *La Creuse* paintings, unfortunately rarely seen together nowadays, was exhibited in 1889 in the Galerie Georges Petit. A large number of these landscapes were sold to American collectors. Their interest in the landscape of the Creuse region can be explained by a certain similarity with American art. Indeed, the Creuse is known for its wild landscapes, made to look even wilder through the eyes of Monet. They were reminiscent of the paintings of the New World produced by one of America's most famous landscape painters, F. E. Church (1826–1900), but without the concept of the ideal. Interpreted as "successions of meteorological analyses" by Monet's friend the critic Gustave Geffroy, these canvases are a perfect translation of the impressions of the landscape painter

looking at nature, completely free of any complacency.

The Creuse studies logically completed the display of the 145 paintings exhibited at the Gallery, illustrating the development of the painter from 1864 to 1889. Monet shared the exhibition rooms with Auguste Rodin. From an artistic point of view this was remarkable because it revealed and emphasized the nature of the each artist and the high level achieved by both. But it did not promote good relations between the two men. The painter was shocked when Rodin put a sculptor in front of one his paintings. He saw the juxtaposition as a slur on his work and he accused Rodin of selfishness. This brutal confrontation of

GALERIE GEORGES PETIT
8, rue de Sèze, 8

CLAUDE MONET

A. RODIN

PARIS
1889

Cover of the exhibition catalog

canvases and sculptures probably contributed to the lasting impression made on the public and critics by the encounter of these two remarkable artists.

Auguste Rodin was already very famous in 1889, but like Monet he remained loyal to his principles: "Even the best work needs time and it is the better for it" he observed looking at the maquettes of his sculpture *The Burghers of Calais.* Like Monet, he enjoyed reviewing his work, and like him, but as a sculptor, he was passionate about cathedrals, the effects of light and shadow, and the rhythm of the facades. In fact he wrote a book about them in 1914. The two men were too similar and too idealistic not to clash now and again. In the eyes of the painter, the sculptor was a rival. Monet's circle of admirers had grown enormously and Durand-Ruel no longer had the exclusive rights on Monet's production, although he was still responsible for paying the painter's debts.

Georges Petit had put forward his claims to represent Monet as early as 1885, and Monet had been able to "sell [his work]

expensively to middle-class buyers" at Petit's Fifth Exposition Internationale in 1886. However, in May 1891 it was in Durand-Ruel's gallery that the artist exhibited his fifteen paintings of haystacks.

Haystacks, poplars, and cathedrals

The subject of the haystack was not new when Monet became interested in it, that is from 1884 onward. Notably Jean-François Millet (1814–75) had used it in several of his works. Always present in scenes of rural life in France in the second half of the nineteenth century, haystacks were less often the sole subject of the painting, as in the pastel drawing by J. F. Millet's *Winter* (1868) in which they appear solitary and frozen in an unusual harmony of blues.

On his arrival at Giverny, Monet painted a few landscapes with small haystacks. These were usually placed in the foreground of the composition with a curtain of poplars closing the background. The summers of 1884, 1885, and 1886 were punctuated by a few landscapes with haystacks but, as in 1888–89, these are more like piles of hay than the famous haystacks. In fact, in 1888–89, other painters in the American artists' colony were painting the characteristic rows of "shocks," stacked sheaves of corn. The haystacks, the subjects of the famous series of 1890–91, are of a different nature; they are made of sheaves of corn piled on top of each other, covered by a conical thatched roof to protect the corn from bad weather over the winter. Unlike shocks, these haystacks, which measure some 13 feet (4 meters) in diameter, can be left in the fields for several months. It was at the Clos Morin, near his house, that the

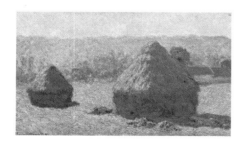

Haystacks, Late Summer, Morning

painter discovered the interest of this subject on a summer's evening. Later, in the 1900s, there would be many postcards from Giverny representing haystacks, helping to make them an even more familiar feature of the Normandy countryside. In the meantime, Monet worked frantically, producing about twenty-five canvases, twelve of them

painted in winter. After a difficult start, disconcerted by the rapidity with which light and shadow moved round these haystacks, Monet was thrilled by this new challenge. In the course of the winter of 1890, after

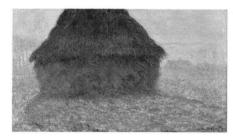

Haystack in the Sun

being encouraged by Octave Mirbeau, he expressed his satisfaction at the work he had produced so far in his letters to Durand-Ruel. The mild weather in the winter of 1890–91 made it possible for him to continue working on the series in spite of the early snows. Snowy landscapes had always had an irresistible attraction for Monet. At this moment he had every reason to feel happy since he had become the owner of his house in November 1890 and could therefore be certain of remaining in this "region that is so beautiful." Monet used to start with a global approach to his subject, next he isolated a particular detail which would then fill the entire canvas. So he began by painting the haystacks in groups of two, clearly represented, although shown from a distance; then he isolated one of them by moving his easel closer. Finally, in a third stage, he framed one haystack in a close-up so large that the canvas seems almost too small to contain it. Monet often proceeded in this way.

Besides this topographical move over the field, the painter also added a chronological variation. This time shift was amusingly underlined by the critic Henri Beraldi, who estimated a time difference of nearly two hours between each canvas. This assessment is probably close to the truth. In 1927, the Duke of Treviso wrote in his *Pilgrimage to Giverny* about the many comings and goings of Blanche Hoschedé to provide the master with enough new canvases. But this was not the whole story. Indeed, the exhibition was a selection from roughly twent-five canvases painted between summer and winter. Very concerned about the "series" effect, Monet took the canvases back to his workshop to harmonize them in relation to each other, revealing once more his subjectivity

as well as his prodigious visual memory. On each of the *Haystack* canvases, the brushstrokes appear very carefully and precisely applied with an extremely disconcerting variety of nuances that reflect his remarkable sense of observation and his amazing sensitivity, which enabled him to capture the effects of light.

The presentation of a selection of fifteen *Haystacks* complemented by a few landscapes of Giverny was spectacular, as Monet felt it was bound to be. For the first time the interest lay in the idea of a series planned by the artist, but paradoxically the exhibition would also lead to the dispersal of the paintings, which were bought for prices ranging from FFr 2,000 to FFr 4,000. A month before the start of the exhibition was due to open in Durand-Ruel's gallery on May 4, 1891, the success of the exhibition was already assured. As Camille Pissarro said to his son: "Times are very difficult for me, Durand cannot commit himself as far as my paintings are concerned... Nowadays, people only want Monet, it seems he cannot produce enough of them, the awful thing is that every one wants to have *Haystacks in the Sunset.*" Pissarro appeared to be quite bitter here, which can probably be attributed to his temporary financial problems. Monet helped him by lending him some money and giving him addresses where he might be able to place his canvases.

Camille Pissarro was not the only one to foresee Monet's success. Octave Mirbeau had already expressed his enthusiasm and written to the painter telling him that he had found it very difficult to tear himself away from the *Haystacks* "whose blond dream seemed to expand and deepen into infinity." The critic Gustave Geffroy also compared the artist to a poet, the only one capable of "narrating mornings, middays, dusks, rain, snow, cold..." It should be said that impartiality was probably not the strong point of the critic, as he was a great friend and admirer of the painter.

Several factors contributed to the success of this series. The simplicity of the subject and its rural connotation, its poetry, the seductive palette in even the more contrasting versions could only please the public, including those who deep down were happy to see Monet produce more conventional paintings again, with a more clearly defined approach. This was one of Pissarro's implied criticisms, but he bowed to the result; Monet appeared

the stronger. The work on the theme of haystacks marked a turning-point in the artist's career. He now had his place in the village as a house owner, he was increasingly respected by the public, and even the critics had calmed down.

In fact, Monet deliberately kept his distance from the group of Impressionists in the hope that he would cease to be the target of the press. The series of the Haystacks was still Impressionist in spirit as in treatment, but at the same time it reveals a symbolist conception of the landscape, in particular by Monet's very subjective choice of color harmonies.

The artist had just entered a period of serene strength, sure of himself, of his art and his business. Indeed, although the presentation of fifteen paintings on the single theme of haystacks appeared like a new challenge, the painter had in fact researched it carefully and thoroughly. He himself made the selection from twenty-five paintings, the result of six months' hard work. Finally, ten of the fifteen canvases exhibited had already been reserved by collectors or dealers: Paul Gallimard, Valadon, de Bellio, and even James Sutton, the American collector whose recent purchase of *The Angelus* by Millet had hit the headlines in the French press.

Monet began to take advantage of the situation by cleverly playing on this rivalry. Thus, he warned Durand-Ruel that he should come to the Giverny studio urgently. He also explained to the dealer in Impressionist paintings that having exhibitions of the group would not be a good idea but that, on the other hand, small presentations of the recent

Paul Durand-Ruel by Renoir

work of a single artist would be much better.

Bearing no grudge, Durand-Ruel even bought some *Haystack* paintings from Monet's daughter-in-law, Blanche Hoschedé, who was painting better every day as a result of her apprenticeship "in the field," as it were. She always stood by the painter, sharing his

moments of joy as well as his disappointments. The series of *Poplars*, exhibited at Durand-Ruel's gallery in March 1892. was a logical successor to the *Haystacks*. There again, it was a familiar subject since poplars were everywhere in the landscape near Giverny and its surroundings. Poplars began to appear in Monet's painting as early in 1887 but they only became a subject in themselves in 1891. The painter had discovered this association of trees and water a few miles away from his house in his row boat, a rather

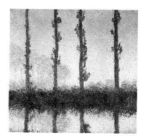

The Four Trees

uncomfortable craft but one that enabled him to travel up the Epte river. Some canvases were painted on the same spot but at different times according to the principle already observed for the *Haystacks*; others were painted by moving along one of the riverbanks.

The use of water as a foreground enabled Monet to emphasize the verticality of the trunks, by bringing the reflection of the trees and sky back into the foreground. Some paintings depict three trees, standing out clearly against the background and dividing the composition vertically into three parts while others form a curved alignment in the shape of an S. The tree tops are outside the field of vision defined by the frame. This was quite a common technique in Monet's work which also to some extent influenced the painters of artists' colony in Giverny. While the haystacks look like static elements, the poplars participate fully in the dynamism of the composition. In the first case, the viewer's eye is attracted directly to the subject, the haystack, while in the second case, the eye is invited to sweep across the canvas following a sinuous route. The subject, on its face banal, trees lined up along the riverbank, is enlarged and transformed without any additional artifice. So for instance, the figures of the Hoschedé-Monet family that appeared in some of his earlier works in 1887 have completely disappeared by 1891. The painter

began to concentrate increasingly on the essence of the subject, water, air, trees and the varied use of materials. Thus, two absolutely identical views could be painted completely differently, with strong brushstrokes in one case, diluted ones in another, using a contrasting palette, and so on.

As he had done with the *Haystacks* series, Monet carefully prepared the exhibition, which this time would show only the *Poplar* paintings for a period of ten days. In January 1892, two months before the exhibition opened, Monet had already sold a dozen canvases, four of them to the Galerie Boussod et Valadon. The exhibition was again a great success, and the concept of decorative painting was born. Octave Mirbeau was the first to note "the absolute beauty of [the] great decoration". Georges Lecomte saw that there a new outlet for landscape painting of which Monet had become the leading

framed in a close-up, a technique which Monet would also use in the *Water Lilies* paintings. Similarly, some more recent critics have argued that Monet's choice of the poplar was not a matter of chance (it is the tree of freedom and symbolic of rural France), and that his decision to paint the *Cathedral* series could be justified by the historical context of the monument and its appeal as a symbol. One thing is certain. Monet was a man of his time who traveled, went to exhibitions, entertained artists, and read a lot, but he was also a man of extreme sensitivity and natural curiosity, supported by an excellent sense of observation. As a painter, his universe was the world around him. Rouen cathedral could not leave anyone indifferent, and Monet knew the city well.

Built in the center of the city and surrounded by a tight network of narrow streets, Rouen Cathedral is overwhelming with its power and dominating strength. The changes caused by the light are continuous, and because it is confined by other buildings there is no possibility of standing back to

presence was physically and morally overpowering, and he even dreamt that the cathedral fell on top of him. In all Monet produced some thirty paintings in which the building occupied the entire canvas. Turner and the many illustrators of *Normandie* and *La France pittoresque* published in the nineteenth century had been able to express the majestic, imposing nature of the building by taking some liberties with its scale and including some characters in the foreground. Monet, on the other hand, crushes the viewer by framing just one part of the cathedral, which fills the entire surface of the canvas. Never had he gone this far in the exploration of a theme.

He was happier with the second part of the project in 1893 than the earlier one. On one particular day in March, he was working on as many as fourteen canvases at the same time. His friend Mirbeau had left the Eure to settle closer to Paris, in Carrières-sous-Poissy, and he continued to encourage Monet from there: "And the cathedrals? I cannot wait to see them stand in their magnificent symphony of stone." He had to wait until

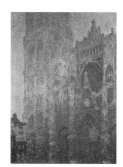
Rouen Cathedral,
The Portal and Tour Saint-Romain, Morning

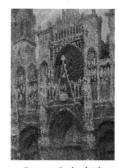
Rouen Cathedral,
The Portal, Overcast Weather

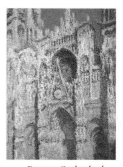
Rouen Cathedral,
The Portal and Tour Saint-Romain, Full Sun

light. Camille Pissarro was of the same opinion: "What a beautiful sight, the three arrangements of the poplars in the evening, this is real painting and it is so decorative!" He wrote to Monet in congratulating him on the success of the exhibition.

Monet followed the events from Rouen where he was painting his third series: *Cathedrals*. Two stays were necessary to complete this mammoth project, one in 1892 and another in 1893. On both occasions the period chosen ran from February to mid-April so that the timing of the season would be consistent. On the other hand, he was unable to rent the same studio in front of the cathedral; he had to move three times. The advisability and objective of this series may be questioned, but on reflection it becomes evident that it followed logically after the rocks in the landscapes of the Creuse, the haystacks and poplars. Here too, the subject was

appreciate it from a distance.

So the close-up framing of the paintings that prevents the viewer from seeing a large part of the building is unavoidable. On this occasion, Monet did not use the technique of displacement by changing the site or position, or the succession of seasons. He simply concentrated on the factor of time. It is easy to imagine the difficulty of such a challenge, all the more because the subject is an austere one, in spite of the delicacy of its architecture. Other painters after him, in particular those belonging to the Normandy School, were less successful after him. Indeed, the range of time is fairly restricted: dawn, morning sun, and full sun. The rain adds another variable by altering the light. As always when grappling with such problems, Monet confided his frustrations to Alice Hoschedé, who had by now become his wife. He was obsessed by the subject whose

May 1895. Indeed, after his return to Giverny, Monet continued to retouch some of the *Cathedral* paintings throughout 1894. Then at the beginning of 1895, he traveled to Norway to visit one of his stepsons who was living there temporarily.

As well as the *Cathedrals*, the exhibition that opened on May 10, 1895 at the Galerie Durand-Ruel included about fifty other paintings that he had produced over the previous few years. But it was the twenty *Cathedrals*, arranged in their various harmonies, that stole the show. They inspired Georges Clemenceau to give the strikingly lyrical title *Révolution des cathédrales* ("The Revolution of the Cathedrals") to an article published in his journal *La Justice*. He wrote

that it was that it was the duty of the government to keep this testimonial to France intact.

In 1894 Monet had begun to negotiate the sale of his *Cathedrals*, which he priced at FFr 15,000, and in order to do so he delayed the opening of the exhibition arranged by Durand-Ruel so as to sell a few more canvases. This strategy had proved very fruitful in the case of the *Haystacks*, and so it proved again since Valadon and Depeaux (a well-known Rouen collector) bought several canvases at high prices. Quite by chance the exhibition of the *Cathedrals* that confirmed Monet's status as an innovative, independent artist, marked the beginning of a series of events. These included the administrative problems of the Caillebotte legacy, the latter's funeral that deeply affected Monet, the death of the collector Bellio, the Dreyfus affair, the matter of the Balzac sculpted by Rodin, and the death in 1897 of Alice Hoschedé's daughter Suzanne Butler. These were followed by the deaths of Mallarmé and Sisley.

But life had to go on. While Monet was deeply affected by these blows, he was always supported by the friendship of those around him and of "his kind and friendly family," as he wrote in a document preserved at the Musée de Vernon. In moments of difficulty, his artistic side was always the first to react, and it is possible that the passing away of his painter and writer friends contributed significantly to his decision to tackle a project far larger than any he had produced before. It seems that this is how the idea of the large decorative compositions of the *Water Lilies* was born in 1898.

The Water Lilies and Clemenceau

Today, "water lilies" unavoidably evokes Monet and Giverny. This unfairly diminishes the other important works that the artist produced in the village. Perhaps it is the fault of the beautifully renovated gardens that attracts large crowds of admirers who are not always well informed about the rest Monet's prodigious career.

It has been estimated that Monet painted over 250 canvases on the single theme of water lilies. These were all produced during the last twenty years of his life. But he continued to paint other subjects during this period, and he also spent some time on the Normandy coast, in Brittany, in London (several times) and in Venice (1908). Finally, there was another vast project in preparation during this period, the decorative paintings, consisting of several large scale representations

without frames that would be "read" as a sequence on the walls of a room. For various reasons the project only really commenced in 1914, and it occupied the artist until his death.

In the meantime, the many fairly long, interruptions corresponded mainly with events related to the family, in particular the death of his second wife Alice in May 1911. He was only beginning to recover from this in 1914, when he had to mourn a second death in the family, that of his eldest son Jean Monet. Fatigue and old age, together with inevitable health problems, particularly his failing eye sight and an operation for a cataract, which has been written about at length, all deeply affected the man and harmed the artist.

Monet's friends were gradually dying off. "It is a sad privilege to grow to such an old age," the artist remarked philosophically. Journalists, dealers and admiring visitors increased every year, but they did not fill the gap. Contrary to the legend, Monet was very sociable until the end of his life and he opened his door to new generations of artists: Bonnard, Vuillard, Maurice Denis, André Barbier, Matisse, Vlaminck, and others. The list of visitors is all the more important because Monet was also interested in the world of literature and performing arts. Among those personalities, one stood out in particular: Georges Clemenceau. From 1908 onwards he lived in his second residence in Bernouville, between Gisors and Giverny. The friendship between the two men of the same

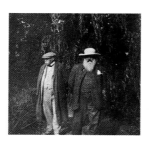

Clemenceau and Monet at Giverny

age (one was born in 1840, the other in 1841) grew stronger every day, and it was an intense, indestructible friendship. They were both men with strong personalities who were to grow old together, dying only two years apart. Georges Clemenceau was appointed Prime Minister and Home Secretary (1906–09) at the time when Monet was creating his first series of *Water Lilies*, but he remained a simple man. With the exception of the Dreyfus Affair, a subject which interested them both, the problems of government were never mentioned. In Monet's company Georges

Clemenceau tended to forget about politics. His friendship was based on other things, and in particular on a passion for art. He had inherited this openness of mind, this curiosity from his father Benjamin. Fascinated by the Impressionists such as Degas, Sisley, and Manet, who painted his portrait, Georges Clemenceau was even more attracted by Monet's personality and he much admired his refusal to make any concessions. Probably because of his nature but perhaps also as a result of his medical training, Clemenceau was attracted by everything that was rational and logical, and he carried out a serious scientific analysis of the techniques of the Impressionists, which he published in his artistic chronicles. Between 1895 and September 1926, the "Tiger" wrote over 1540 letters to the artist, but he also wrote about his relationship with Monet in two books, published barely two years after Monet's death: *Monet, cinquante ans d'amitié* ("Monet, 50 years of friendship") and *Monet: Les Nymphéas*. In these works, Clemenceau was much helped by Blanche Hoschedé-Monet, who devoted herself completely to looking after her father-in-law between 1914 and 1926. In fact, after the artist's death, Clemenceau transferred all his affection to her. He showed an unfaltering friendship to the man and he was an irreplaceable support to the artist through his presence and his letters until the very end.

Georges Clemenceau lived through all early stages of the genesis of the Grandes Décorations, from the negotiations with the State to their installation after 1926. But what a long distance the artist had to travel to reach this point, and how many works of art were destroyed in the process!

The first Water Lilies

With the serene strength so characteristic of his personality, Monet continued to pursue his ideal: to translate what he felt with as much truth as possible, his truth. Since 1901–02, his gardens had reached their full maturity. Monet the gardener had, with much difficulty and great patience, created a work of art in its own right. As a creator, Monet was as proud of his garden as of his paintings.

What is interesting is the successful outcome of his project. By enlarging his garden, and altering the water-garden, Monet did not conceal the fact that he was creating "new themes to paint". It was in those terms that he made his official requests to the Préfecture to divert water from the Rû river. So in this

case the painter became the creator of his subjects before becoming their interpreter. Poplars, haystacks and cathedrals were borrowed from the landscape with the possible risk of temporary unavailability in the case of long-term projects. But this time it was the painter who arranged and composed the site. This is a long way from the approach

Monet's Garden Irises

adopted in Argenteuil, where Impressionism developed and blossomed with spontaneous compositions.

But the peace of mind brought by this new creation was only superficial, and it was limited to certain material solutions. The painter no longer needed to roam the countryside, and he was now able to work in more comfortable conditions. Water, and the atmosphere, combined with the reflection of the elements of the landscape, remained the main objective.

Between 1899 and 1909 Monet worked untiringly to overcome obstacles. By traveling abroad, Monet was able to distance himself from the problems and take his mind off them, while strengthening his impressions. In London and Venice, he rediscovered the force of an evanescent architecture presented in a landscape that had become conventional again. In his garden in Giverny, he turned to other subjects as well as the water lily ponds. *Irises* appeared to defy the laws of gravity, while the strong architectural presence of the subject of the *The Japanese Bridge* was emphasized by the absence of vegetation. It was used again after 1918 but this time completely destructured by the heavy bunches of wisteria flowers.

Similarly, spatial references were questioned again in the later views of the pond whose edges invaded by lush vegetation became blurred with the surface of the water, thus removing the horizon line. It was in 1909 that the Galerie Durand-Ruel exhibited *Water lilies, a Series of Studies of Water*. There were forty-eight canvases in all, painted between 1903 and 1908. Four of them were circular in shape, and one of these was be offered to the Musée de Vernon by the artist. This choice completely baffled the authorities at

the time, all the more so because Monet disapproved of frames, which he believed were too restrictive in relation to the diffusion of his subjects in space.

The exhibition was manifestly successful: compared with the previous series, he was leaning even more towards the concept of decorative painting. There were some who claimed that Monet had chosen the easy route, in that he was no longer an innovator but the follower of a trend that at the time (1900–10) was encouraging the development of floral and plant subjects, both in the field of interior decoration and architecture. By contrast. others saw in this series of *Water Lilies* the foundation of abstract painting. In their eyes, the ultimate stage along this road was reached with the *Grandes Décorations* of 1918, some panels of which they believe reflect certain abstract characteristics.

In fact, these two interpretations were developed after the death of the painter, after which a great deal was written about this part of his work. At the time of the exhibition, it is probable that the artistic context contributed to the understanding of the forty-eight paintings dealing with the decorative theme of water lilies. Coincidence or

The Water Lily Pond, Harmony in Green

adaptation, influence or appropriateness to the context, this could be the subject of endless debate. The only certainty is the painter's attraction to decorative painting in as far as it is part of the landscape. In other words, both for himself and the public, Monet wanted the subjects to engulf the individual. In the case of the painted walls, the viewer is well and truly inside the subject. This statement would only become completely true with the project of the *Grandes décorations*, painted in a room specially set aside for it. The most concrete aspect of the work is the interpretation of space. Monet's work is very coherent in spite of appearing otherwise beause of the variety of themes. The reassessment of three-dimensional space, apparent in

several paintings produced between 1904 and 1908, in particular the circular ones, was the most important element. Innovative and logical at the same time, it was consistent with previous developments such as the rejection of the traditional format usually used for landscapes, traditional perspective, conventional subjects, and so on.

On the other hand, while the paintings of haystacks and cathedrals appeared as autonomous works in spite of being part of a series, it seems that the presentation of the *Water Lilies* emphasized the problem of the future of the series. How could the dispersal of paintings that so obviously belong together be accepted? This question was not new. Octave Mirbeau, Gustave Geffroy, Georges Clemenceau already shared this opinion when the *Cathedrals* were produced. This time, reading the various reviews of the exhibition, it seems that the concept of the decorative ensemble has become even stronger. Louis de Fourcaud anticipated "with great sadness the future dispersal of these paintings that are merely parts of single work, complementing each other (…)." "It is true that one would dearly like to keep them all together in a large room that one would be allowed to visit, and which would be given splendor and serenity by them!" he added. For Monet, the man who always doubted, who found it increasingly difficult to let go

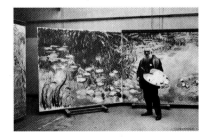

Monet in front of the Water Lilies

of his paintings, each one conceived from the other, with its own history, the words of the critics were reassuring and encouraged the project of the "great decorations."

The Grandes Décorations

Monet was not by nature a decorative painter. The four large canvases produced for the drawing room of the Château de Rottenbourg in Montgeron were commissioned by Ernest Hoschedé at a time when the artist was thinking about monumental paintings (the project of *Le Déjeuner sur l'herbe* was not far off) and he was in financial difficulties. Each canvas appeared

to be conceived as a separate work whose dimensions were simply larger than usual. There was no hint of a development of the theme in relation to the size of the room, its use, or the furniture. A few years later Durand-Ruel asked the artist to decorate the panels of the door to his salon. Monet's letters to Durand-Ruel complained of the slowness of the work that deprived him of "pleasant sessions in the fresh air," and described the problems he encountered: "I believe I have now worked out how to solve the problems of your panels" he wrote in September 1883, but a few months later he wrote: "to produce these six panels (Durand-Ruel had ordered thirty-six) I have had to destroy countless earlier ones! At least twenty, perhaps as many as thirty…"

The project of the *Grandes décorations* was set in a completely different context. This time it was Monet's own idea, which he carefully researched and prepared. As a result he was quite confident and during the 1914–18 war he ordered the construction of a new studio in which he would store the large painted panels. He asked a building firm in Vernon to carry out the work. It was the largest project ever undertaken by Monet. The painter was aware that did not have a lifetime in front of him. He was 75 years old when he took possession of his new studio. The war reached the edge of the village where the house of the American sculptor Frederic William MacMonnies had been converted into a temporary hospital.

News from his old friend Renoir revealed that, in spite of his ailing health, he was continuing to paint. Monet also knew that Renoir's two sons had been seriously wounded in the war. In his own family, his younger son Michel Monet had volunteered, and Jean-Pierre Hoschedé had also joined the army.

offering a gift to the State was also a genuinely sincere gesture. Posterity was already guaranteed, since Caillebotte's legacy had given Monet a place at the Louvre. His fortune was considerable, although severely reduced by his lavish way of life.

At first, the conclusion of the *Grandes décorations* remained uncertain. On November 12, 1918, the day after the Armistice, Monet wrote to Georges Clemenceau: "Dear and great friend, I am on the point of completing two decorative panels that I want to sign and date with the date of the victory, and I am asking you now to offer them to the State. (…) It is the only means I have of participating in the victory." Monet intended them for the Musée des Arts Décoratifs and he wanted Clemenceau to make a choice. As usual, Monet was working on several paintings at the same time. He did not paint exclusively in his studio but also in the open having selected several other outdoor subjects: *The Japanese Bridge*, *Willows*, *Irises*, and so on.

Between 1916 and 1926 the number of large canvases or panels suitable for the *Grandes décorations* increased, and this was bound to lead to some confusion. At the same time, Monet also painted other canvases in the same spirit. *The Water Lily Pond, Morning* seemed like a giant version of a Water Lily painting of 1904 or even 1914. Moreover, the panels intended as a gift remained almost interchangeable until the end. In 1920, there were almost forty. There was a certain ambiguity because of the difficulty of distinguishing between sketches, studies and completed works. Today in Giverny and in Vernon, local tradition still

décorations, the overall scheme became clearer. In 1920, Monet planned to give twelve panels, each one measuring 6½ x 13 feet (2 x 4 meters). *Clouds*, *Willows*, *Agapanthuses*, and *Green Reflections* corresponded to the four themes. About twenty panels measuring 6½ x 26 feet (2 x 6 meters) were mcuh admired by the visitors to Monet's studio. But Monet did not reserve them, at least not at the time. This clearly showed the intensity of the artist's efforts to bring the project to a successful conclusion. Monet worked on his own, which was unusual in the field of decorative paintings, and this underlines the strictly personal nature of the project and its realization. Georges Clemenceau kept a watchful eye on the project because he understood the discipline involved in its creation. On the other hand, the cataract operation that Monet had been advised to undergo in 1917, but actually deferred until 1923, did nothing to help the painter's morale. The threat of destruction or inappropriate retouching continued to hang over the all the panels.

The whole business of the gift was far from straightforward. Georges Clemenceau only had a verbal agreement to define it and resolve the problem of the location. In 1921, Monet, disappointed by the perspective of the Orangery in Paris, not far from the quays of the Seine, threatened to cancel the project. Clemenceau had to summon up all his energy, his friendly pushiness and his diplomacy to persuade Monet to continue his work. The artist's failing eyesight also made him realize that he should resume work on the project before he became completely blind. He only had ten per cent of his vision

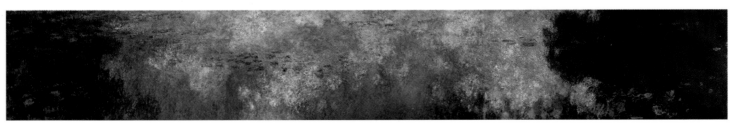

Water Lilies: Clouds

The painter's pride was probably hurt. Monet did not want to be remembered as an old man incapable of overcoming the trials of life, indifferent to the social context. The project of the *Grandes décorations* appeared to have been conceived as a new challenge for the painter, but the idea of

only uses the terms *Water Lily Studies*, although the various paintings on this theme, signed and sold during the painter's lifetime must be considered as authentic easel paintings, entirely completed.

Gradually, while he researched and studied the panels intended for the *Grandes*

in the left eye, while his right eye could only perceive light sources. Then, to the great relief of Blanche Hoschedé and Georges Clemenceau, he signed the deed of gift on April 12, 1922, before his notary in Vernon. Monet was still capable of dealing with colors, relying on his imagination and memory.

But he had to choose the tubes of colour through their labels or their arrangement. It is easy to understand the distress of the artist who had already seen Degas and Mary Cassatt go blind.

After his cataract operation in 1923, Monet's close vision improved slightly, but he

the masters of the Impressionist school, the bold interpreter of light." In the entry on Impressionism, Monet occupied the same position as Renoir, Degas, and Sisley.

Indeed, at the time of his death it appears that Monet was known better for the work he had done before the *Grandes décorations*.

combined with a meditation on nature that was vital to this artist's creative process. Looking back, it is always easy to find an explanation for the development of a particular artistic movement. However, it is important to try and place the genesis of Monet's project back in its original context, and leave

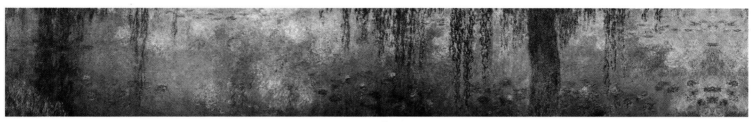

Water Lilies: Morning, with Weeping-Willows

perceived much too much yellow. Georges Clemenceau had good reason to be worried because Monet might still decide to rework some panels that had been considered finished, changing them for the worse. Louis Gillet was similarly worried in 1924. Did the already completely work still belong to the painter? Should precautions be taken to ensure that the artist did not start retouching the panels, bearing in mind that, as he had himself admitted, in 1923 his vision perceived too much yellow, and several months later, far too much blue?

At the beginning of 1925 Monet became extremely dejected, as the date for handing over his gift approached. He wrote to Pierre Bonnard, whose house in Vernon he had visited several times, saying that he regretted his idea of donating the panels.

The artist still felt the same the following year. Georges Clemenceau was well aware of the painter's physical and mental state, and he succeeded in persuading the government to defer the donation until after the artist's death, which occurred in 1926. He had long understood that the painter could not part with the *Grandes décorations*, and that he must allowed to believe that he could still conceive great works of art and make improvements to his great scheme.

In May 1927, the public was for the first time able to see the 22 panels whose choice had been approved by the painter. Georges Clemenceau continued to oversee the operation right until the end.

In the 1923 edition of the French encyclopedia *Larousse Universel*, next to his portrait in line, Monet was described as "one of

The many changes of the situation that preceded the actual handing over to the State inevitably influenced some critics. Not all of them understood the very personal significance the transaction held for Monet. Some people saw the project merely as the work of an old man who was going blind.

One should therefore be cautious about treating this work as the artist's final testament, even though it was his last one. Metaphorically, Monet could only die with a paint brush in his hand. Blanche Hoschedé-Monet stressed that in the last days of his life, he remained very lucid and talked mainly about his garden, probably because he realized that he no longer had the physical or mental strength to paint, and not because he saw the *Grandes décorations* as the final point in his work.

They were not a conclusion to his life's work but they occupy a place of their own. Although some of their elements and subjects were borrowed from previous works and from the period in which they were painted, they remain atypical and timeless. Monet's achievement was that he initiated a dialogue, without claiming to conclude it. The aim of the *Grandes décorations* in the state they had reached in 1921–23 was to show the pond in the water-garden at Giverny with its varied vegetation, observed at different times of the day; and they were to be displayed in a special setting, open to the public. It was an invitation by the artist to share the pleasure he had had in creating a garden, to understand his very personal concept of his art, and finally to dream and wonder a little about nature. It is difficult to consider these works as abstract paintings because, even though the subjects are no more than the reflection of themselves, they are still perceptible to the viewer, as they are in the *Clouds* series,

the paternity of the abstract movement to Kandinsky or Malevitch.

The painter and the artists of Giverny

During the long years he spent in Giverny, Monet lived through events that are today considered very much part of the history of American art. This explains why the village attracts such large number of American art lovers. Indeed, the village of Giverny was home of a large colony of American artists between 1886 and 1914.

No one knows exactly what attracted the first painters from the East Coast of America to come and settle in Giverny. The phenomenon of artists' colonies was very common in the second half of the nineteenth century, and the arrival of artists in Giverny was initially somewhat reminiscent of Monet's move to Chailly. The reasons were the same. In this case, William Leroy Metcalf came to Giverny in 1886 and painted a few rural scenes; the following year he was joined by John Leslie Breck, William Blair-Bruce and Theodore Wendel. The village only had a population of 300, but it boasted three or four cafés. The artists' favorite haunt was one run by Lucien and Angelina Baudy. At first the couple was reticent, but later they did everything they could to ease the life of these young artists, thus contributing to the expansion of the colony.

In 1886–87 Monet was already known in artisic circles, but none of the first arrivals mentioned his presence as a reason for their move to Giverny. Their works were often dedicated to Madame Baudy, the "patronne" of the café, in payment for their board and lodging. The choice of rural themes, the broad brushstrokes, the atmosphere of the

compositions that were still very shut-in were more reminiscent of the Barbizon School than of Monet. This first generation of Giverny artists still used traditional references. Quite a number of them worked hard for the Salons, in particular for that of the Société des Artistes Français.

Indeed, artists who became noticed in official Paris milieux were very likely to receive orders from American art patrons and dealers. This was a long way from the approach of Monet, who relied only on himself to establish his reputation. However, although these artists were not interested in Impressionism, they certainly came to know Monet well. During the years 1886–90, the Impressionist painter often met with them at the café Baudy. Soon—too soon according to Monet—life in Giverny revolved around the American colony. The growing number of these "amateur painters" led to a certain Bohemian atmosphere in the village. Monet, always very possessive of his family, sensed in this a threat to its unity. He had just read Émile Zola's latest novel, *L'Œuvre*, sent to him by the author himself. It is impossible that he did not recognize himself in the person of Lantier. In 1890–91 he began gradually to isolate himself from the members of the colony, just as his fame was growing.

Meanwhile, under the direct influence of Monet or the more general one of the Impressionist movement, the American artists began to lighten their palette, to alter the framing of their compositions, and to change the technique and thickness of their brushstrokes. On returning home, some remained committed Impressionists, like Richard-Émile Muller, who belonged to the second generation; others went back to using dark colors as they had originally done. Several remained on friendly terms with Monet.

Theodore Robinson was one of the first to meet Monet, and he remained a loyal admirer who encouraged him in his letters: "People in New York are very interested in your paintings, I think that people with taste are beginning to appreciate them" (March 1892).

Theodore Earl-Butler, one of the colony's pioneers, gradually won Monet's trust, helped by his friend Theodore Robinson. Although extremely close to Monet through his marriage to the artist's step-daughter, Theodore Earl-Butler had a completely independent career, clearly illustrating the evolution in the work of the Giverny artists. The

members of the artists' community lived a very convivial life but each one remained true to himself. Theodore Earl-Butler exhibited at the Salon des Indépendants, at the Salon of the Artistes Français, and after 1900 at the Rouen Salon.

Some members of the artists' colony tried to make the Impressionist pioneer's work known to their compatriots, but they were not immediately successful. Nevertheless, their efforts certainly helped Durand-Ruel's

Monet at Giverny

initiative in April 1886, which had led to the "Impressionists of Paris" exhibition in New York.

The artists of the second generation no longer owed anything to Monet. It was the time when he was working exclusively in his garden on the themes of the pond and the water lilies, the iris garden, the rose tree avenues, and so on. Meanwhile the village of Giverny was becoming very cosmopolitan and its population was growing. A number of artists lived there on a permanent basis and studios were built and extended. On returning to America the artists described the great freedom enjoyed by artists in Giverny, recommending that Normandy should be included in any tour of France.

In practice, every artist had to adapt the lessons of Impressionism for himself. Faced with the development of modern technology and the urbanization that was affecting both the New and Old World, the role of the American artist was to sublimate nature. But unlike Monet, the American artist was taught to work with deference to the subject and to be careful to position it in its place or context. Consequently, in the traditional itinerary of the person from New York or Philadelphia who traveled to Munich and then to France, the time spent at Giverny often had a special place in the work of the artist, with paintings expressing great freedom. Giverny was therefore one of the most enriching experiences in the career of the artist, and this

is why so many artists included it in their European tour. However, Monet was far from being the only attraction that drew so many American artists to Giverny and Impressionism. John Singer Sargent, a member of the colonies at Grez and Barbizon, discovered Monet's work when he visited the Second Impressionist Exhibition at the Durand-Ruel gallery in 1876 and he was immediately appreciative of the painter. But Mary Cassatt also played an important part in the development of Impressionism in America. She was invited by Edgar Degas to exhibit with the Impressionists in 1877 and remained closer to him than to Monet. At the funeral of Degas in 1917, she expressed great pleasure at meeting Monet again but emphasized her allegiance to the rules of the romantic Impressionism of the early days; she said how little she cared for the recent work of the artist of the *Water Lilies*, which she considered merely decorative work.

Monet and the rest
Edouard Manet

"Yes, Manet was a discovery for me and my generation." It is clear that Manet, his senior by eight years, was an important point of reference and an example to Monet.

Le Déjeuner sur l'herbe was generally disapproved of when it was presented at the Salon des Refusés in 1863, and *Olympia* caused a memorable scandal at the 1865 Salon, where had Monet successfully exhibited two landscapes in the same year. So why did Monet use this very sensitive theme again? It was clearly an expression of admiration for Manet, and at the same time a challenge. Emboldened by his latest success at the Salon, Monet was passionate about his new project. It involved life-size figures painted in the open, completely unlike anything that had ever been done before. But the project was delayed by bad weather and the lack of available models, among them the faithful Bazille, and it was finally abandoned. In the end Monet had to satisfy himself with a less audacious project, although it was still over 13 feet (4 meters) square. This painting was the *Women in the Garden*. Manet was amused by it, unlike the members of the jury that refused the painting for the 1867 Salon.

This marked the beginning of a growing friendship between Manet and Monet. Invited to the Café des Batignolles by Manet, he met Degas, Fantin-Latour, Cézanne, and the art critic Duranty. At these meetings, Sisley, Bazille and Renoir would be talking to Emile

Zola, who made preliminary notes of the occasions for his future novel, *L'Œuvre* (1886).

The friendship between Monet and Manet was at its height during the Argenteuil period. Did Manet borrow more from Monet at that time? Does it matter? They painted each other's portraits in the course of wonderful painting sessions on Monet's studio-boat. Several canvases by Manet show the friendship between the two families. *The Monet Family in the Garden* (page 76) is an example of the closeness between the families, as well as of Manet's use of figures painted in the open.

The Manet family was also present during the more difficult times that marked the end of the Argenteuil period. Édouard Manet helped Monet financially several times, while Gustave Manet offered Monet a considerable sum for a number of paintings already finished or yet to be painted, to be chosen in the studio.

What is known as the *Olympia* Affair should be seen in the context of their friendship, and it was an opportunity for Monet to pay off a debt that, after the death

The Monet Family in the Garden, by Manet

of the painter, was only a moral one. The event that triggered the whole affair was probably the announcement by Suzanne Manet, the artist's widow, that she was going to sell Manet's painting *Olympia*. When Monet learned that the painting might be going to America, he reacted immediately. The little group at the Café des Batignolles was asked to contribute, as were the dealers. Monet had of course asked the family's opinion and he decided to collect a subscription of FFr 20,000 to buy the painting and offer it to the State. The operation had a dual purpose: on the one hand, to pay homage to Manet, on the other, to help his widow, whose livelihood was very precarious. The sum was considerable since the painting had not found a buyer willing

to pay the asking price of FFr 10, 000 when the contents of Manet's studio were sold. This project was a very personal one to Monet, and he did everything in his power bring it to a successful conclusion. He acquired the backing and help of all his friends, apart from Émile Zola. The writer refused to be associated with what seemed to him a way of forcing the hand of the State. He was happy to see Manet in the Louvre, but on condition he entered through the front door. Monet was dumbfounded, even angered, although they resumed their friendship later. Indeed, the Dreyfus affair gave Monet a chance to renew their relationship and applaud the writer's courage.

Informed about the project by the painter Berthe Morisot, the wife of Eugène Manet, Puvis de Chavannes showed himself equally reticent. Was not Monet not moving a little too fast? Would it not be a good idea to inquire what the Government thought about it? In fact, Émile Zola and Puvis de Chavannes were setting out the problem. Could the State accept this gift, and if so, was *Olympia* a good choice? But Monet was consistent to his principles of obstinacy when he had decided to do something, and three-quarters of the sum was raised. For him it was a question of doing, not of arguing. In fact, some subscribers seemed more interested in pleasing Monet than in taking part in a project in favor of Manet. There is no doubt that Monet's strong personality played an important part in this. It is probably also true that the painter saw an opportunity to take revenge on the Governnment and on public opinion by offering the State a painting that had caused such a scandal. Entrusted with writing to the Minister of State Education, A. Fallières, Monet used clear arguments that would throw the responsibilty onto the decision makers: "The rival buyers are from America", and "the departure of so many works of art that are the joy and glory of France…"

The choice of work had been made by the artists closest to Manet. The *Olympia* seemed the most characteristic, the work in which "the artist appears in the heat of his victorious struggle." This statement was not conciliatory, but it was said anyway. The only field where a concession was made was the location of the painting. During the post-mortem decade that had to pass before it could be accepted by the Louvre, the Luxembourg Museum would be acceptable.

The *Olympia* affair was finally concluded in November 1890, after a year of negotiations from the opening of the subscription. Georges Clemenceau allowed the painting to enter the Louvre in 1907, when he was Prime Minister.

This business was significant in Monet's life. The painter rarely took a public stand;

Olympia, by Manet

this was the first such occasion and he emerged victorious. The intensive correspondence connected with the *Olympia* affair strengthened a number of his friendships and Monet's house in Giverny soon became a popular meeting place for Mirbeau, Mallarmé, Helleu, Rodin and Berthe Morisot.

Mallarmé

The poet Mallarmé was a close friend of Manet, corresponding with him and visiting Giverny several times. Monet always kept the most celebrated letter to have passed through the Vernon post office, written by the poet in 1890 and addressed as follows:

Neither winter nor summer
deceives the vision of Monsieur Monet
who lives and paints in Giverny
near Vernon in the Eure

The poet was a great admirer of Monet's work and the two friends had much in common. He sought perfection as the painter did, and he liked to retouch certain lines and verses, even several years after they had been published. Like Monet, he preferred to suggest the subject rather than name it. The enjoyment of the poem lay in solving its content. Man has to dream, and Mallarmé was perfectly at one with Monet's painting, which suggested effects, rather than imposing them on the viewer. Like him, he was attracted by the magic of the London fog (he too had lived in London), and he confessed that he felt a great sense of emptiness and sterility when faced with the too-perfect blue of the southern skies. Apologizing for his refusal to illustrate a book,

Monet sent Mallarmé a letter: "You know the sympathy and admiration I have for you, well allow me to prove it to you by presenting you with a small canvas as a token of my friendship…"

Mallarmé accepted and, accompanied as so often by Berthe Morisot and her husband Eugène Manet, he went to Giverny in July 1890. The poet went home with a large, old canvas, *The train at Jeufosse,* which impressed him deeply. Mallarmé admired this token of friendship hanging in his study until his death in 1898. He also bought two other paintings by Monet. As for Monet, he read all Mallarmé's works. One of the painter's habits was to read by the fire in the evening. Usually, the books he read had been sent directly by their authors or recommended by friends. The translation of Edgar Allan Poe's poems by Mallarmé enabled Monet to enter the realm of fantasy, and, encouraged by Mirbeau, he also read Maeterlinck. As befitted the patriarch he had become, he did not hesitate to recommend books to the members of the family. Thus, Alice Hoschedé read Tolstoy, but she probably did not read the complete works of Mirabeau.

Contrary to legend, Monet did not live like a hermit in Giverny. He corresponded widely and his letters give a good idea of the large number of loyal friends surrounding him. It is true that Monet was reluctant to open up in public. He was very reserved and he did not talk much to the locals or to the press, especially to art journalists, because he believed that what counted was his work and not what he had to say about it. He lived a little by the children's saying "Giving is giving, taking back is stealing." He never remained angry for long; friendship always prevailed and in its name he always displayed great tolerance. After the deaths of Édouard Manet, Gustave Manet, and Berthe Morisot (Mme Eugène Manet), he very naturally transferred his affection to the latter's daughter, Julie Manet.

Similarly his friendship with the "old master" Eugène Boudin only ended in 1898 when Boudin died. Monet never denied the role played by the Normandy landscape painter whom he met in 1858. "I have not forgotten it was you who first taught me to see and understand," he wrote to his friend shortly before his death.

Monet's friends were part of his everyday life. At the start, his letters were often requests for money, but this changed later on. Zola was asked to find out more about the little town of Poissy, Pissarro was asked for the addresses of good wine cellars, he asked Mallarmé for recipes for cooking girolles, and so on. All this clearly illustrates the relative simplicity of Monet's life, even at the end of his life when he was surrounded by wealth and the gratitude of others.

But the best proof of the respect accorded Monet by his friends was found in the salon-studio of his house in Giverny. Gustave Geffroy explained it clearly: "As well as being a room, it is also a museum, the museum of his admirers and his trade guild." Indeed, Monet had gathered here paintings by Corot, Jongkind, Delacroix, Fantin-Latour, Boudin, Manet, Degas, Caillebotte, Pissarro, Sisley, Cézanne, Renoir, Berthe Morisot, Signac, Vuillard, Marquet, and Rodin. It is true that it is customary for artists to exchange small pictures with each other, but in Monet's case the works did not all end up in his salon by chance. Monet sometimes exchanged some of his own paintings for works in Durand-Ruel's magnificent collection. Other works came from art sales where he started buying as soon as his financial situation allowed it. He also cast covetous glances at the works of his painter friends. Thus, he bought, or to be exact, converted a debt of Camille Pissarro's into, a magnificent painting, *Sweet Peas.*

From 1895–98, the crates sent to and fro from the station at Vernon station often contained works by his contemporaries that he was lending for retrospective exhibitions.

Travelling Companions

In spite of all the pitfalls and hazards of their careers as painters, and the inevitable divisions within the group of Impressionists, Monet remained faithful to his friends from the early days such as Renoir and Sisley, whom he had known since 1865. Bazille, unfortunately, died at the front in 1870.

Once in an open air painting session, Manet made fun of Renoir. Monet ignored the remarks and more importantly he did not repeat them to Renoir. Their friendship remained intact, and it was because of it that Monet retraced the route of the Bordighera subjects on his own in 1884, and that in 1900 Renoir apologized in advance for having agreed to be decorated. He knew

Monet's feelings on the subject of official decorations. But the friendship of the two men went back too far for it to be to be threatened by this. Right up to the last exhibitions of the Impressionist group, Monet continued to respect Renoir's judgement. Both remained faithful to the romantic Impressionism of the early days and opposed to its other developments. When looking for locations, Renoir never forgot Monet and it was probably on his advice that he visited Brittany in the 1880s.

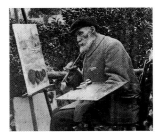

Auguste Renoir at Cagnes-sur-Mer

Renoir suffered some very difficult times during 1890–91 but they did not affect their friendship. These pioneers of Impressionism had traveled a long way together. Monet had on the whole abandoned the human figure, unlike Renoir who had finally become successful with his portraits, his groups of figures such as the *Moulin de la Galette* (1876), and *Bathers.* The great success of his works at the Durand-Ruel gallery in 1892 enabled him to move permanently to the south-east, to Cagnes-sur-Mer, so that the two painters saw much less of each other. The preparation of Berthe Morisot's retrospective at Durand-Ruel's gallery at the beginning of 1896 was probably one of their last collaborations.

Both were by now successful and recognized by the public and a circle of collectors, and for them group exhibitions were a thing of the past. They now enjoyed financial as well as artistic independence. But the two men who shared so many memories remained firm friends. Monet was deeply affected by Renoir's death December 3, 1919: "With him part of my life has disappeared, the struggles and enthusiasm of youth (…) I am now the only survivor of the group." A few years later, Monet concluded: "Degas, Renoir and I have had our revenge. We can certainly say that we have had a happy life, the others died too young." He was thinking of Sisley, (1839–99), his other companion from the early days whom

he had met when they were both working in Gleyre's studio. Monet used to say of him that he had died without ever being understood. Indeed, Sisley's works often fared badly at Impressionist sales of the time. Much less close to Monet because of his preference for locations in the Seine-et-Marne region, the painter was nevertheless one of the first members of the group of Impressionists, and as such was regarded as a friend by Monet. When he found he had throat cancer and realized the end of his life was near, he made contact with Monet, who came to

Alfred Sisley

see him several times at Moret-sur-Loing with Alice Hoschedé. Pissarro, Renoir and Monet were all at his funeral. In April, the Durand-Ruel gallery organized an exhibition showing the works of the four artists, a chance homage to the lasting friendship that united them.

In the meantime, Monet had organized a sale for the benefit of the Sisley children. This sale, fixed for May 1, 1899, was preceded by a two-day exhibition at the Galerie Petit. Anxious to achieve good results, Monet contacted Paul Durand-Ruel and contacted all his old friends: Renoir, Degas, Julie Manet (whom he knew through her mother Berthe Morisot), Fritz Thaulow (with whom he had recently exhibited together with Sisley), Pissarro, Helleu, Roll, Mary Cassatt, Carrière, Vuillard, Rodin, and Lebourg. He also approached some artists exhibiting at the "Société Nationale" of which Sisley was a member. Cézanne immediately responded to the call. Monet entrusted the writing of the catalog introduction jointly to Arsène Alexandre and Gustave Geffroy, a clear indication of how much he admired these critics. The sale included some twenty paintings left by the artist and others offered by the artists whom Monet had contacted.

The sale of the critic Théodore Duret's collection (1894), one of the first articles written by the new art critic Clemenceau

who had temporarily returned to civilian life, the success of Monet's exhibitions at the Durand-Ruel gallery (1895, 1898), the sale of the Sisley atelier (1899), that of the Desfossé collection, that of Count Doria's (May 1899), followed by the sale of the widow Chocquet's collection, were seen by the public and the Impressionists themselves as decisive and positive. Only Cézanne, misunderstood by the public, was still attacked by the critics. The vociferous Doctor Gachet, Chocquet and Renoir defended him, as did Monet who had

Paul Cézanne

always admired him, owning a dozen of his paintings. At the Doria sale, he instructed Paul Durand-Ruel to buy *Melting Snow* for him, and he encouraged Count Isaac de Camondo to buy as well. It was not just a matter of helping one of the last members of the group to survive; it was also a way of expressing his own admiration for Cézanne's work. When Cézanne came to Giverny in 1894, he lodged at the Hôtel Baudy because of his extreme shyness, but Monet succeeded in bringing together on the same day Cézanne, Rodin, Clemenceau and Geffroy.

Passing through, Mary Cassatt also met him unexpectedly at dinner at the Hôtel Baudy, a meeting whose story is now famous. Full of anxieties, Paul Cézanne did not stay long in Giverny and fled like a thief, leaving his paintings behind. Monet made sure that they were sent on. Local gossip said the opposite, but that seems unlikely, since the painter could well have afforded to buy some.

Cézanne saw painting as a profession of faith and at the same time as a craftsman's trade. Monet's bourgeois way of life in 1894 would indeed have alarmed him and might also have made him doubt the success of his career while he was finding his way. "If only he had had the support that I have had," Monet commented sadly, aware of

the scale of his difficulties. He alerted Mirbeau and Geffroy to the situation so that they would encourage Cézanne with their articles.

Monet and Paul Cézanne had considerable admiration and respect for each other. There was no rivalry between them. The static landscapes of the south of France were the complete opposite of the landscapes of the valley of the Seine. Frequently overrun by changeable weather, Normandy is a land of contrast and changing landscapes, every day being different and with very clearly marked seasons. The landscapes of the south are very different, with immutable, omnipresent elements. Like Monet, Cézanne worked only from nature, not as an interpreter but as a meticulous observer.

He was very attached to the Impressionism and he exhibited regularly with the group, but like Monet he expressed himself more through color. The interest of Cézanne's research into colour lay in the revelation of its construction and the wonderful possibilities it revealed, which his admirer Monet had foreshadowed. Cézanne was a builder. He was interested in the permanence of things, not in the ephemeral. Both men shared the same ideals, and both were guided by the same uncompromising principles (how many hours must have been spent working on the same subject, how many paintings will have been destroyed…). But both artists broke away from the Impressionism of the early days, and each developed in his own way.

SOPHIE FOURNY-DARGÈRE

Claude Monet was born in Paris on November 14, 1840, two days after Auguste Rodin. It was the time of the July Monarchy and France was governed by Louis-Philippe, the "Citizen King". The business bourgeoisie prospered in this period but Monet's father, who was a grocer, suffered financial difficulties. These forced him and his family to leave Paris in 1845 and move to Le Havre, where relatives who were also grocers proposed a partnership. Le Havre was a port where merchants and ship owners traded with the islands, Martinique and Guadeloupe, the Americas and Africa.

The arts were largely ignored within the Monet family, most of whom were grocers or other small commercial traders. Nonetheless, the young Monet's sensitivity developed very early, encouraged possibly by his mother but certainly by his aunt Marie-Jeanne Lecadre, two women whose taste and inclination differed from those of the rest of the family. The young Monet was

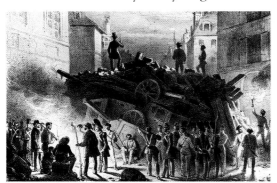

2. *Barricade on the Rue Saint-Martin on the night of February 24, 1848.*

not a docile, obedient child and he found school unbearable. He spent his time walking around, observing and recording the faces and scenes of everyday life. In 1857, before he abandoned his studies, which he found boring, he attended drawing classes at the Collège de la rue de Mailleraye which later became the Lycée du Havre. The class was taught by François-Charles Ochard, a pupil of the painter Jacques-Louis David. It was at about this time that he began producing caricatures, first of his teachers, then of the bourgeois observed in the streets of Le Havre. He soon acquired quite a reputation and even earned some money, selling his caricatures for a good price. He was later to say: "At fifteen I was known throughout Le Havre as a caricaturist. In fact, my reputation was so well established that people would ask me openly to produce *portraits-charges* (unkind character sketches) for them. The large number of such orders, combined with the inadequacy of the funds provided by my mother, gave me an idea which was rather bold and naturally shocked my family: I charged for my portraits. Depending on the person, I would charge ten or twenty francs for a caricature and it worked wonders."

1

Le Havre

2.
Claude Monet was born in Paris in the middle of the 19th century, a time marked by the workers' revolt of February 1848 which removed the constitutional monarchy. The Second Republic proclaimed universal suffrage and abolished slavery in the French colonies.

3

1, 3, 5.
At fifteen, Monet was sketching the boats moored in the harbor at Le Havre. He was also drawing clever caricatures of the "bourgeois" he met in the streets of the town and famous individuals such as the writer Champfleury, for which he relied on newspapers.

4

4.
Monet was twenty-one in 1861. Persuaded by Boudin and encouraged by Troyon, whom he had met in Paris, he decided to be a painter. This *Corner of the studio* was one of his first canvases.

1. *Le Havre, Grand Quay, View from the Lock,* 1844. F. D'Andiran. Lithograph. Bibliothèque Nationale, Paris.

3. *The Writer Jules François Husson, Known as Champfleury,* after Nadar, c. 1858. Crayon heightened with gouache. 12½ x 9½ in. (32 x 24 cm.) Musée Marmottan, Paris.

4. *Corner of the Studio,* 1861. Oil on canvas. 72 x 50 in. (182 x 127 cm.) Musée d'Orsay, Paris. RMN.

5. *Two Fishing Boats, c.* 1859. Lead pencil. 10½ x 6¾ in. (27 x 17.2 cm.) Musée du Louvre, Paris. RMN.

5

Paris

But don't neglect painting... (Troyon)

Exhibited in the shop window of a supplier of artists' materials called Gravier, Monet's drawings caught the eye of a young painter with a free approach to art, who had distanced himself from existing conventions. His name was Eugène Boudin and he was living at Le Havre at the beginning of 1858. Boudin also exhibited his seascapes in Gravier's shop and Monet thought that "they had nothing artistic about them". But the two did meet in Gravier's shop: "Oh, you are the young man who is producing these little drawings? It is a pity you only do caricatures. There are some good aspects in your work. Why don't you paint?". Monet's reticence suddenly disappeared and the "strange little brute" that he was, having been won over, became Boudin's friend and pupil. Under his influence, Monet learnt to love this "fluid, confused music" of the Normandy sky and clouds, the cliffs and the noise of the sea, so well orchestrated and interpreted by Boudin.

Within his own family, Monet had found a close ally in the person of his aunt Marie-Jeanne Lecadre. A friend of the painter Amand Gautier, she also painted and she encouraged her nephew, believing in his talent. On the other hand, Monet had a less satisfactory relationship with his father, who could not accept that his son had left school to become a painter. Nevertheless, he was twice persuaded by Marie-Jeanne Lecadre to ask the city of Le Havre for a grant to enable his son to go and study in Paris, but on both occasions his request was refused.

But the young Monet did not wait for the answer to the second request; he set off for Paris at the beginning of 1859. When he arrived there he sought advice from the painter Constant Troyon, who suggested that he should spend time at the Louvre copying old masters, a traditional practice among young painters, and to join Thomas Couture's studio. Monet preferred the Académie Suisse, which was run by Charles Suisse, like François-Charles Ochard a former pupil of David.

Monet did not forget his friend Boudin: he wrote and told him about his visits and projects, and he also asked that he should join him in Paris.

1

Constant Troyon was a very successful landscape painter with plenty of orders. Monet discovered his work at the Paris Salon in 1859 and expressed his admiration in a long letter to Boudin. He went to show his drawings to Troyon who told him: "Go to the country, study and, above all, do everything thoroughly."

2.

"If I have become a painter, I owe it to Eugène Boudin", Monet wrote later. Boudin had influence on Monet's development. Working next to Boudin, Courbet had told him: "You are the only one who understands the sky".

3. A scene from Trente and de Paris (*"Thirty years of Paris"*) *by Alphonse Daudet, illustrated by M. Montégut. The Brasserie des Martyrs.*

3.

At the Académie Suisse, Monet struck up a firm friendship with Camille Pissarro. It was in this period that he frequented the bar called the Brasserie des Martyrs— in his own opinion, far too much: "At that time I used to go to the famous Brasserie of the Rue des Martyrs, which made me waste a lot of time and was also very bad for me. That's where I met all the people Firmin Maillard mentions in his book *Les derniers bohèmes...* ('The last Bohemians)".

1. *Watercourse with Undergrowth*, undated. Constant Troyon.
Oil on panel. 12¾ x 18¼ in. (32.5 x 46.5 cm.)
Musée du Louvre (Moreau-Nélaton gift), Paris. RMN.

2. *The Conversation*, 1876. Eugène Boudin.
Oil on wood. 4¾ x 10 in. (12 x 25 cm.)
Musée Eugène Boudin (E. Boudin legacy), Honfleur.

4. *Surroundings of Honfleur, Snow, c.* 1867.
Oil on canvas. 32 x 40 in. (81 x 102 cm.)
Musée du Louvre, Paris, RMN.

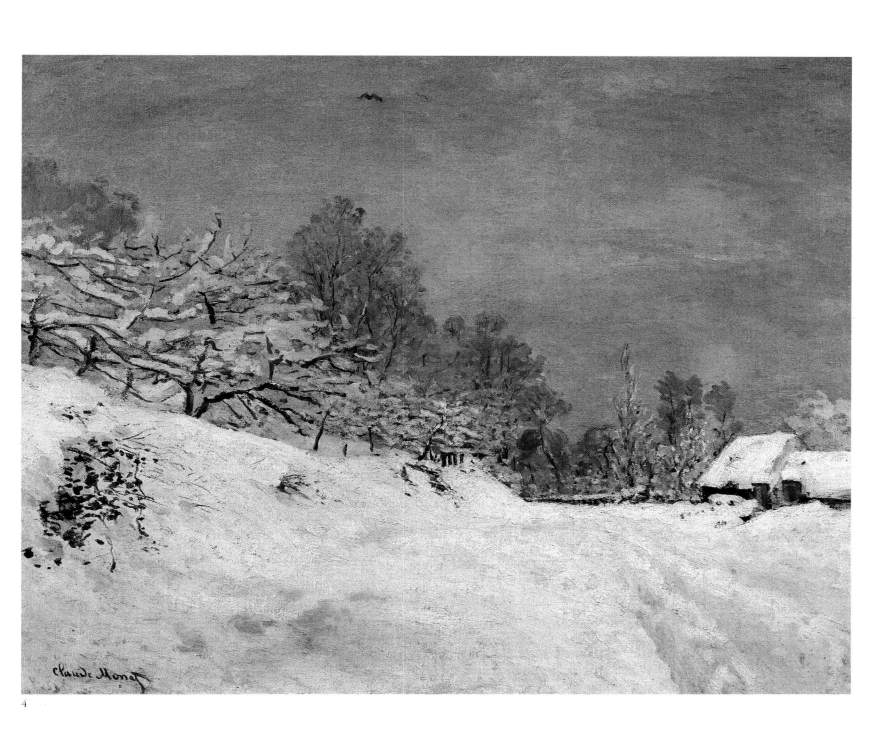

4

For Monet, the meetings with friends in the smoky Brasserie des Martyrs came to an end in 1861. At that time military service was based on drawing lots and the term of enlistment was seven years. He was unlucky in the draw and had to leave for Africa where he was stationed with the Chasseurs d'Afrique in Algeria. There he was dazzled by the light and the sun. Accustomed to the fog and mists of Normandy, the intensity of the colors and the luminosity of the sky were a revelation to him. But in the spring of 1862 he came down with typhoid fever and was sent back to Le Havre for six months to convalesce. He never returned to Algeria. It was then that the young Monet met the Dutch painter Johan Barthold Jongkind, whose work he knew and admired, and from whom he sought instruction. The advice Monet received from him, together with that of Boudin, influenced him strongly with excellent results.

1. Restaurant Saint-Siméon, Honfleur 1

But the Monet family was ever watchful and anxious to supervise the evolution of what was to them quite a worrying vocation. They sent Claude Monet to Paris to ask the advice of Auguste Toulmouche, a genre painter, a relation by marriage of the Lecadre family. Toulmouche was encouraging and advised Monet to go and work in the free studio of the Academy painter Charles Gleyre, like Renoir, Bazille and Sisley. Gleyre was then fifty-six years old and suffering from eye problems. A dreamer and idealist, he was an unselfish man who did not ask for payment, just a contribution to the rent. He turned down the Légion d'honneur, avoided publicity and renounced Louis Napoléon Bonaparte after his coup d'état, out of loyalty for the Republic.

The first Salon des Refusés was held in 1863, composed of works rejected by the official Salon, and held next to it. Monet visited the Salon des Refusés where Manet's *Déjeuner sur l'herbe* caused such a scandal, and he followed Gleyre's traditional teaching without enthusiasm. It is said he later boasted that he decided to leave the studio to have "more freedom", taking his companions with him. But it is more likely that Gleyre, being ill, gave up teaching in 1864. In May Monet returned to Normandy with Bazille. The two friends rented a room at the Saint-Siméon inn while Jongkind found lodgings in Honfleur.

2

3. 3

On his return from Africa Monet met Jongkind in Trouville. He later wrote: "From that moment he became my master and to him I owe the definitive training of my eye." Although shocked by Jongkind's bohemianism, Aunt Lecadre nevertheless invited him because he encouraged Monet.

2. *Portrait of Claude Monet in Uniform*, 1861. Charles-Marioe Lhuillier. Oil on canvas. 14½ x 9½ in. (37 x 24 cm.) Musée Marmottan, Paris.

3. *Entrance to the Harbor, Honfleur*, 1866. Johan B. Jongkind. Oil on canvas. 16½ x 22 in. (42 x 56 cm.) Musée du Louvre (gift of Hélène and Victor Lyon), Paris. RMN.

4. *Charmer*, 1868. Charles Gleyre. Oil on canvas. 32½ x 20 in. (82.5 x 50.5 cm.) Kunstmuseum, Basel.

5. *Road to Saint-Siméon*, 1864. Oil on canvas. 32¼ x 18 in. (82 x 46 cm. National Museum of Western Art (Matsukata collection), Tokyo.

2.
At the age of twenty-one, young men drew lots for conscription. A "good" number exempted them, but a "bad" one condemned them to serving in the army for seven years. In 1861, Monet drew a bad number and joined the Chasseurs d'Afrique. In Algeria he caught typhoid fever and was sent back to Le Havre to convalesce. He never returned because his Aunt Lecadre "bought him out" and someone else took his place.

5.
During the 1830s Constable, Turner, and Corot were all charmed by the beauty of Honfleur. Later Courbet, Daubigny, Jongkind, Monet, and Bazille all came to live at the Saint-Siméon farm. This was where Monet painted the *Road to Saint-Siméon Farm*. The picture can be seen on the wall of *The Studio in the Rue Fürstenberg*, painted by Bazille in 1865.

4.
Back in Paris, Monet studied at Gleyre's studio. The painter of this *Charmer*, the Academician was a surprisingly liberal master who was much liked by his pupils, the future Impressionists. "He encouraged everyone to develop their own skills freely and to follow the path best suited to their talent." (Charles Clément).

4

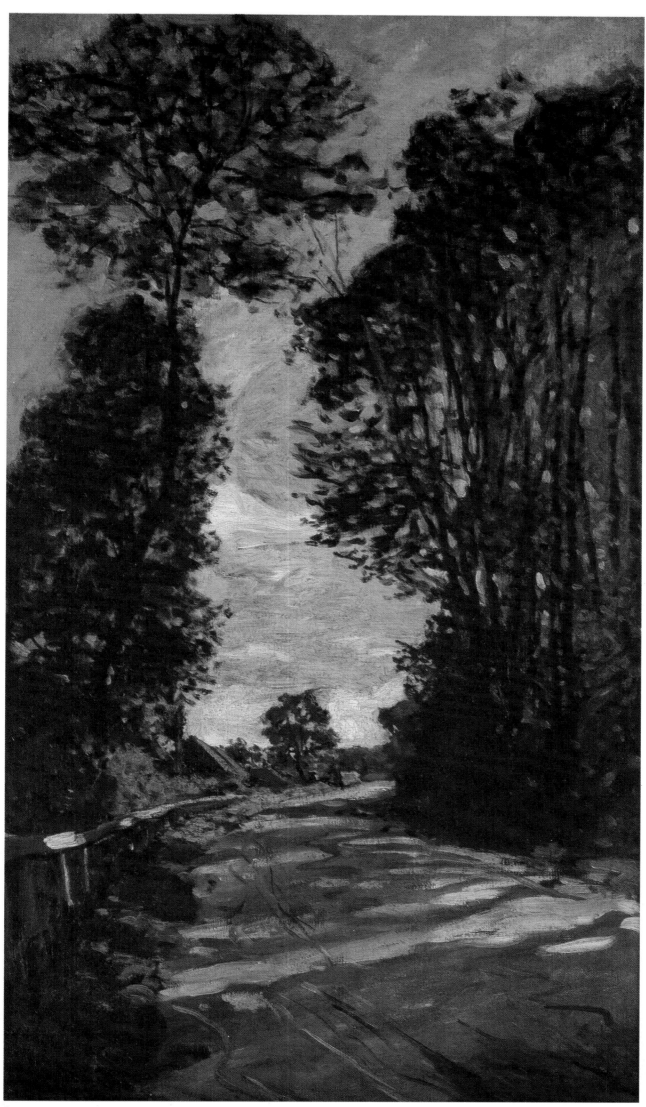

Two of the painters Monet met when he first settled in Paris played an important part in his development as a painter: Daubigny and Courbet. Daubigny was one of the first to express the need to paint in the open. "Our paintings are never light enough," he boldly stated at a time when painters were still using bitumen, and Monet admired him so much that he begged his aunt, Madame Lecadre, to give him the small painting by Daubigny that she owned. It was Daubigny who introduced the young Monet to the famous art dealer, Durand-Ruel: "Here is a young man who will become better than all of us." As for Courbet, he played a vital part in the development of all the artists who became the Impressionists. His art marked a clear break between the existing official art and the art of the future. He encouraged and stimulated the young Monet, who at the end of his life confided to his biographer, Gustave Geffroy: "Courbet has always been so encouraging

1.

Monet discovered Daubigny's work at the Salon when he arrived in Paris, at the same time as he saw that of Troyon. Monet wrote to Boudin that "Daubigny's paintings are really beautiful." His paintings in the open air, his watery landscapes and his technique of "juxtaposed touches of color" all heralded Impressionism, to such an extent that Odilon Redon wrote of Daubigny that he was "the painter of a moment, of an *impression.*"

"Paint what you see, what you feel, what you like" (Courbet)

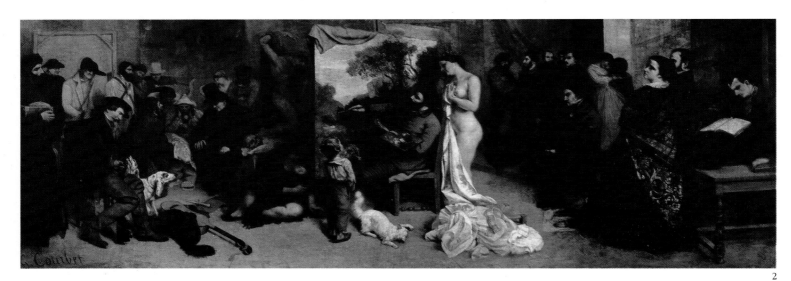

2

and good, even lending me money when times were difficult." Courbet's importance was already recognized at the 1855 Universal exposition where eleven of his paintings were exhibited.

But Courbet was infuriated by the rejection of other paintings, notably *The Studio*. The master of Ornans therefore decided to build a pavilion next to the official pavilion where he would exhibit his rejected paintings as well as those of about thirty other artists.

A few years later he too settled near Honfleur, like Daubigny, Boudin, Troyon, Jongkind and Monet, to try and capture the light of the countryside of the Normandy coast.

2.
The Studio by Courbet. Refused by the Universal Exposition of 1855, Courbet exhibited in his private pavilion. Future Impressionists recognized him as their master, and Monet remembered that Courbet had encouraged him with kindness as well as financially.

3. Gustave Courbet

1. *A Normandy Scene.* Charles Fr. Daubigny.
Oil on wood. 10¼ x 17¾ in. (25 x 45 cm.)
Musée du Louvre, Paris. RMN.

2. *The Studio*, 1855. Courbet.
Oil on canvas. 141 x 235 in. (359 x 598 cm.)
Musée d'Orsay, Paris. RMN.

4. *Farmyard in Normandy, c.* 1864.
Oil on canvas. 25½ x 32 in. (65 x 81.3 cm.)
Musée d'Orsay, Paris. RMN.

3

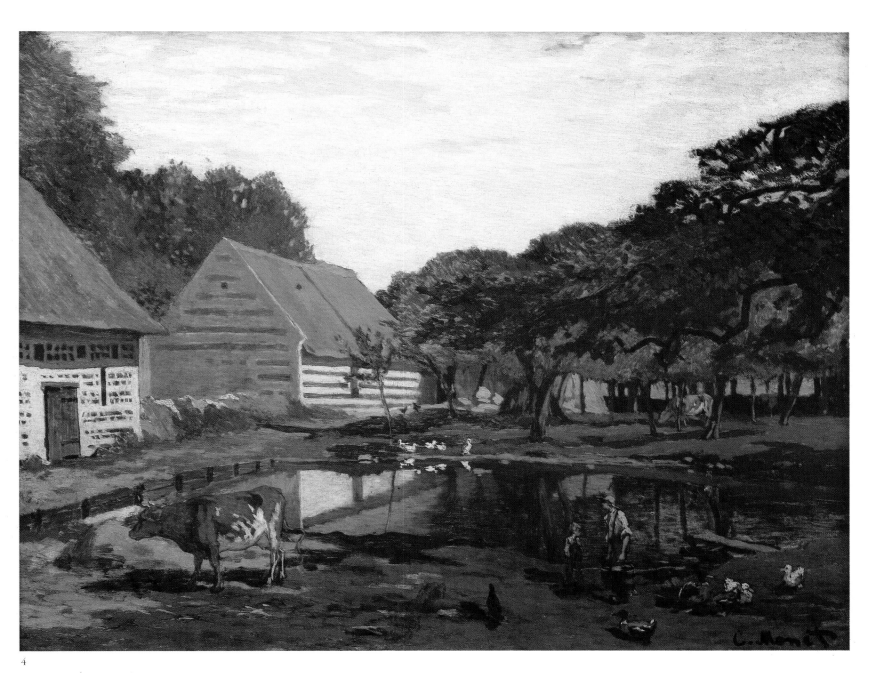

4.

4.
After leaving Gleyre's studio, Monet and his freind Bazille left for Normandy. Living at the Saint-Siméon farm, Monet discovered the countryside and painted his *Farmyard in Normandy.* The collector Raymond Koechlin, who later shared Monet's taste for the Japanese, owned this painting and left it to the State in 1931.

> "I can think only of my painting,
> and if it were to be a failure,
> I would go mad."
> (Monet to Bazille)

From Manet to Monet…

Manet, Monet: Monet greatly enjoyed this almost perfect homonym but Manet found it irritating: "Who is this Monet who behaves as if he

Le Déjeuner sur l'herbe by Manet caused an amazing scandal at the 1863 Salon while Cabanel, an academy painter, received

1 2

was called Manet and takes advantage of my well-known name?". Monet may have seen Manet's work at an exhibition organized in the Boulevard des Italiens in 1863, among which were *Music at the Tuileries*, *The Spanish Ballet*, and *Lola de Valence*, next to paintings by Courbet, Corot, Delacroix and Stevens. The technique used by Monet in his own *Déjeuner sur l'herbe* reveals a similarity between his approach and Manet's, especially in the representation of female figures.

The two artists each exhibited two paintings at the 1865 Salon. Monet showed *The Mouth of the Seine at Honfleur* and *La Pointe de la Hève at Low Tide*, while Manet's paintings were *Christ insulted by the soldiers* and *Olympia*. Critics showed an interest in Monet's work and his canvases were noticed, but for Manet it was different and once again he caused a scandal rather than attracting admiration. Like his *Déjeuner sur l'herbe* in 1863, his *Olympia* raised an almost universal outcry. The painting of a young woman lying naked while receiving a bunch of flowers from a black maidservant was scandalous in several ways. First, she was evidently a prostitute. Then the strange color of her skin shocked many, so she was described as "a female gorilla" or "the odalisque with a yellow stomach." "I would like to have you here with me, my dear Baudelaire, insults are falling thick and fast like hail," Manet wrote to his friend in despair.

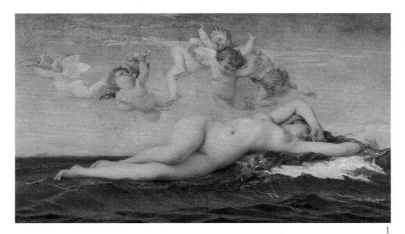

3

1. *Birth of Venus*, 1863. Cabanel.
Oil on canvas. 51 x 88½ in. (130 x 225 cm.)
Musée d'Orsay, Paris. RMN.

2. *Olympia*, 1863. Manet.
Oil on canvas. 51½ x59 in. (130.5 x 150 cm.)
Musée d'Orsay, Paris. RMN.

3. *The Improvised Ambulance*, 1865. Bazille.
Oil on canvas. 18½ x 37½ in. (47 x 65 cm.)
Musée du Jeu de Paume, Paris. RMN.

4. *The Promenade*, 1865.
Oil on canvas. 37 x 27 in. (94 x 69 cm.)
National Gallery of Art, Washington.

the official seal of approval with his *Birth of Venus* (1), which was bought by Napoleon III. Cabanel became a member of the jury and always remained hostile to the Impressionists. Two years later, Manet created another scandal with *Olympia* (2), a kind of scathing response to Cabanel.

Monet had not forgotten Manet's *Déjeuner sur l'herbe* and he took a room at the Lion d'Or inn in the Forest of Fontainebleau where he started making sketches for his own version of the *Déjeuner sur l'herbe* that he wanted to paint. His friend Bazille and a young model, Camille Doncieux, posed for him in *The Promenade* (4), characters that were to appear almost unchanged in Monet's *Déjeuner*.

Bazille painted Monet in bed in *The Improvised Ambulance* after he had been injured by a discus thrown by an English sportsman.

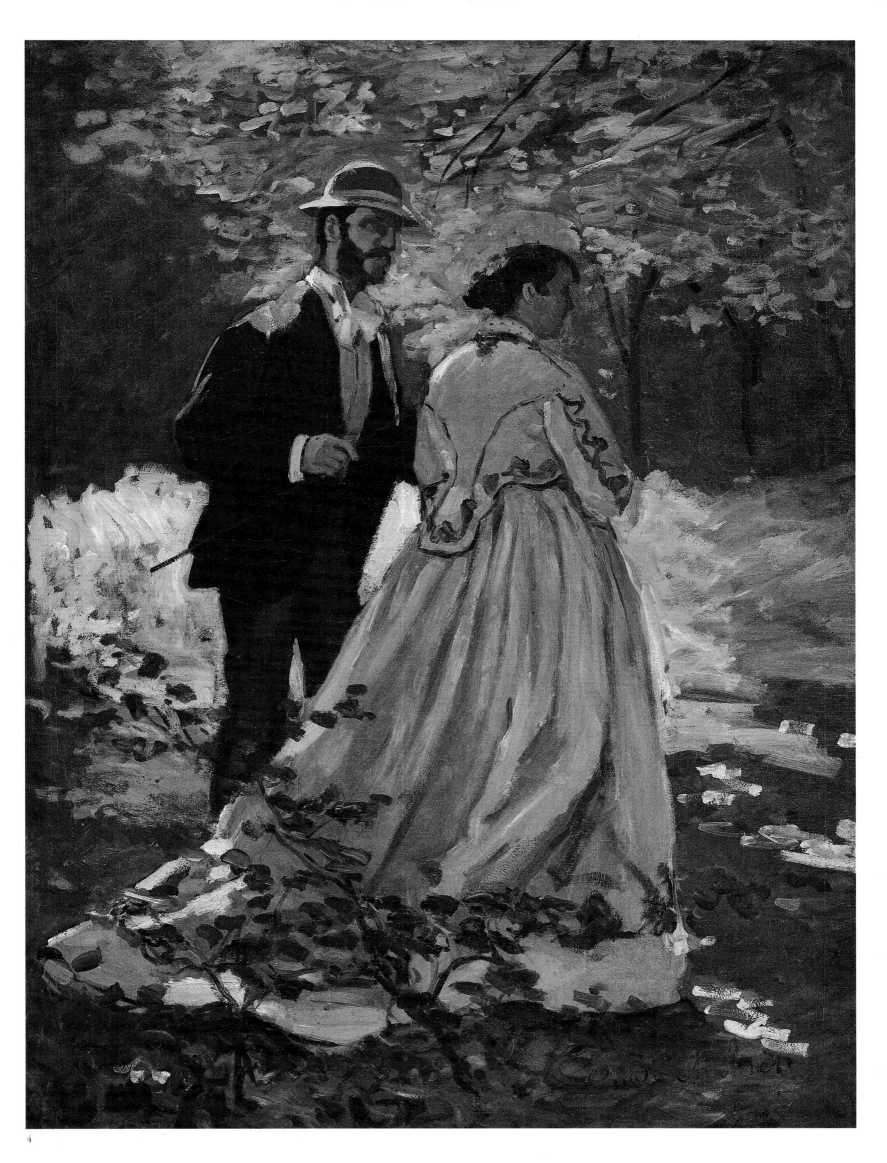

At that time, the nude still had to be presented under the guise of a mythological figure, as for instance in the *Birth of Venus* by Cabanel, an Academician; this was presented at the 1863 Salon and bought by Napoleon III.

While Manet was laughed at by everyone, Monet was the object of general praise. After visiting the 1865 Salon the art critic Paul Mantz wrote in the *Gazette des Beaux-Arts*: "(…) but the use of harmonious colors and similar tones, the feeling of values, the breathtaking effect of the ensemble, a daring approach to seeing things and to attracting the viewer's attention; these are some of the qualities which Monsieur Monet possesses to a high degree. His *Mouth of the*

1.
The Impressionists always admired Delacroix. Here Fantin-Latour, with a bunch of flowers in his hands, is surrounded by Manet, Duranty, Cordier, Legros, Whistler, Champfleury, Bracquemond, Baudelaire and Balleroy.

2.
In the studio in the Rue Condamine, Bazille is seen showing a painting to Monet and Manet. Renoir is talking to Zola, while E. Maître is sitting at the piano.

1

Seine stopped us in our tracks when we strolled past it, and we shall never forget it."

Such remarks encouraged the young painter to undertake ever more daring projects, and even to compete with other artists, especially Manet, and in particular with his *Déjeuner sur l'herbe*. But Monet's rivalry with Manet was even apparent in *Women in the Garden*. Monet started this painting out of doors, in Ville-d'Avray where he was living at the time, but he finished it in his studio in Honfleur. It was rejected by the 1867 Salon but his friend Bazille bought it off him for the sum of 2,500 francs, payable in monthly installments.

In April 1865, Monet was living at Chailly in the Forest of Fontainebleau, staying at the Lion d'Or inn. Bazille depicted him lying in a bed after an accident, waiting for treatment: the painting came to be called *The Improvised Ambulance*. Bazille, a man with a warm personality, loved to use his friends as models: Renoir, Sisley, Astruc, Manet, Edmond Maître all sat for him.

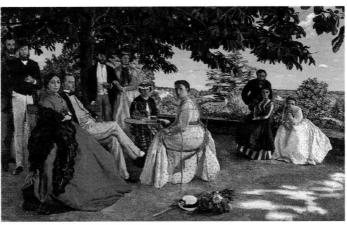

3.
The Family Reunion was painted by Bazille in 1866 in Médic, in the part of France where he was born. The atmosphere of the Languedoc lent itself perfectly to the representation of sunlight piercing through the trees, creating spots of light on the ground in the shade. The characters look as if they were caught by photographer, a technique which was much loved by Bazille. At the 1868 Salon the painting was hung in the "refuse dump," but Zola still noticed it: "There is a charming group in this painting, the group formed by the two young girls sitting on the edge of the terrace."

4.
To escape from his debtors, Monet took refuge in Ville-d'Avray, near Paris. There, out of doors, he painted *Women in the Garden*. This painting had been commissioned by Bazille for a price of 2,500 Francs, payable in monthly installments.

1. *Homage to Delacroix*, 1864. Fantin-Latour.
Oil on canvas. 63 x 50½ in. (98 x 128 cm.)
Musée d'Orsay, Paris. RMN.

2. *The Studio in the Rue Condamine*, 1870. Bazille.
Oil on canvas. 38½ x 50½ in. (98 x 128 cm.)
Musée d'Orsay, Paris. RMN.

3. *The Family Reunion*, 1867. Bazille.
Oil on canvas. 60 x 90½ in. (152 x 230 cm.)
Musée d'Orsay, Paris. RMN.

4. and 5. (detail) *Women in the Garden*, 1866.
Oil on canvas. 11½ x 80¾ in. (255 x 205 cm.)
Musée d'Orsay, Paris. RMN.

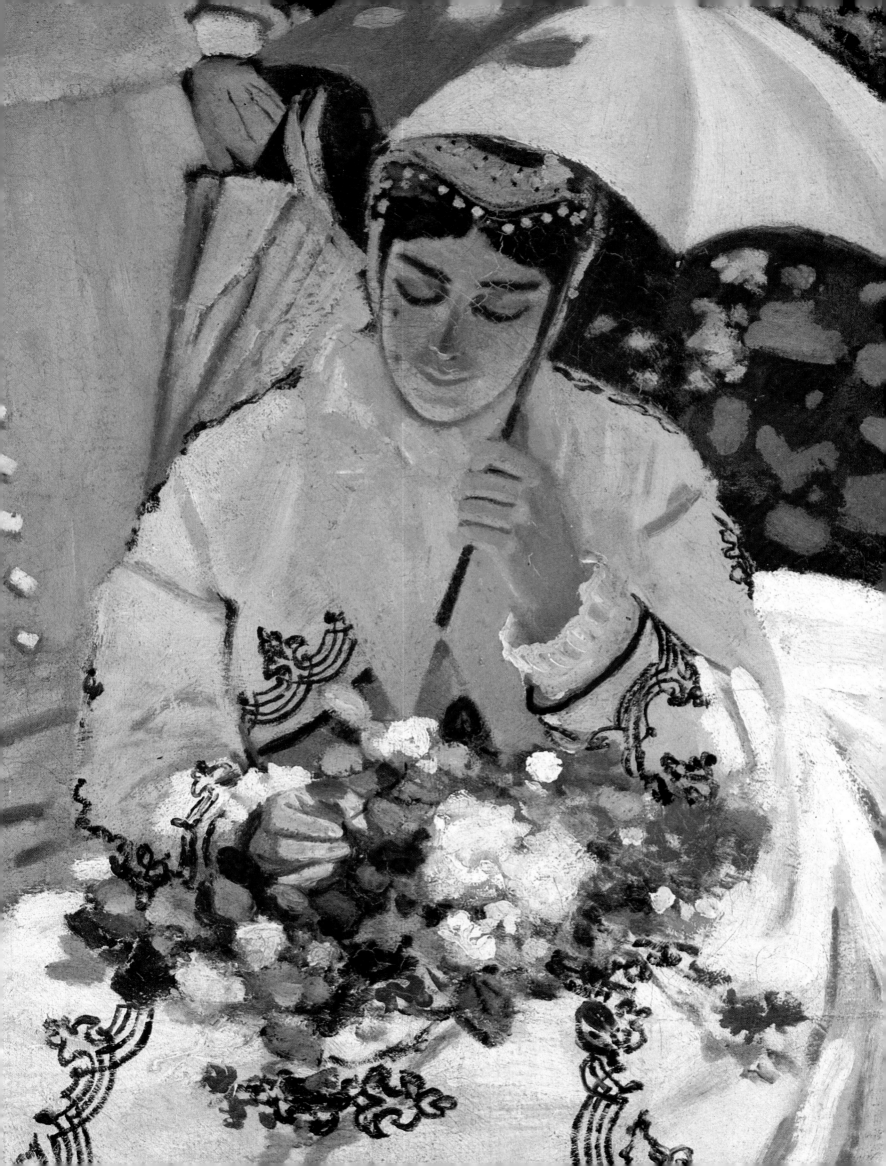

1.
Jeanne-Marguerite Lecadre, Aunt Sophie's daughter, was Monet's cousin. In 1866 he painted her in the garden, a white silhouette with a long shadow, placed to the left of the composition. The mass of flowers in the middle ground stands out as a mass of light touches of color against a background of dark foliage.

C amille Doncieux was nineteen when she started sitting as a model for Monet. She soon became his companion, to the great displeasure of his family. In 1867 she gave birth to Jean, the first of their two children, while Claude Monet's father continued to tell him to leave her. *Camille* was presented at the 1866 Salon. Dressed in a full dress, green with black stripes which trailed behind her, the young woman appears to be walking nonchalantly away. The painting shows her in three-quarter view, seen almost from the back, her head slightly bowed in the manner of the model in *The Studio* by Courbet. Although badly placed in the Salon, the painting immediately caught the highly appreciative attention of the public. The critics too were enthusiastic; one of them was Emile Zola, at the time a friend of Cézanne and admirer of Manet. He wrote: "I had just walked through these cold, empty rooms, frustrated at not having discovered any new talent, when I suddenly noticed this young woman with her long dress trailing behind her and walking through the wall as if there was a hole in it. You cannot imagine how good it is to admire a little when you are tired of laughing and shrugging your shoulders. I do not know Monsieur Monet, I even believe that in the past I would not have looked carefully at any of his paintings. And yet I feel that I am one of his old friends …" *Camille* also inspired Ernest Hervilly to write a poem, and in *L'Indépendance belge* it was said that "*Camille* is now immortal and she is known as *The Woman in the Green Dress*."

2.
Also in 1866, Monet spent some time in Marlotte, in the Forest of Fontainebleau, where impoverished young painters used to meet up. The *Auberge de la mère Antoni* (or Anthony) was a happy place for them and it is depicted in this painting. Could Monet be the man with the beard standing at the back? Jules Lecœur is definitely present, as is Sisley with his straw hat and the newspaper *L'Evenement* in front of him.

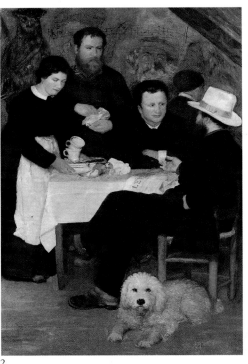

2

1. *Jeanne-Marguerite Lecadre in the Garden*, 1866.
Hermitage Museum, Saint Petersburg.

2. *The Inn of Mère Anthony*, 1866. Renoir.
Oil on canvas. 76¾ x 51¼ in. (195 x 130 cm.)
Statens Konstmuseer, Stockholm.

3. *Camille, or The Woman in the Green Dress*, 1866.
Oil on canvas. 91 x 61¾ in. (231 x 157 cm.)
Kunsthalle, Bremen.

3.
Camille was exhibited at the Salon of 1866. Gustave Geffroy thought that "the vision is beautiful and unusual. The beautiful creature passes, appears and disappears as she walks past full of grace."
But Edmond About's opinion was that "a dress is no more a painting than a correctly written sentence is a book."

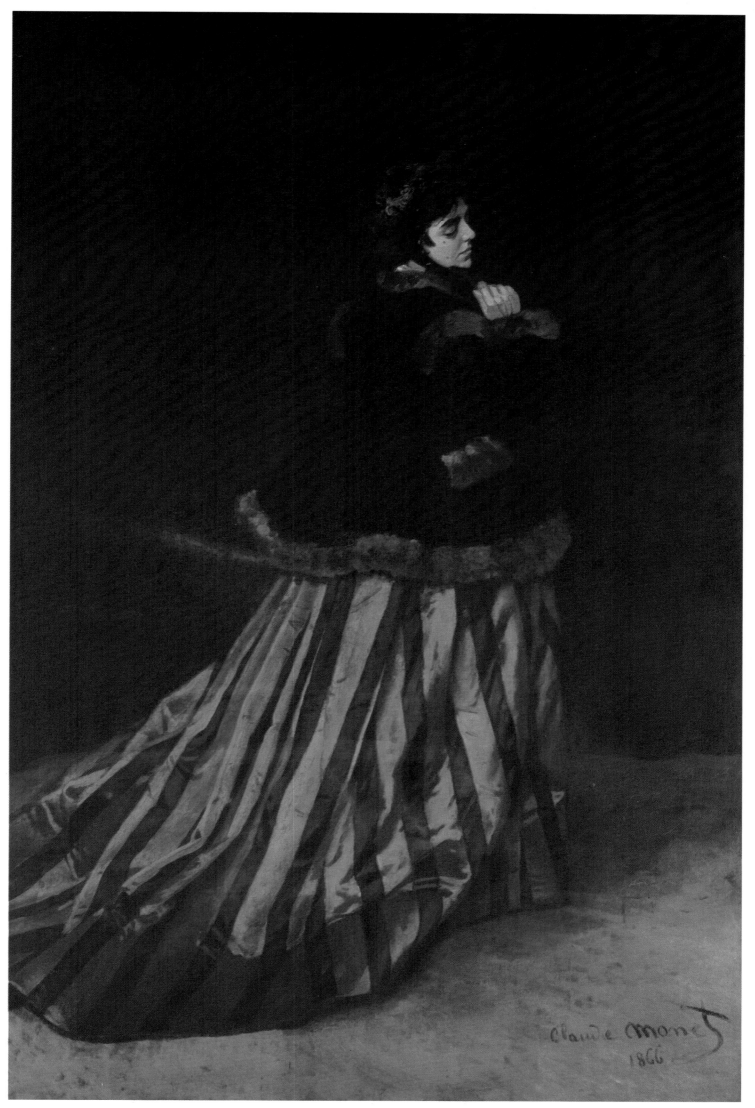

Le Déjeuner sur l'herbe

It was not *The Woman in the Green Dress* but another more ambitious painting that Monet had first intended to present at the Salon in 1866. Monet's ambition was formed by a combination of the influence of Courbet, the lessons of the Barbizon School (spontaneity, the presence of nature, and bold brushstrokes), and the revelation and scandal of Manet's *Le Déjeuner sur l'herbe*. The result was a painting 20 feet wide and over 13 feet high (6 x 4 metres) with a dozen characters in a pastoral setting, having a picnic in the forest.

In April 1865 Monet moved in at the Lion d'or inn, in the Forest of Fontainebleau and started sketching. But it rained constantly there, and Monet had also hurt his leg. As a result the large canvas was completed in the studio in the Rue Fürstenberg—which was indeed the usual procedure. Courbet went to visit Monet. People had mentioned *Le Déjeuner sur l'herbe*, and he wanted to meet "this young man who painted other

"Monet is finishing his enormous sandwich which is costing him the earth."
(Boudin)

The scandal caused by Manet's *Déjeuner sur l'herbe* at the 1863 Salon was still present in people's minds when two years later Monet, as a kind of challenge to Manet, started working on a similar subject set among the undergrowth in the Forest of Fontainebleau. The sketch (2), now in the Pushkin Museum in Moscow and once owned by the singer Faure,

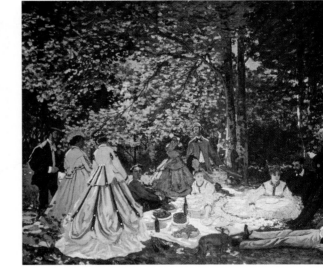

1 2

things besides angels" and also to see his "open air paintings". This marked the beginning of a lasting friendship between the two men. Courbet made a few suggestions but Monet was not satisfied with the changes he made, and the *Déjeuner sur l'herbe* was rolled up and stored in a cellar. Monet left it there for several years before leaving it with his landlord as a guarantee for unpaid rent in 1878. He retrieved it six years later in a pitiful state: the damp had rotted the canvas in places. Monet cut out and rescued two fragments: today one is at the Musée d'Orsay while the other is in a private collection. The study in the Pushkin Museum, a reduction of the painting subsequently reworked and dated 1866, emphasizes the success of the open-air composition. When it is compared with the fragments of the large canvas it highlights the difficulties Monet encountered when transferring it to a larger scale.

1. *Le Déjeuner sur l'herbe*, 1863. Manet.
Oil on canvas. 82 x 104 in. (208 x 264.5 cm.)
Musée d'Orsay, Paris. RMN.

2. *Le Déjeuner sur l'herbe*, 1866.
Oil. 51¼ x 71¼ in. 130 x 181 cm.
Pushkin Museum, Moscow.

3. *Le Déjeuner sur l'herbe*, 1865–66.
Oil on canvas. 165 x 59 in. (418 x 150 cm.)
Musée d'Orsay, Paris. RMN.

4. *Le Déjeuner sur l'herbe* (central part), 1865–66.
Oil on canvas. 97½ x 85½ in. (248 x 217 cm.)
Musée d'Orsay (private collection), Paris. RMN.

shows Bazille appearing twice. He is represented on the far left, and also lying at the foot of the tree. Figures and nature form a chromatic whole, made up of fragmented touches of colour. The characters do not look as if they are posing, but they blend in with the foliage where they are gathered in natural, free poses. The white touches of the shirts and light-colored dresses echo the dappled light penetrating the green canopy of tangled branches. Monet was not satisfied, and he did not show the painting at the 1866 Salon. Years later, in Giverny, he would often show the carefully preserved central fragment (4) to his visitors, as he is here to the Duke of Treviso.

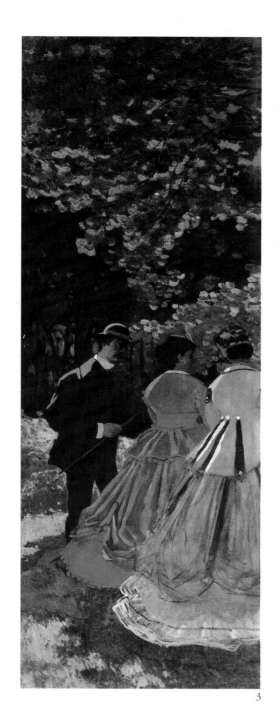

3

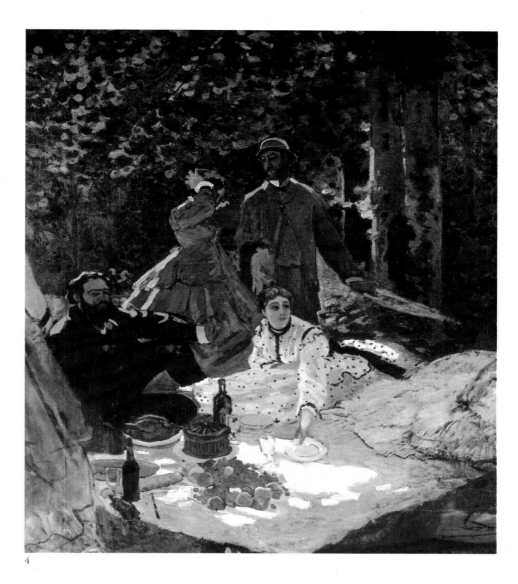

4

5

Camille Doncieux was pregnant. The news came as a shock to Monet and he immediately informed his family. The young woman was invited to Sainte-Adresse but she refused the invitation: was it because she was aware that Adolphe Monet, Claude's father, wanted his son to abandon her? She gave birth in Paris, attended only by the student doctor to whose care Monet had entrusted her. Deeply distressed, the painter turned once again to his friend Bazille: "I do not know what to say, you have remained silent with such obstinacy, not replying to my many letters and telegrams. Nothing has moved you. And yet you know me and my situation better than any one else. I have had to turn to strangers to borrow money and been snubbed. I am really cross with you, I did not think you would abandon me like this, it is really too bad of you... I am having a terrible time. I have had to return here to please my family and also because I did not have enough money to live in Paris while Camille was suffering. She gave birth to a big baby boy whom I love, in spite of everything and I do not know how, and I suffer when I think that his mother hasn't got anything to eat... Come on Bazille, there are things you cannot leave till tomorrow. This is one of them and I am waiting. In the hope of hearing from you I shake your hand." Yet Monet did not seem to be suffering in Sainte-Adresse: "I have been in the bosom of my family for two weeks now, as happy and as well as possible." During that time he painted two canvases, radiating serenity and tranquil happiness. *The Terrace at Sainte-Adresse* shows four characters: seen from behind: Aunt Lecadre, sitting next to Claude's father Adolphe Monet, who is represented with respect and even affection; and near the balustrade, Jeanne-Marguerite in conversation with a young man wearing a top hat. *The Regatta at Sainte-Adresse* seems to emanate a serenity far removed from Monet's problems. This painting was bought by Henri Hecht, a powerful banker, very keen on Monet's work and whose brother, Albert already owned several paintings by Manet.

1

Sainte-Adresse

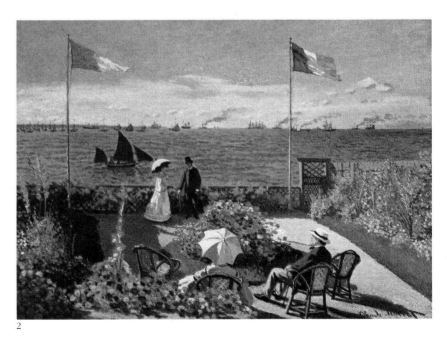

2

1 (detail) and 2. *The Terrace at Sainte-Adresse*, 1867.
Oil on canvas. 38½ x 51 in. (98.1 x 129.9 cm.)
The Metropolitan Museum of Art, New York.

3 (detail) and 4. *The Beach at Sainte-Adresse*, 1867.
Oil on canvas. 29½ x 40 in. (75.2 x 101.6 cm.)
The Metropolitan Museum of Art
(W. Church Osborn legacy), New York.

5 (detail) and 6. *By the Water, Bennecourt*, 1868.
Oil on canvas. 32 x 39½ in. (81.5 x 100. 7 cm.)
Art Institute (Potter Palmer Collection), Chicago

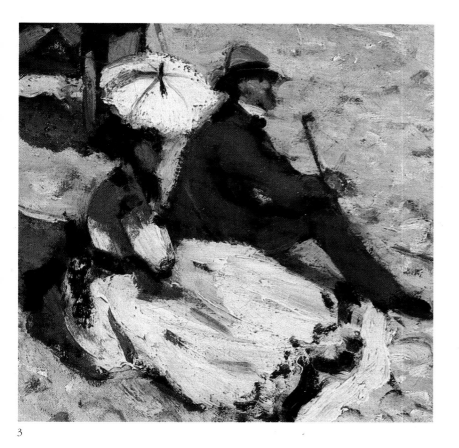

3

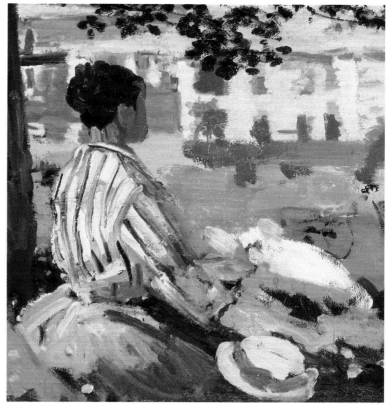

5

Monet complained to Bazille that Camille who about to give birth in Paris "was completely penniless." But on the other hand, forced to stay in Sainte-Adresse to please his family, Monet said that he "would be extremely happy without this imminent birth." It is true that *The Terrace at Sainte-Adresse* (1, 2), painted that summer in the family house, expresses serenity and happiness. Jeanne-Marguerite Lecadre's white dress is luminous among the red geraniums looking out towards the Atlantic. Monet's father, seen in three-quarter view from behind, is resting and looking at the view, as is the viewer, seeming as it were to look over his shoulder. In *The Beach at Sainte-Adresse* (3, 4), the father is still looking out towards the ocean, which Monet reveals to us. Later, in Bennecourt, Camille in *By the Water* (5, 6) also turns her back towards us as she contemplates the reflection of the sun on the river. These details highlight Monet's approach where the figures are not the subject of the work, but help the viewer contemplate the effects of light and water.

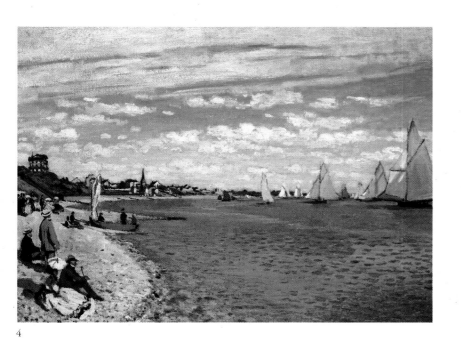

4

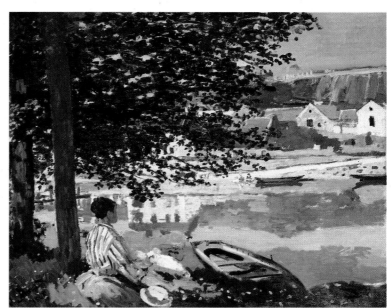

6

A first patron

It sometimes happened that patrons and rich collectors behaved towards non-conformist young painters like monarchs of the past. For instance, the publisher Charpentier became the patron of Renoir. Louis Gaudibert was another artists' patron. A wealthy collector, he had married the daughter of a notary from Le Havre and, like his parents, he was on friendly terms with the painter Amand Gautier and Doctor Gachet. He and his wife both appreciated Boudin's work. In 1868, Louis Gaudibert met Monet through Boudin or Gautier—it is not known which of them—and bought a few paintings from him. This unexpected help arrived at the right moment because Monet's situation was still as difficult as ever, and his family had canceled all financial help since the birth of Monet's son. Louis Gaudibert commissioned a portrait of his wife from Monet who produced a much less conventional painting than Camille's portrait, far more complex in the treatment of fabrics. Nonetheless the *Portrait of Madame Gaudibert* is still reminiscent of *The Woman in a Green Dress*. This genre of slightly mundane painting, in the manner of Alfred Stevens, probably did not reflect what Monet wanted to paint, but Gaudibert's commission met his needs at the time and Monet was happy to do it. Gaudibert was pleased with the portrait for which he paid the modest sum of 130 francs. The painting remained in the Gaudibert family until 1951 when it was bought by the French National Museums.

Soon after painting Madame Gaudibert, Monet spent the autumn and the winter of 1869 on the Normandy coast with Camille and their son Jean, in a house near Fécamp that he had rented with Gaudibert's help. This is where he painted this intimate work *The Luncheon*, depicting his little family in a bourgeois setting. Representing a scene from everyday life, this painting clearly shows the influence of realism and the naturalist school inspired by Flaubert and Zola.

1

1.
Monet had just been thrown out of the inn where he was staying, "without a stitch on his back." He wrote to Bazille saying he did not even know where he was going to sleep that night. He was so upset that said he would throw himself into the river. He traveled to Le Havre in the hope of "obtaining something from his collector." At the Le Havre International Exhibition he won a medal but sold nothing. Even worse, his canvases were seized by his creditors and eventually bought by Louis Gaudibert, who collected Monet's work. According to Boudin, he paid the derisory sum of eighty francs. Gaudibert gave the artist an allowance, and Monet painted this portrait of Madame Gaudibert for him.

2.
This allowance solved Monet's financial problems. From Le Havre the painter went to Fécamp and wrote to Bazille: "I am as happy as a fighting cock, surrounded by everything that I love (…) and I believe I shall produce serious work this year. And in the evening, I go home to a good fire and my little family. If you could see how sweet your godson is now. I shall paint him for the Salon, with other figures naturally. This year I shall produce two paintings with figures, one of an interior with the baby and two women…". One of the two women was Camille. In the background is a young servant girl: these were days of relative prosperity. *The Luncheon (of Jean)* was probably one of the two paintings by Monet that were rejected by the 1870 Salon.

1. *Madame Gaudibert*, 1868.
Oil on canvas. 85 x 59 in. (216 x 138 cm.)
Musée d'Orsay, Paris. RMN.

2. *The Luncheon*, 1868.
Oil on canvas. 90½ x 59 in. (230 x 150 cm.)
Städelsches Kunstitinstitut und Städtische Galerie, Frankfurt am Main.

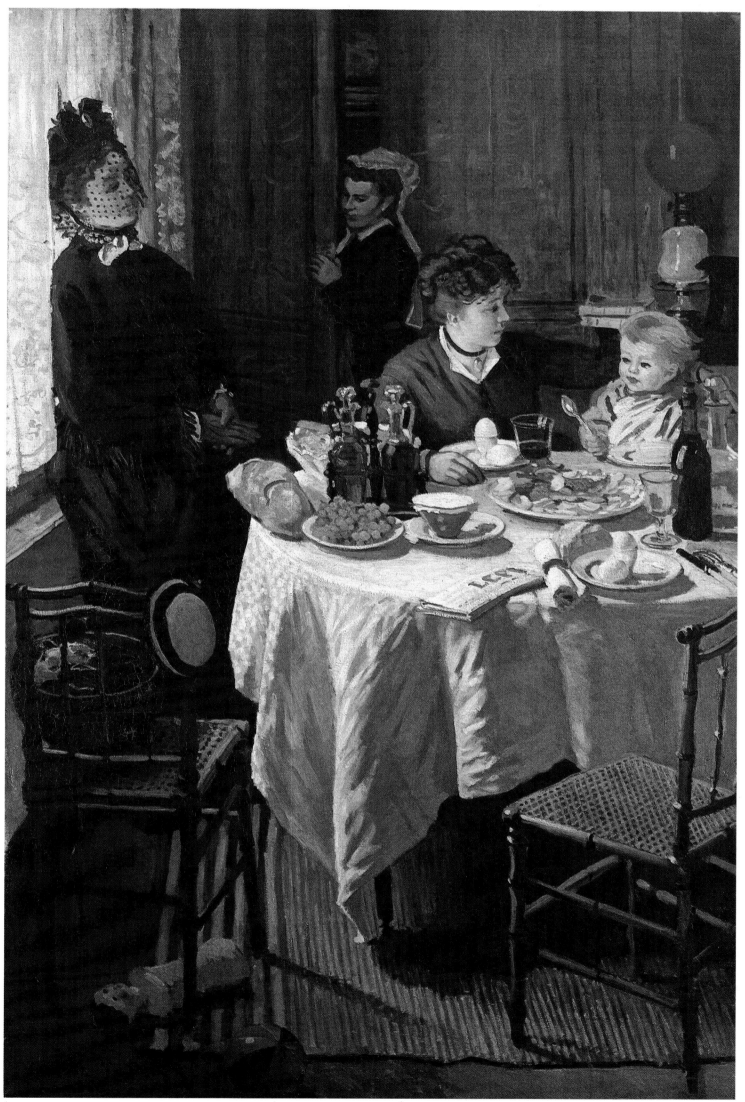

1

For Renoir, snow made "a kind of mould on the face of nature." For Monet, in his quest for fluidity in his use of color, the gray skies pierced by a white sun, the opalescent snow and the translucent ice were all subjects for paintings. In any case, he had to paint whether it was summer or winter because he had to sell in order to survive. He worked until dusk fell suddenly upon him, painting doggedly, numb and perished with cold. *Ice on the Seine at Bougival* dates 1867. The broad, flat tints in this painting reveal the already significant influence of Japanese prints upon the man who was to become the "most impressionist of the Impressionists." In 1856, the painter and engraver Bracquemond found some sheets of Hokusai engravings that had been used to wrap china shipped from Japan. Monet claimed that in 1862 he too had found some such engravings, also being used as wrapping paper, in a consignment arriving at Le Havre. *The Magpie* was painted in 1869 during a stay in Etretat. It is a painting with dazzling light effects. Later, in Vétheuil, Monet would develop the same theme in *Breakup of the Ice*, and in 1895 he traveled to Norway in search of winter landscapes.

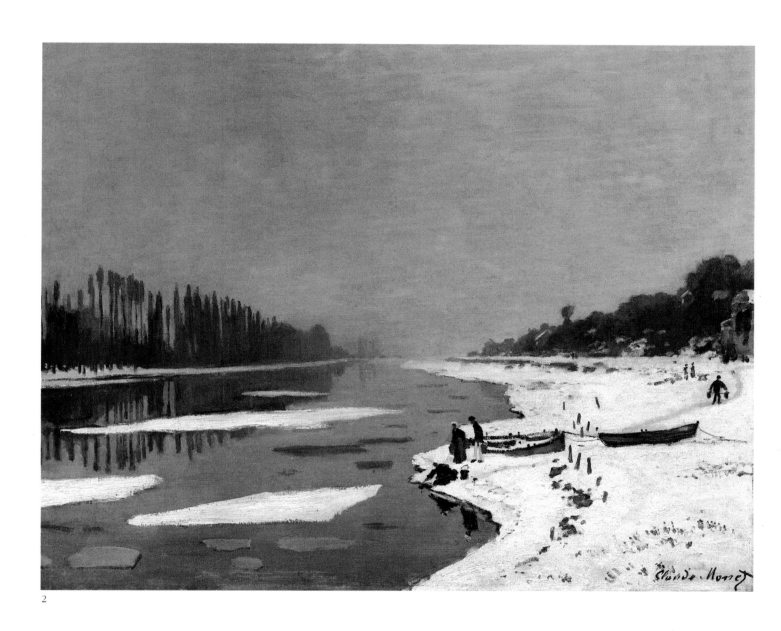

2

1. *The Magpie*, 1869.
Oil on canvas. 35 x 51¼ in. (89 x 130 cm.)
Musée d'Orsay, Paris. RMN.

2. *Ice on the Seine at Bougival, c.* 1867.
Oil on canvas. 25½ x 32 in. (65 x 81 cm.)
Musée d'Orsay, Paris. RMN.

La Grenouillère

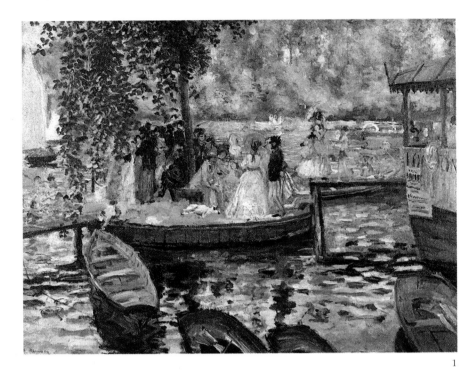

"I have a dream, a painting,
of the pools at La Grenouillère for
which I have made a few bad sketches,
but it remains a dream."

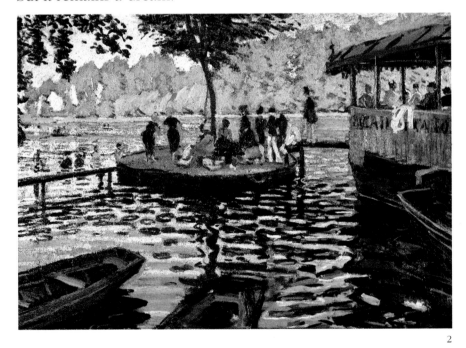

In the spring of 1869, and once again with Gaudibert's help, Monet was able to rent a house in Saint-Michel de Bougival. But money was still very scarce and he pestered Bazille with tearful letters: "For a week we have had no bread, no wine, no fire for cooking, no light… And as usual, I cannot work because I have no paints. In fact, I should put an end to it all because I cannot expect an instant fortune, and if all those who treat me like you had each given me forty or fifty francs I would not be where I am now." And Renoir, who spent some time at Monet's house, confirmed this: "We do not eat every day, but I am happy all the same because Monet is good company as far as painting is concerned. I hardly paint at all because I haven't got much paint." But the two friends were more determined than ever in their misery: "I have a dream for the next salon," Monet wrote to Bazille, "a painting of the baths of La Grenouillère for which I have made a few rather bad rough sketches, but it is only a dream. Renoir who has just spent two months here also wants to paint this subject." In fact this dream was to become a reality, a reality of historic importance, because it was here, on the island of Croissy in the middle of Seine, that Impressionism was born in 1869. La Grenouillère was where the upper classes came on Sundays to enjoy themselves among the rowers and the rather forward girls known as "grenouilles" ("frogs"). Guy de Maupassant described the atmosphere in two of his novellas, *La Femme de Paul* and *Yvette*: "It sweats stupidity, and it stinks of vulgarity and the intrigue of the bazaar."

But Monet had another, more attractive, vision of the scene, made up of numerous strokes of light colors, and the quivering effects of light and water. These would be the main components of a new approach to painting. Renoir concentrated more on human figures, but Monet's characters are dots of colors hardly distinguishable from the surrounding foliage. Renoir was so conscious of his opposition to official art that he did not dare to submit his painting to the 1870 Salon. The two paintings that Monet submitted were rejected; one of them was probably one of the views of the *Pools at La Grenouillère* that is missing today.

1. *La Grenouillère*, 1869. Renoir.
Oil on canvas. 26 x 34 in. (66 x 86 cm.)
Statens Konstmuseer, Stockholm.

2. *Pool at La Grenouillère*, 1869.
Oil on canvas. 28¾ x 36¼ in. (73 x 92 cm.)
National Gallery, London.

3. *La Grenouillère*, 1869.
Oil on canvas. 29¼ x 39¼ in. (74.6 x 99.7 cm.)
The Metropolitan Museum of Art
(Mrs H. O. Havemeyer bequest), New York.

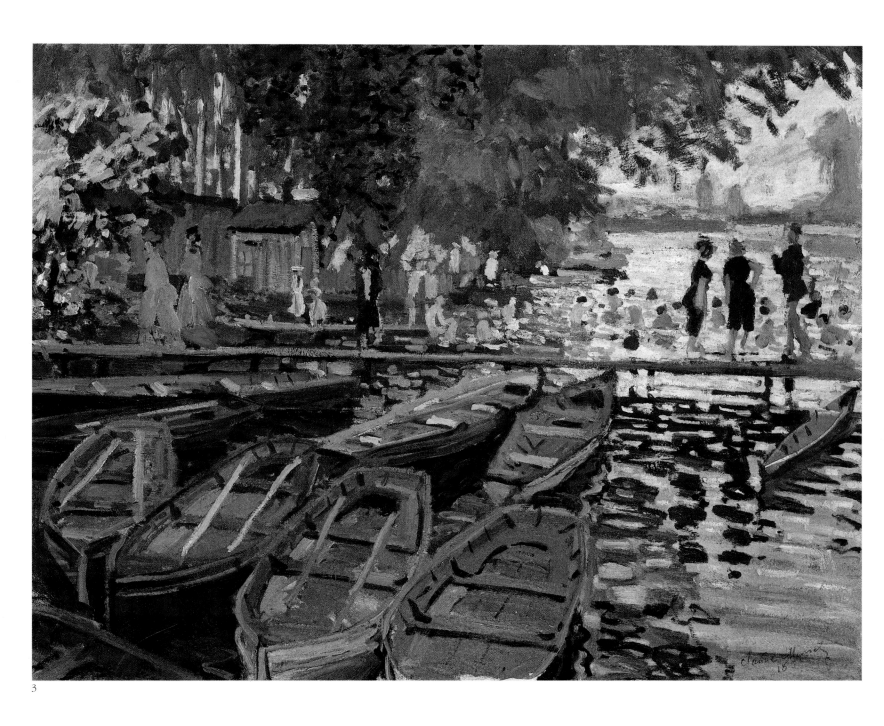

3

Renoir and Monet, side by side at their easels, painted together the little islet at La Grenouillère, known as the "Pot à fleurs" (flowerpot) or the "Camembert" (cheese). It was reached by a pontoon, while a second footbridge leads to the boat-like swimming establishment. The rowboats moored along the bank could be hired. Like Renoir, Monet painted different aspects of La Grenouillère. *The Pools at La Grenouillère* is a painting that disappeared during the Second World War, and it is is known only through a poor photograph of the German collector Eduard Arnhold, and a couple of sketches.

Aunt Lecadre was dying and there was no need to worry about upsetting her any longer: at last Monet could marry Camille. The wedding took place in Paris on June 28, 1870, and Courbet was one of Monet's witnesses. However, war was about to break out with Prussia and there was the risk that the painter might be called up.

Monet knew that the studies painted by Boudin in Trouville were selling well, so he decided to move there with his family. Before he went he entrusted a number of his paintings to Pissarro for fear that they might be seized. Monet set up his easel in front of the Hôtel des Roches Noires (which still exists there today) and painted the idle society life at the busy seaside resort. The beach scenes he painted have strongly contrasting light and shade in compositions where the structure is created by vertical flagposts and lights. In the foreground of one,

Camille is sitting on the beach under a sunshade, lost in thought, framing the picture in a manner that is almost photographic. The passing clouds create a shimmering effect in the summer light and Monet has successfully expressed the transparent quality of the atmosphere.

Looking back on these times later after Camille's death, Boudin (who had joined Monet in Trouville) wrote that "these memories take us back into the past which was not always so happy as then… And I can still see you with poor Camille in the Hôtel de Tivoli. I have even kept a drawing I made at the time of you sitting on the beach. There they are, three women in white, still young. Little Jean is playing in the sand, while his father is sitting on the ground with a card in his hand… and not working. It is a precious memory of those days that I have always kept." On July 19, France declared war on Prussia. It was a disaster and France was defeated. On September 1, the Emperor and 100,000 men were taken prisoner at the fateful battle of Sedan. Bazille, who had volunteered, was killed. Because of the war, paintings did not sell. Monet was in terrible trouble and he went to Le Havre to ask his father for money, leaving Camille and his son at the hotel with the bill unpaid.

The summer of the war

In the summer of 1870, as if unconscious of the imminent defeat at Sedan (1), the holiday makers are enjoying themselves

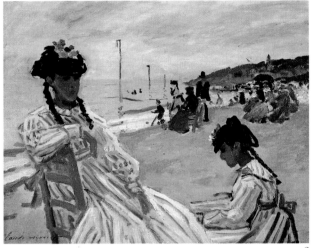

1. *The Aftermath of the Bloody Battle of Sedan, September 3, 4 and 5, 1870.*
Lithograph after L. von Elliot.
Bibliothèque Nationale, Paris.

2. *On the Beach at Trouville*, 1870–71.
Oil on canvas. 15 x 18 in. (28 x 46 cm.)
Musée Marmottan, Paris.

3. *Beach at Trouville*, 1870.
Oil on canvas. 15 x 18 in. (28 x 46 cm.)
National Gallery, London.

4. *Hôtel des Roches Noires, Trouville*, 1870.
Oil on canvas. 31½ x 21½ in. (80 x 55 cm.)
Musée d'Orsay (permanent loan), Paris. RMN.

on the promenade and beach at Trouville. People are meeting and greeting each other in front of the Hôtel des Roches Noires, and time slips effortlessly by. Within a few days, Monet would not have enough money left to pay his bill, but neither this nor the war affected the happiness of those days. Camille is posing in these little paintings (2, 3) that might attract a buyer. She seems to be leaning back to reveal the sea and the sky to the viewer. They are masterpieces whose free impressionist brushstrokes are typically Monet, while the theme is reminiscent of Boudin.

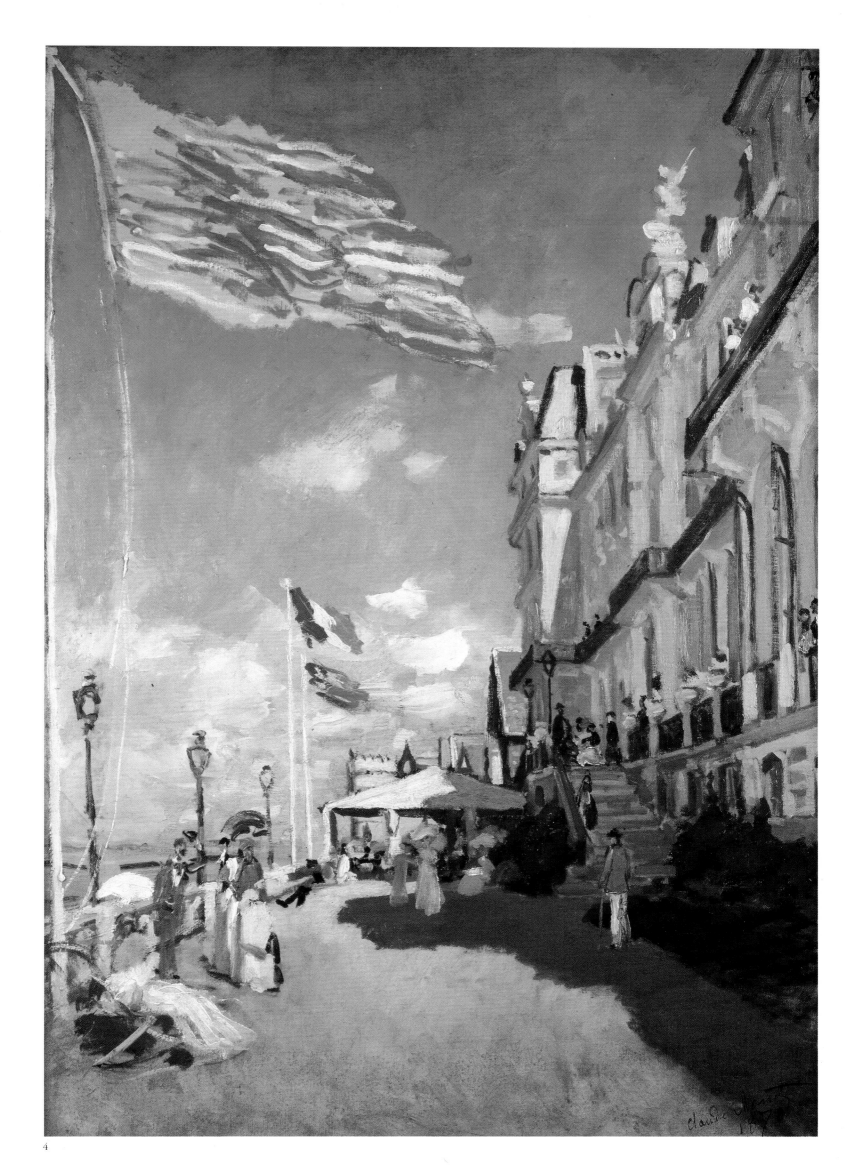

4

onet fled to London and he was not the only one: "The flight to England is complete" he wrote to Boudin. He found lodgings in the West End and met up in a pub with other French artists such as Pissarro, Boudin, and others, notably including Daubigny who was very taken with their work and introduced them to the art dealer Durand-Ruel. He too was in exile in London, and he immediately displayed their paintings in his shop. "Without Durand, we would

2 *The River Thames and Houses of Parliament in 1870*

1

1.

Rain, Steam and Speed: these three words could be said to anticipate Monet's themes. He found Turner "unlikable because of the exuberant romanticism of his imagination." Pissarro recognized in Turner "the value of division as a technique, but not for accuracy." Nevertheless, the two friends were absolutely amazed by London, and Monet told Gustave Geffroy of their "joy at realizing that what one was looking for had already haunted another mind."

have all starved to death," wrote Monet, since he and Pissarro had had no success at all when they submitted their work to the Royal Academy. The two friends spent long hours at the National Gallery and the South Kensington Museum (now the Victoria and Albert Museum). There they studied the Turner collection and Constable's paintings. Monet always denied their influence on his work, particularly Turner's, but Pissarro acknowledged it: "We were particularly surprised by these landscape painters who were so similar to us in their rendering of light, air and passing atmospheric changes." Indeed, the relationship between Turner and the Impressionists was so striking that in 1885 Emile Verhaeren wrote about the "*impressionist* Turner" in *L'Art moderne*. Turner himself had written: "I do not paint to be understood but to show what the scene was like." This desire to translate the fleeting sensations of a particular moment clearly heralded Impressionism, even if his preference for dramatic, nocturnal scenes, stormy seas and threatening skies still linked him to Romanticism.

Meanwhile, the news from France was becoming increasingly alarming. The German army had requisitioned Pissarro's house in Louveciennes and destroyed some of his canvases, fragments of which were found along the road. In January 1871 Monet learnt of his father's death. By May refugees were fleeing to England in increasingly large numbers, bringing with them the news of the cruel repression of the rebels of the Commune. Courbet was thought to have been executed by shooting. Monet then

3

1. *Rain, Steam and Speed*, 1844 . Turner.
Oil on canvas. 36 x 48 in. (91 x 122 cm.)
National Gallery, London.

3. *Street in Upper Norwood*, 1871. Pissarro.
Oil on canvas. 17¾ x 21¾ in. (43.5 x 55.5 cm.)
Neue Pinakothek, Munich.

4. *The River Thames and the Houses of Parliament*, 1871.
Oil on canvas. 18½ x 28¾ in. (47 x 73 cm.)
National Gallery, London.

3.
Durand-Ruel had opened a gallery in London and he held his first exhibition there in December 1870. It included two paintings by Pissarro, including *Upper Norwood*, where the painter was living.

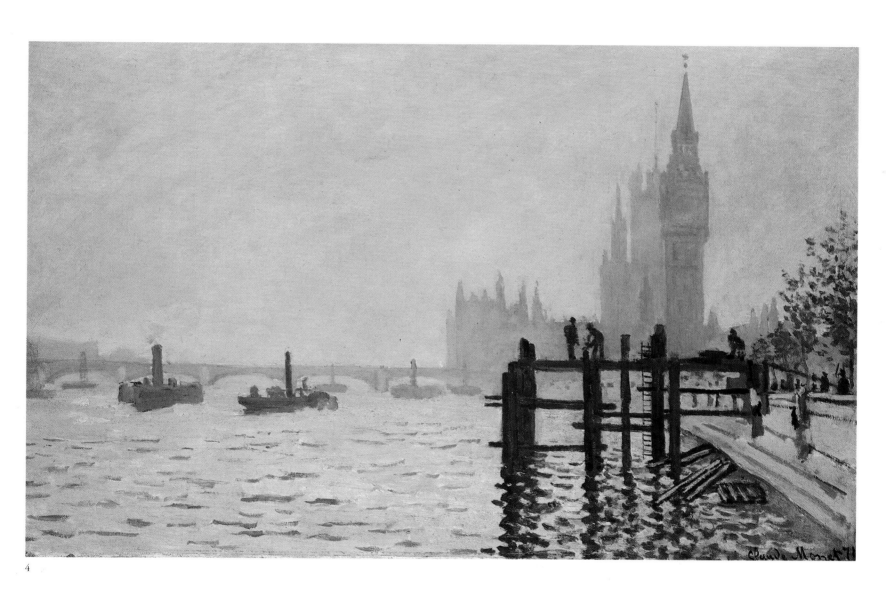

4

4.
*The Thames and the
Houses of Parliament*
demonstrated the need
Monet felt to define the
merging of the water with
the atmosphere in his
subject by horizontal and
vertical elements. Thirty
years later the need for
these formal elements
disappeared, with the
revolutionary *Waterlilies*.

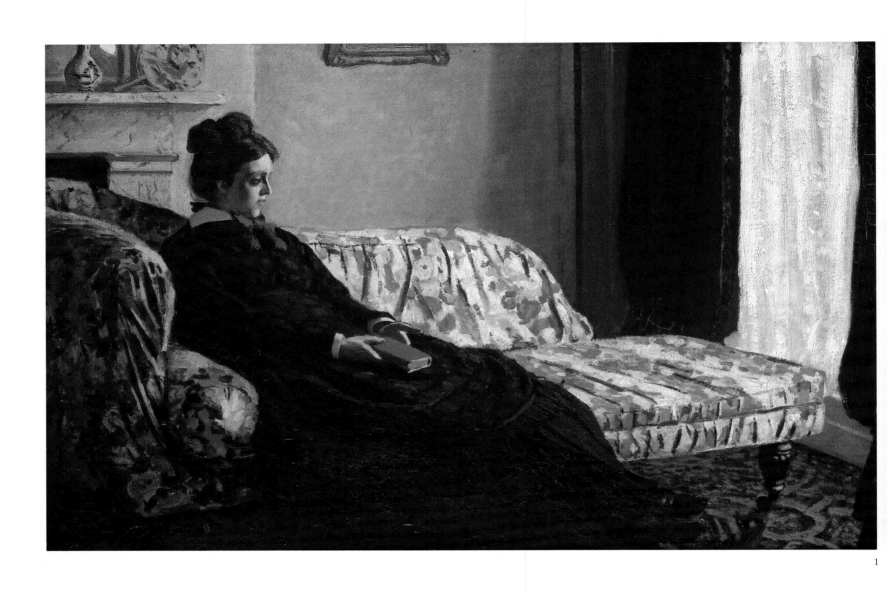

1

2.

In Paris on May 16, 1871, the Vendôme column, symbol of the Empire, was knocked down to the sound of the Marseillaise. Courbet was there. He had wanted it to be destroyed, but a few days earlier he had resigned from the Commission des artistes de la Défense Nationale because of the excesses of the Commune. He was arrested on June 7 and transferred from prison to prison.

1.

Monet painted this picture of *Camille in Thought* in the London apartment he had rented from Whistler's art dealer. She has closed the book she was reading and, lost in a dream, she appears to be giving in to melancholy caused by her exile. The painting was exhibited at the Universal Exhibition held in Kensington, London in 1871.

4.

Gustave Doré was distraught by what he saw in London in the 1860s, and he set out to highlight the misery of the English capital in engravings, depicting the streets swarming with people and even then blocked by traffic jams.

3.

Monet decided to go and live in Holland until the political situation in France had calmed down and the massacres of the repression had ceased. He settled in Zaandam where he was enchanted by his surroundings. in this prolific period, he painted the houses along the river Zaan, the boats, and the windmills.

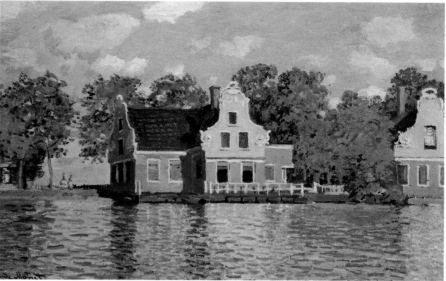

decided to leave England and, rather than return to France, he moved to Holland where he settled in Zaandam with his family. He was no longer plagued by money worries, since he had inherited a little money from his father and Camille gave French lessons, increasing their income. While Courbet languished in the Sainte-Pélagie prison, Monet was extremely productive during his stay in Holland. The constantly changing Dutch sky, the boats, the windmills and the inhabitants were a permanent source of inspiration: "This is a perfect place for painting; you could not find anything more amusing to paint, brightly colored houses, hundreds of windmills and delightful boats. The Dutch are quite friendly and almost all of them speak French." Monet had read with interest the journals of Delacroix, who had also been passionately interested in Dutch art, like all the Romantics. The pre-Impressionists of the Barbizon School, particularly Daubigny, borrowed

1. *Camille in Thought*, 1871.
Oil on canvas. 19 x 29½ in. (48 x 75 cm.)
Musée d'Orsay, Paris. RMN.

3. *Houses beside the Zaan at Zaandam*, 1871.
Oil on canvas. 18¾ x 29 in. (47.5 x 73.5 cm.)
Städelsches Kunstitinstitut und Städtische Galerie, Frankfurt am Main.

4. *Ludgate Hill, London*, 1868. Gustave Doré.
Engraving.

certain subjects from the Dutch landscape—riverbanks, canals, windmills, moonlit landscapes and so on.

Monet's stay in Holland had an influence on his painting in that it was there that he discovered a completely different kind of art, from the Far East. He was able to buy Japanese engravings and decorated Chinese vases very inexpensively, and he later included them in some of his Argenteuil paintings.

1

Argenteuil

1.

At the age of 19, Monet saw several paintings by Corot in the 1859 Salon, and he wrote to Boudin that they were "simply wonderful." The old master who was 75 when he painted this *Pond at Ville-d'Avray* recommended that one should "never lose sight of the impression that has moved us." In 1874, "the Manet group" celebrated Corot's 50 years of painting in Argenteuil.

2.

Train in the Snow, the Engine shows the station at Argenteuil during the winter of 1874–75. The lacy trees with their naked branches and the wooden fence shaded with black stand out against a background of snow and smoke, lit up by the two lanterns on the front of the engine.

3.

In 1872, Monet was invited to Rouen by his brother where he painted *The Robec Stream*. From its naturalistic approach, this return to Normandy appears to have reminded him of Troyon. But the industrial modernity present in this composition, is conveyed by oblique touches where the factory smoke merges with the dark sky.

4.

A landscape without figures, *The Seine at Argenteuil* reflects a moment of light that makes the sky and the river meet and merge.

5, 6.

Renoir visited Argenteuil and made this picture of *Monet Painting in his Garden.* Monet himself painted a picture of his house, conveying the splashes of light falling on the sand of the terrace and reflections of sun and shadow surrounding the child and hoop.

7.

Snow at Argenteuil is an impression of silence conveyed through the transparency of naked branches.

8.

The line of the tops of the trees curves from the top down towards the transverse line of the Argenteuil bridge in the distance behind the pond, freeing the aerial space that is filled with burgeoning cumulus clouds. In the foreground the shadow of the trees adds depth to the canvas, punctuated by the white sails and the figures silhouetted against the shade.

1. *Pond at Ville-d'Avray Seen through the Foliage,* 1871. Corot. Oil on canvas. 17 x 21½ in. (43 x 55 cm.) Musée Marmottan, Paris.

2. *Train in the Snow, the Engine,* 1875. Oil on canvas. 23¼ x 30¾ in. (59 x 78 cm.) Musée Marmottan, Paris.

3. *The Robec Stream,* 1872. Oil on canvas. 19¾ x 25½ in. (50 x 65 cm.) Musée d'Orsay, Paris. RMN.

4. *The Seine at Argenteuil,* 1873. Oil on canvas. 20 x 24 in. (50.5 x 61 cm.) Musée d'Orsay, Paris. RMN.

5. *Monet Painting in his Garden at Argenteuil,* 1873. Renoir. Oil. 19¾ x 24 in. (50 x 61 cm.) Wadsworth Atheneum (Anne Parish Titzell bequest), Hartford.

6. *The Artist's House at Argenteuil,* 1873. Oil on canvas. 23¾ x 28¼ in. (60.2 x 73.3 cm.) Art Institute (M. A Ryarson collection), Chicago.

7. *Snow at Argenteuil,* 1874. Oil on canvas. 21½ x 29 in. (54.6 x 73.8 cm.) Museum of Fine Arts (Anna Perkins Rogers), Boston.

8. *The Lake at Argenteuil,* c. 1872. Oil on canvas. 23½ x 31¾ in. (60 x 80.5 cm.) Musée d'Orsay, Paris. RMN.

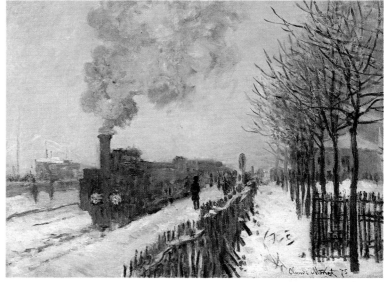

2

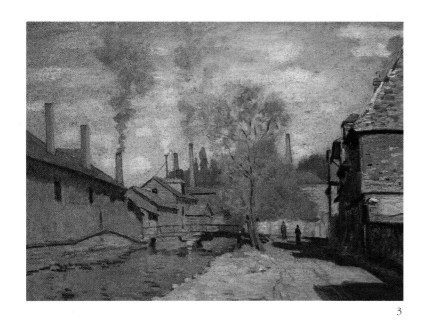

3

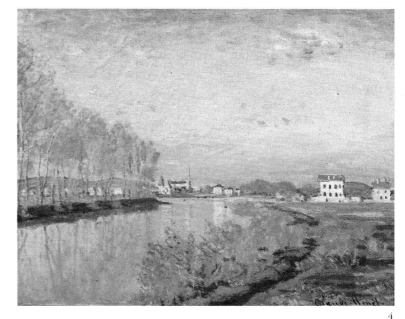

4

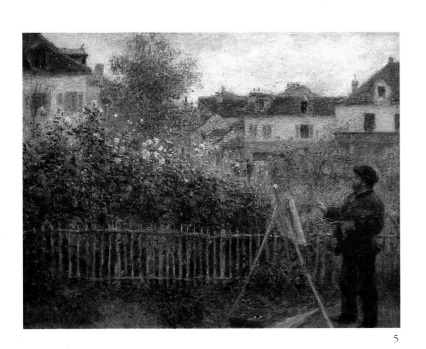

5

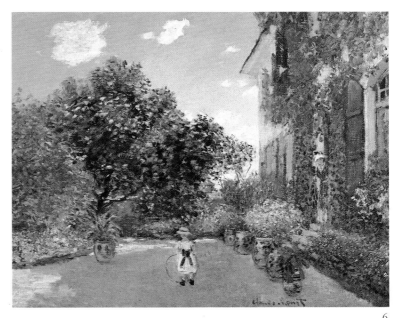

6

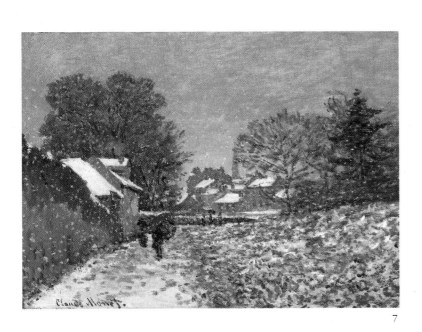

7

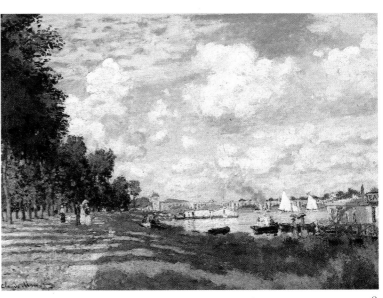

8

61

Impression...

Back in Paris, Monet moved into a hotel and rented Amand Gautier's former studio, not far from the Gare Saint-Lazare where he "regularly worked from ten o'clock in the morning till four in the afternoon," as he wrote to Pissarro. He would meet up with friends at the Café Guerbois which he frequented with Renoir. It was there that he learnt of Bazille's death, killed on the front line in November 1870. Degas, Fantin-Latour, Cézanne, Manet, and Pissarro all went to the Café Guerbois, the cradle of Impressionism where the artistic ambitions of these independent painters were developed and endlessly debated: Zola described the Guerbois in *L'Œuvre*, where it was called the Café Baudequin. Later Monet rented a house in Argenteuil, probably through Manet, and invited Boudin to the "house-warming."

Edmond Renoir, the painter's brother, was entrusted with making the catalogue of the first exhibition of the "Société des peintres, sculpteurs et graveurs" to be held in April 1874 in premises lent by the photographer Nadar. Seeing this painting, which Monet had simply entitled *Seascape*, Edmond Renoir asked him for a less vague title. "Just put: *Impression, Sunrise*," the painter replied. He was unaware that this title would give its name to Impressionism, at the cost of great uproar and a storm of criticism. Monet had painted the canvas from the window of his room in the Hôtel de l'Amirauté during a stay at Le Havre. Although later dated 1872 by the painter himself, it was probably produced the following year. Some see Turner's influence in it, which would justify the date of 1872, the year Monet returned to France. But others see the influence of Jongkind, who had already used the same against-the-light viewpoint.

Impression, Sunrise, 1873.
Oil on canvas. 19 x 25 in. (48 x 63 cm.)
Musée Marmottan, Paris

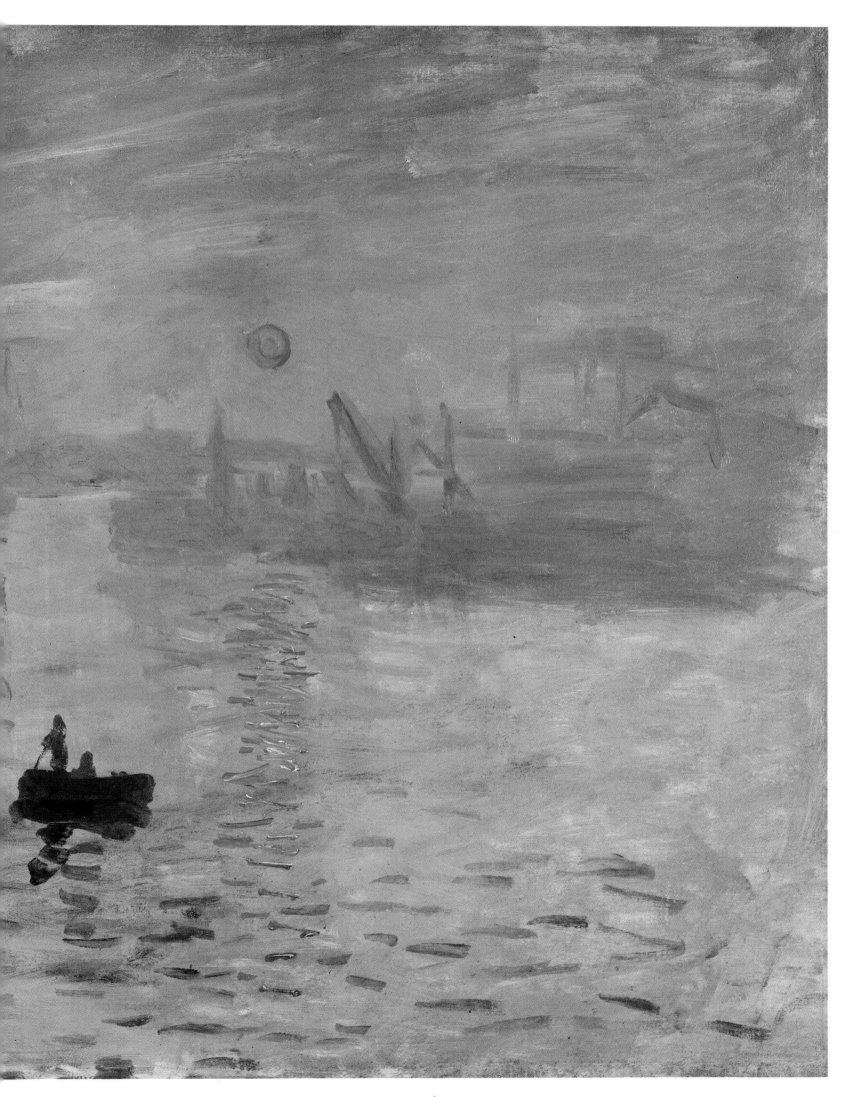

1

2

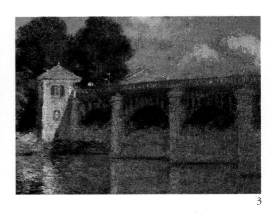

3

Argenteuil was then only a village on the Seine with a few thousand inhabitants. Just half-an-hour from the Gare Saint-Lazare by train, this village had become a haven of peace and rural pleasures for townspeople, but industrialization was already making its presence felt and factory chimneys could be seen on the horizon. In the spirit of the time, industry symbolized progress, and Monet associated it with nature by including it in several of his compositions. But unlike Amand Gautier, Courbet, or the anarchist Guillaumin, he was unaware of the social consequences of industrial progress. When he went with Boudin and Amand Gautier to visit Courbet, who was interned on parole in a clinic in Neuilly clinic, he did so out of loyalty to his master and friend, and not out political complicity. Trains, stations, metal bridges were no more to him than smoke dispersing, part of the architectural structure of pictorial space. Two bridges span the Seine in Argenteuil: one is a road bridge built for pedestrians, carts and carriages, and the other is a railway bridge. Monet not only studied and observed their arches and girders so as to reproduce them in his Argenteuil paintings; he also enjoyed watching regattas from them.

This interest in yachting and racing dating back to the 1850s was encouraged by the newly fashionable idea that sport was a health-promoting occupation. Regattas were organized on the Seine by Parisians who had founded several clubs. The reflections of the horizontal hulls in the water and the linear verticality of the masts are important elements of the composition of the Argenteuil paintings. Monet produced more paintings during the six years he spent in Argenteuil than in the previous thirteen years. He had given up the idea of large canvases which were expensive and thus difficult to sell. Art dealers and collectors were becoming interested again, Durand-Ruel was doing well and he bought 29 paintings from Monet in 1872. The painter's financial situation was rapidly improving, and he now employed two servants and a gardener. Argenteuil was the time and the place for masterpieces. Manet, Sisley, Renoir, and Caillebotte were all neighbors and they often worked together. Renoir painted *Monet Painting in his Garden*, Sisley *The Bridge at Argenteuil*, Manet *The Studio-Boat* (belonging to Monet) and *The Monet Family in the Garden*, and Sargent *Monet*

The 19th century exalted science and industry. Jules Verne imagined what it promised and Emile Zola described its social consequences. The Impressionists merely noticed that it transformed the landscape: tunnels and bridges were works of art cutting through mountains or crossing rivers. In order to "convey the impression of what one sees," bridges in their eyes were not just evidence of the surrounding modernity, but they were structures that were also useful in their compositions. A single span in this Van Gogh (1), diagonal perspective lines punctuated by vertical pillars in several Monets (2, 3, 7), a horizontal line in the distance in this Guillaumin (5), or close up in this Monet (8), the architecture of bridges provided spaces for the play of light on the water, conveyed by countless vibrant touches of color.

4

5

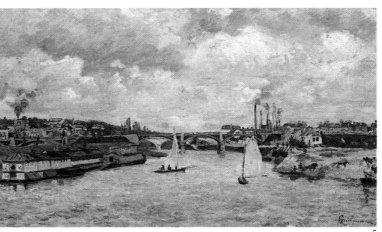

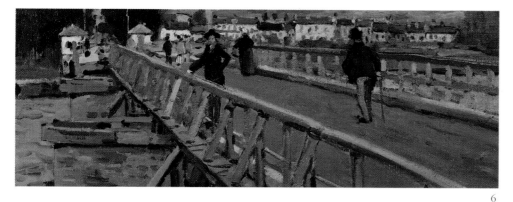

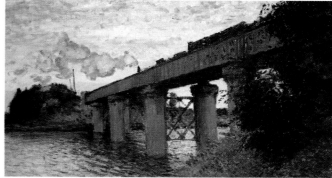

6

7

1. *Fishing in Spring* (detail), 1887. Van Gogh.
Oil on canvas. 20 x 23½ in. (50.5 x 60 cm.) Art Institute (MacCormick gift), Chicago.

2. *The Bridge at Argenteuil* (detail), 1874. Oil on canvas. 23½ x 31½ in. (60 x 79.7 cm.)
National Gallery of Art (Mr and Mrs Paul Mellon collection), Washington.

3. *The Bridge at Argenteuil* (detail), 1874.
Oil on canvas. 23¾ x 31½ in. (60.5 x 80 cm.) Musée d'Orsay, Paris. RMN.

5. *The Bridge at Charenton*, 1878. Armand Guillaumin.
24 x 39½ in. (61 x 100 cm.) Oil on canvas. Musée d'Orsay, Paris. RMN.

6. *Footbridge at Argenteuil.* (detail), 1872. Sisley.
Oil on canvas. 15¼ x 23½ in. (54 x 71 cm.) Musée du Louvre, Paris, RMN.

7. *The Railway Bridge at Argenteuil* (detail), c. 1873.
Oil on canvas. 21¼ x 28 in. (54 x 71 cm.) Musée d'Orsay, Paris. RMN..

8. *Bridge at Argenteuil*, 1874.
Oil on canvas. 23½ x 32 in. (60 x 81.3 cm.) Neue Pinakothek, Munich.

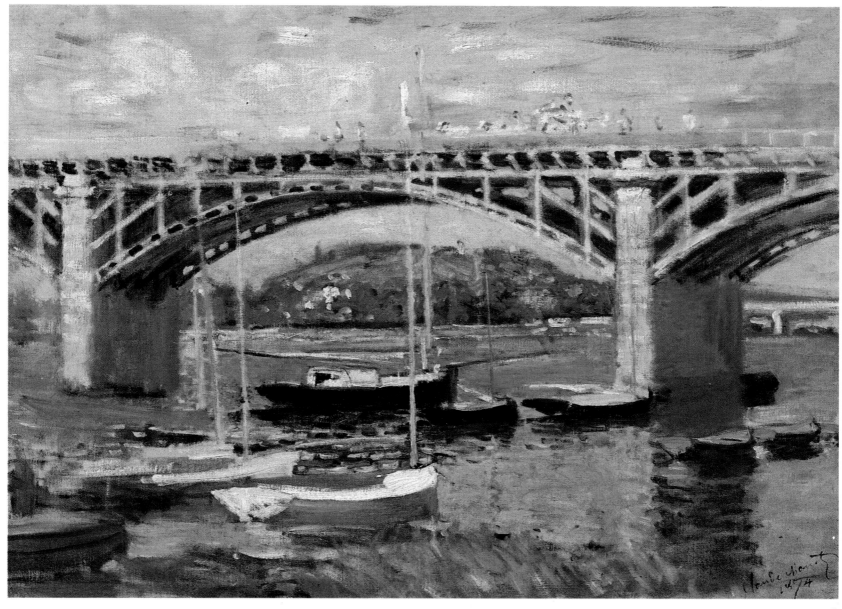

8

Painting by the Wood. Camille and little Jean were at the center of this happy circle, sitting for Manet, Renoir and Monet himself.

But the Third Republic was no more favorable to young painters than the Second Empire, and the jury of the annual Salons remained as hostile as ever. Only Manet was accepted for the 1873 Salon, while Monet did not even submit any paintings. The friends who met at the Café Guerbois, also known as the *groupe des Batignolles*, tried to form a cooperative that would organize a rival exhibition to thwart the narrow-minded jury of the official Salon. Bazille and Courbet had already envisaged a solution like this before the war. In April 1873, the critic and writer of naturalist fiction Paul Alexis, himself a regular at the Café Guerbois, wrote a number of articles on this subject for *L'Avenir National*. In these he echoed the displeasure of the painters and proposed the creation of an organization of the artists themselves, thus working towards the disappearance of the jury "that claims to delineate the local roads of talent and the railways of genius." Monet replied to Paul Alexis's article in the same publication on May 12: "Monsieur, a group of painters who have met together at my house read your article in *L'Avenir National* with great interest and pleasure. We are very happy to see you defending our ideas and we hope that, as you said, *L'Avenir National* will support us when the Society we are in the process of forming is set up properly." Pissarro, Jongkind, Sisley, Amand Gautier, and Guillaumin were all co-signatories of this letter.

In January 1874, a rich collector and fabric merchant, Ernest Hoschedé, put 24 paintings from his collection up for sale at the Hôtel Drouot, including some by Monet (*The Seine at Argenteuil*, page 61), Courbet, Diaz, Corot, Sisley, Degas and Pissarro. The reason for the sale was more to find out the value of such paintings than because of the economic recession that was beginning to affect the country. The prices asked were quite high, yet there was no shortage of buyers. Pissarro was extremely happy: "The effects of the Drouot sale are being felt as far as Pontoise. People are very surprised that one of my paintings should have fetched as much as 950 francs." This successful sale prompted Ernest Hoschedé to buy new paintings, and it also encouraged the painters in their exhibition plans. Where should the painters exhibit? "The dealers were not interested in us. So we had to exhibit, but where? Nadar, the great Nadar who has a heart of gold, lent us his shop," wrote Monet. The photographer and aeronaut Félix Tournachon, also known as Nadar, was a friend of Baudelaire, Jules Verne, Offenbach and Manet. He was

Coal Barges, c. 1875.
Oil on canvas. 21½ x 26 in. (55 x 66 cm.)
Private collection, RMN.

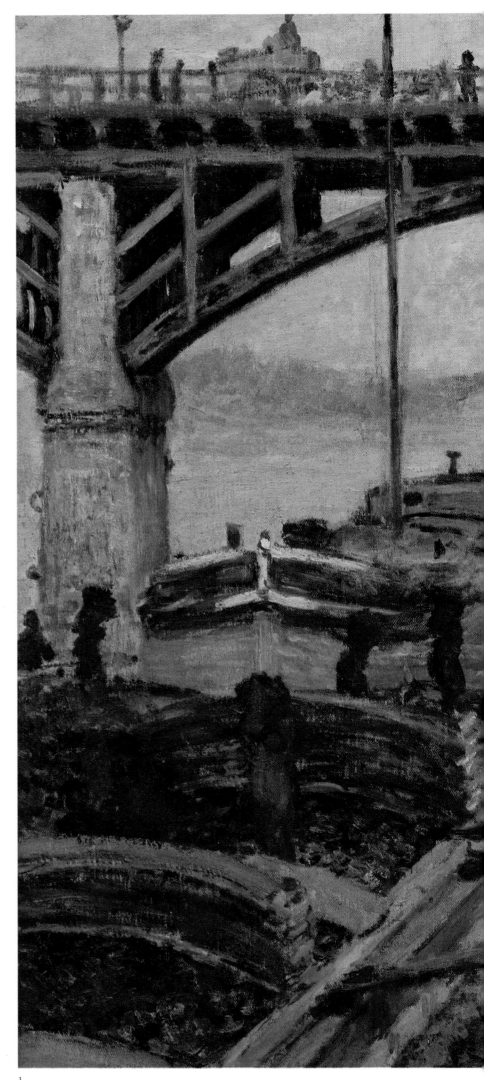

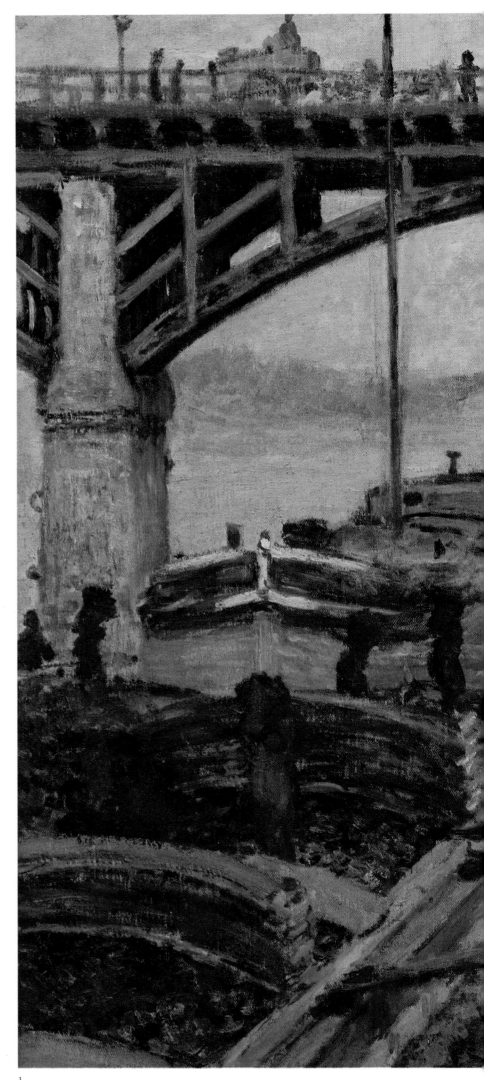

1

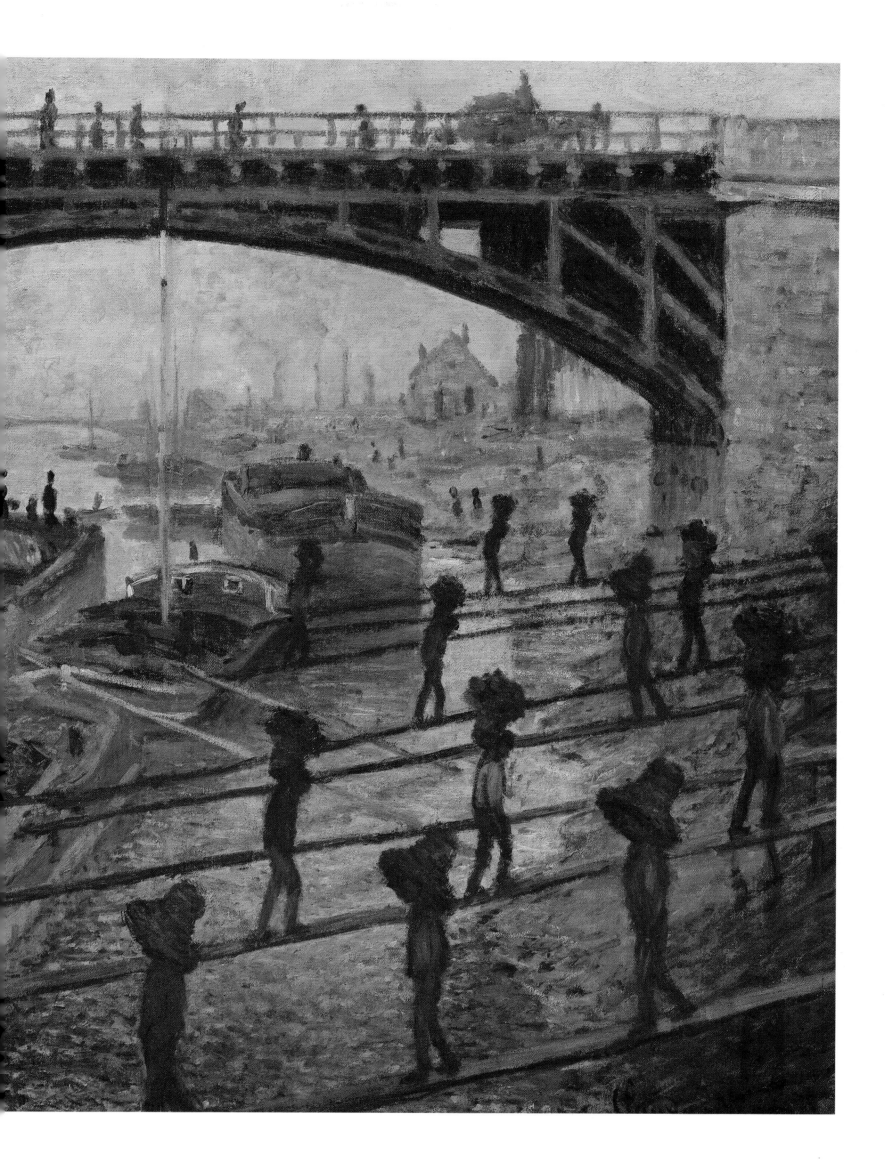

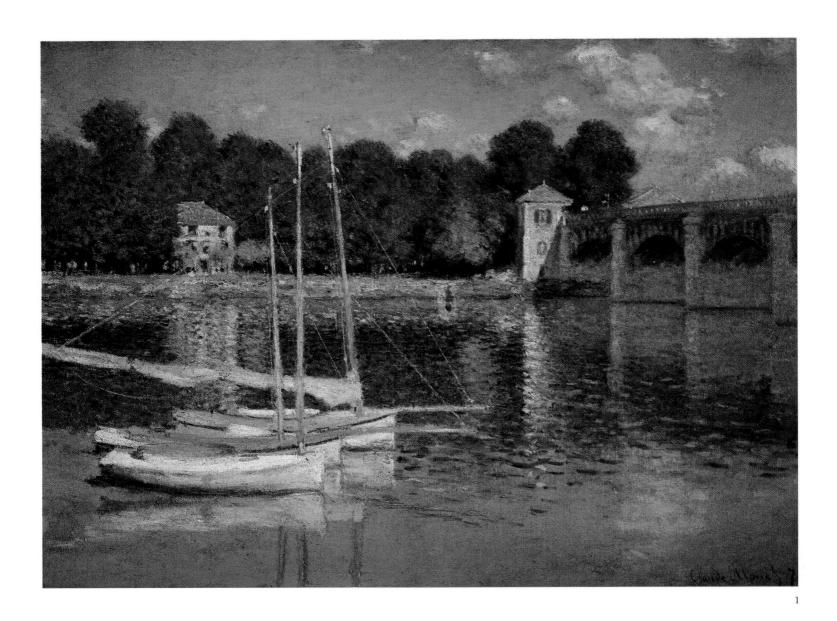

1

an unusual man. Generous and always interested in difficult causes, he lent his shop in the Boulevard des Capucines to the "Société des Peintres, Sculpteurs et Graveurs" ("Society of Painters, Sculptors and Engravers) that Monet, Degas, Pissarro and their friends had just founded, and which Degas casually suggested should be called "Capucine". The exhibition ran from April 15 till May 15, 1874, and it was seen by over 3,000 visitors. Many artists took part, but not Manet, not because he disagreed with the Society but because he was afraid of irritating the jury of the official Salon where he believed he had a chance of being accepted.

Claude Monet's contribution consisted of three pictures in pastel and five paintings: *The Boulevard des Capucines, Poppies, The Luncheon, Impression, Sunrise,* and *Fishing Boats Leaving the Harbor, Le Havre*. His friends wrote favorable reviews, but critics and gossip writers went to town. Commenting on *The Boulevard des Capucines,* Louis Leroy wrote the following imaginary dialogue in his article for *Charivari* in which an old friend "decorated and honored by several governments" said: "(…) there's certainly an impression, or I am no judge of what I see… But could you tell me what those numerous black shavings are at the bottom of the painting?" "But they are people walking," I replied. "So, is that what I look like when I walk on the Boulevard des Capucines?… Good gracious! Are you making fun of me?" Of *Impression, Sunrise*

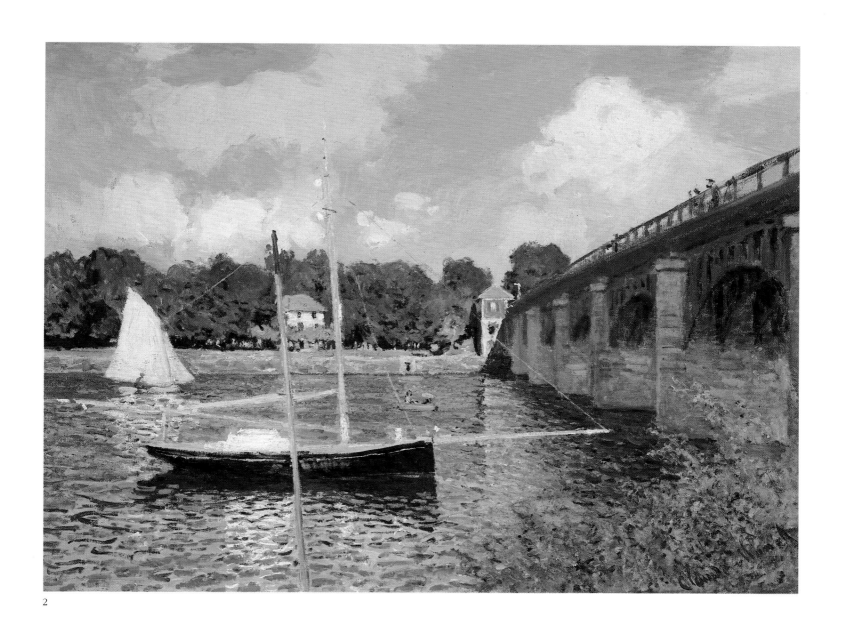

2

1. *The Bridge at Argenteuil*, 1874.
Oil on canvas. 24 x 31½ in. (60.5 x 80 cm.)
Musée d'Orsay, Paris. RMN.

2. *The Bridge at Argenteuil*, 1874.
Oil on canvas. 23½ x 31½ in. (60 x 79.7 cm.)
National Gallery of Art (Mr and Mrs Paul Mellon collection),
Washington.

1

he said: "It was Monsieur Monet's privilege to give him the fatal blow. 'Oh! There it is, there it is!' he cried in front of painting number 98. 'I recognize Papa Vincent's favorite! What does it represent? Look at the catalogue. *Impression, Sunrise.* Impression, I thought so. I thought to myself that since I was impressed there must be some impression in it… And what freedom, what ease in the brushstrokes! Even wallpaper in an embryonic state looks even more finished than this!'" Unlike the Hoschedé sale which had been a pleasant surprise, the first Impressionist exhibition was a financial disaster. Each of the participants had to pay 184 francs in order to balance the books. All they were left with was the name "Impressionists"…

Later, Louis Leroy boasted that he had been the movement's godfather by inventing the name. Ernest Hoschedé bought *Impression, Sunrise* for 800 francs, an enormous sum considering the unfavorable response to the exhibition. He sold it later to Doctor Bellio for 210 francs. The painting was finally bequeathed to the Musée Marmottan, but it was stolen in 1985. It was recovered in 1990 and restored, and it is now hanging in the museum again.

The failure of this first Impressionist exhibition added to the financial problems which Monet was experiencing again. Durand-Ruel had stopped buying. In April, the painter had not been able to pay his rent, and in October he was forced to move. During the winter, in those

2 3 4

1. *Regatta at Argenteuil* (detail), *c.* 1872.
Oil on canvas. 19 x 29½ in. (48 x 75 cm.)
Musée d'Orsay, Paris. RMN.

2. *The Bridge at Argenteuil* (detail), 1874.
Oil on canvas. 23½ x 32 in. (60 x 81.3 cm.)
Neue Pinakothek, Munich.

3. *The Bridge at Argenteuil* (detail), 1874.
Oil on canvas. 23⅜ x 31½ in. (60.5 x 80 cm.)
Musée d'Orsay, Paris. RMN.

4. *The Bridge at Argenteuil* (detail), 1874.
Oil on canvas. 23½ x 31½ in. (60 x 79.7 cm.)
National Gallery of Art (Mr & Mrs Paul Mellon collection),
Washington.

5. *The Red Boats* (detail), Argenteuil, 1875.
Oil on canvas. 23½ x 32 in. (60 x 81 cm.)
Fogg Art Museum, Cambridge.

5

difficult times, Monet started painting snowy landscapes and dark skies again: *Train in the Snow*, and *Snow at Argenteuil*. His desperate eagerness to sell paintings irritated his friends. Pissarro said of him that, like Gauguin, he was a "terrible art dealer." However, Manet did try and help him by writing to the art collector Theodore Duret: "My dear Duret, I went to see Monet yesterday. I found him very unhappy and very hard up. He asked me to find someone who would buy between ten and twenty paintings of their choice from him, to the tune of 100 francs. Would you like us to do this together, let's say 50 francs each?". The group then decided to organize an auction at the Hôtel Drouot, run by Durand-Ruel and Claude Pillet. Paintings and watercolors by Monet, Renoir, Sisley and Morisot were thus put up for sale. The preface in the catalogue was a reminder: "It should not forgotten that this group of artists, systematically excluded from the Salon, recently assembled and displayed about a hundred works in the house, formerly inhabited by Nadar on the Boulevard des Capucines. These paintings are very varied in their personal expression but they are nevertheless conceived on the basis of well-defined tenets, and there they received what their powerful colleagues deny them: discussion. This "test" was most helpful and it should take place again in spring. Meanwhile, the artists mentioned above, appeal to the public at the Hôtel Drouot." The paintings included in the sale were received with hostility by part of the public, as reported in the *Figaro*: "Some of the paintings put up for auction were so horrible that they met with strong disapproval." *L'Echo* concluded more objectively: "Even in the heyday of the great rebellion of Romanticism against the Academy, we did not hear worse curses or more enthusiastic outbursts than this afternoon in front of the paintings by Mademoiselle Morisot and Messieurs Claude Monet, A. Renoir and Sisley." Unfortunately, Monet's works did not fetch more than 200 francs.

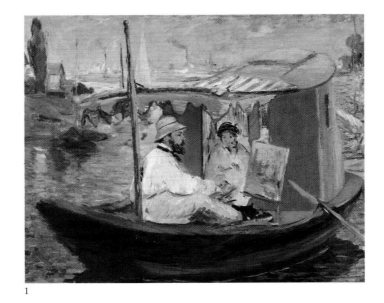

1

"A profitable sale suddenly put enough money in my pocket to enable me to buy a boat and build a wooden cabin on it where I could install myself with my easel. I spent so many happy

hours with Manet on this boat! There he painted my portrait while I painted his and that of his wife. These happy times with their illusions, their enthusiasm, and their fervor ought never to end." Caillebotte, enthusiastic about boat building , helped Monet construct this floating shed, for which the services of an engineer scarcely seem necessary. The idea probably came from Daubigny who already had such boat, *Le Botin*. Seen at water level, the hulls, sails, and poplars inverted in the water became mere reflections of liquid light.

1. *The Boat*, 1874. Manet.
Oil on canvas. 32½ x 39½ in. (82.5 x 100.5 cm.)
Neue Pinakothek, Munich.

3. *The Studio-Boat*, 1874.
Oil on canvas. 19¾ x 25¼ in. (50 x 64 cm.)
Rijksmuseum Kröller-Müller, Otterlo.

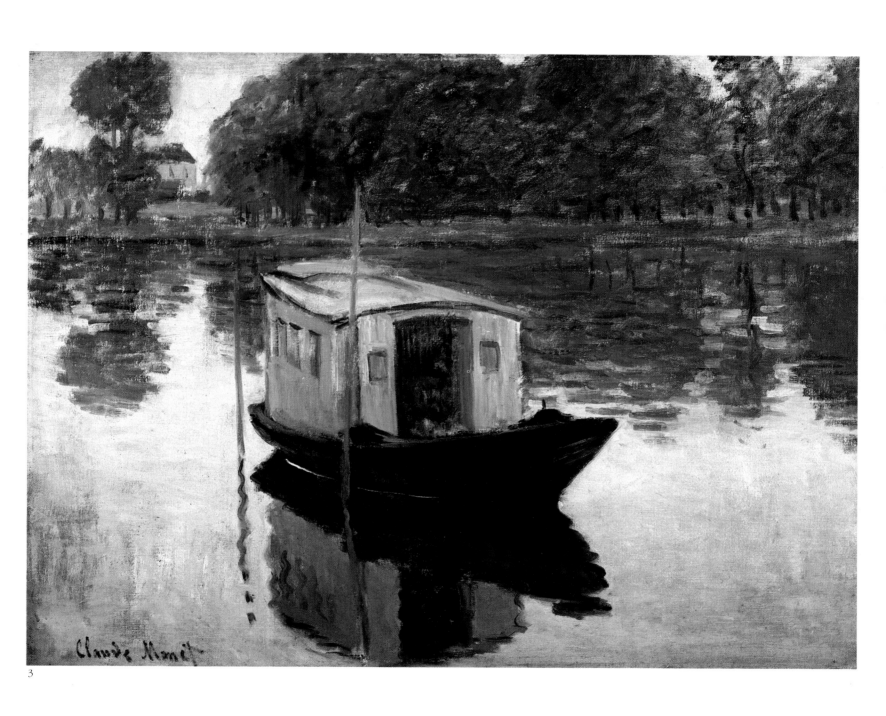

3

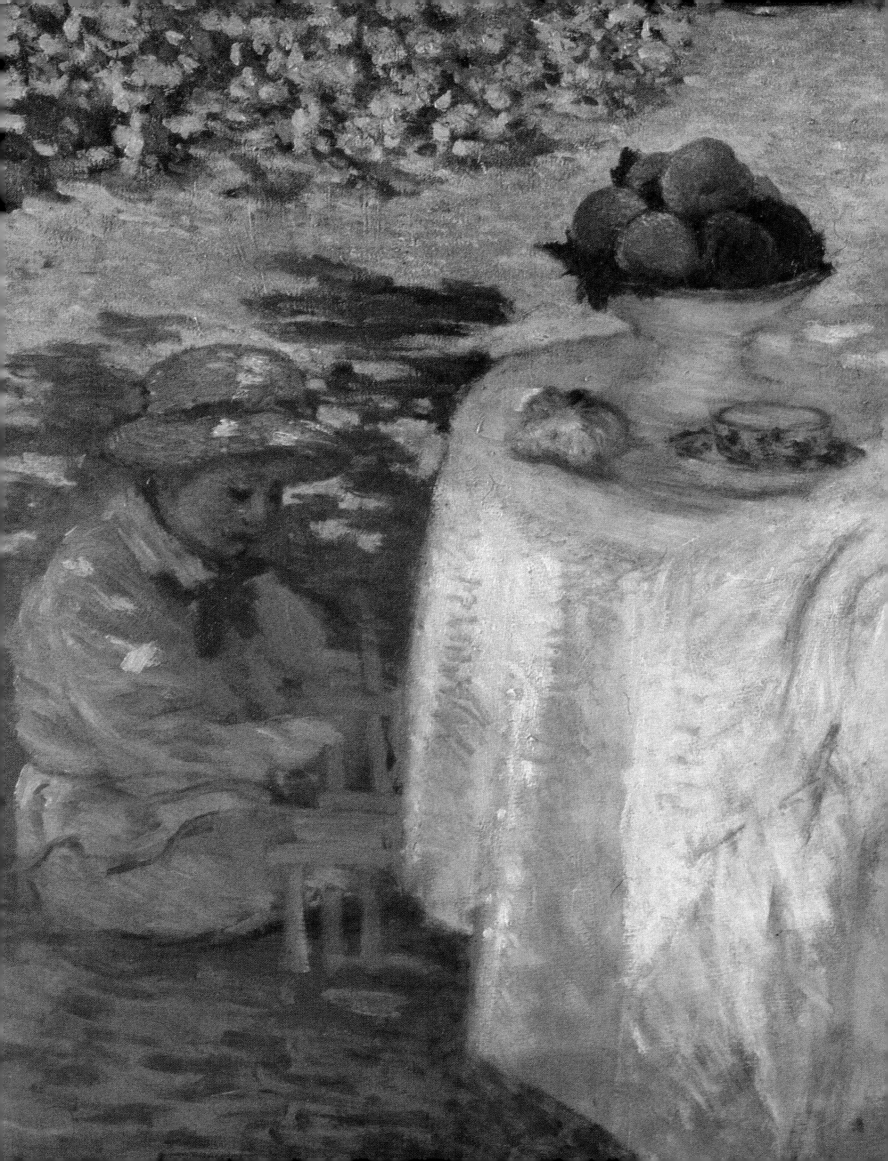

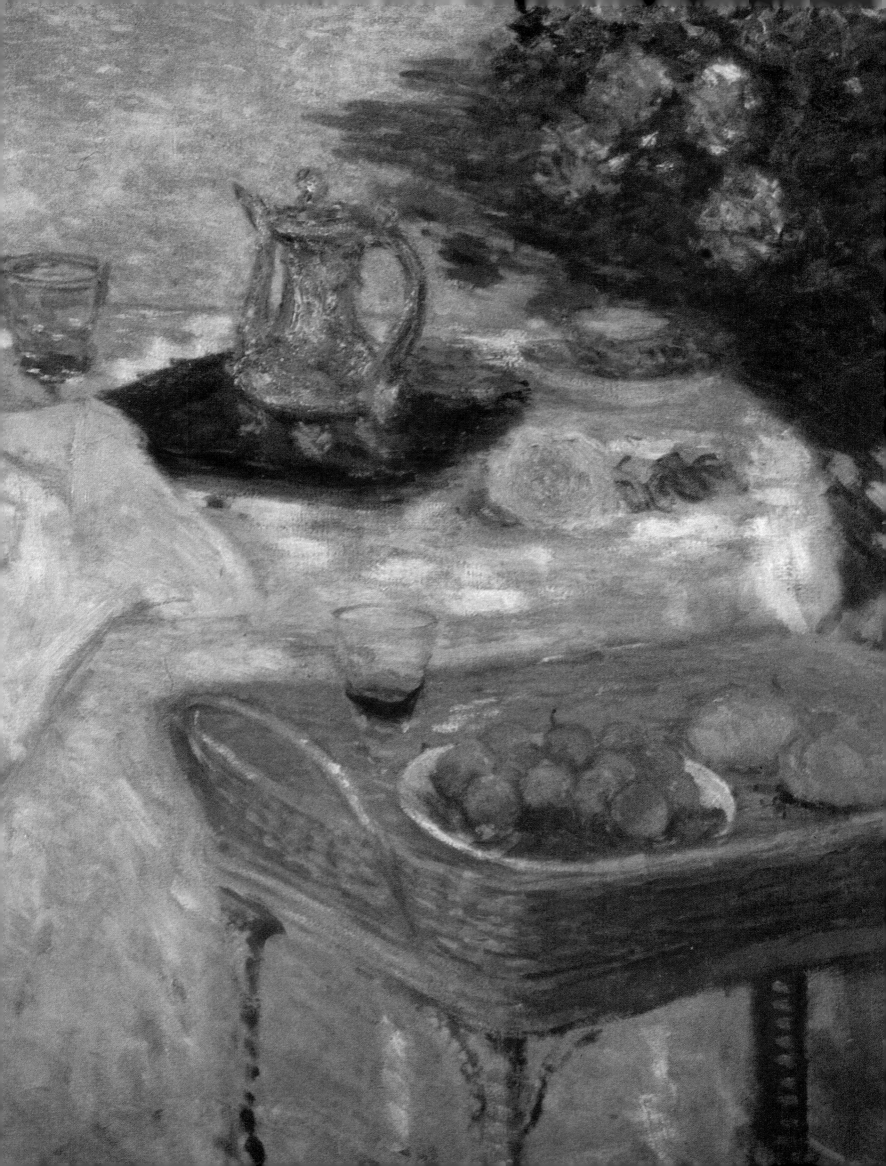

1

Camille

Until 1966, 40 years after Monet's death, Camille's tomb remained abandoned by everyone. Yet Camille's face and silhouette lit up the Argenteuil period. Sensual or dreamy, walking or mothering a child, she enchanted all the artists who joined Monet in his garden. *The Luncheon* (1) is one of the few large canvases Monet painted during that period. It is an intimate scene in which the objects isolated in splashes of light, a sunshade, a basket with grapes and a hat hanging from a branch, create a serene harmony. The white silhouette of Camille can be seen in the background against a mass of vibrant colors. Sitting with little Jean for Manet, she has spread her light-colored skirt around her while Monet is looking after his flowers surrounded by chickens (2). Renoir painted her in the same position at the same moment (7), and then again among the tall grass from which she seems to emerge (4). Monet sees her as a tiny figure among the poppies (3) and again in the garden, under the sunshade, reminiscent of Trouville (6). Finally, Sargent revived her memory in a later canvas by depicting her as a figure in a copse watching Monet painting (5).

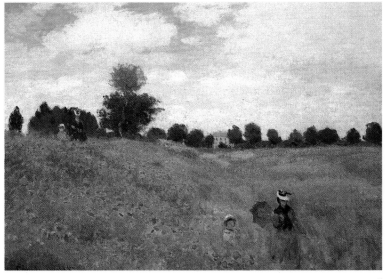

2

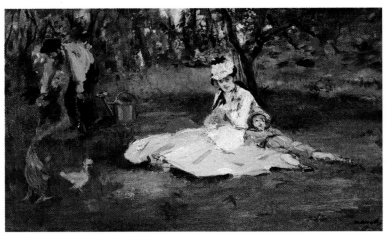

3

1. and detail on previous pages:
The Luncheon, 1873.
Oil on canvas. 73¾ x 80 in. (162 x 203 cm.)
Musée d'Orsay, Paris. RMN.

2. *The Monet Family in the Garden*, 1874. Manet.
Oil on canvas. 24 x 39¼ in. (61 x 99.7 cm.)
The Metropolitan Museum of Art (J. Whitney Payson bequest), New York.

3. *The Poppy Field at Argenteuil*, 1873.
Oil on canvas. 19¾ x 25½ in. (50 x 65 cm.)
Musée d'Orsay, Paris. RMN.

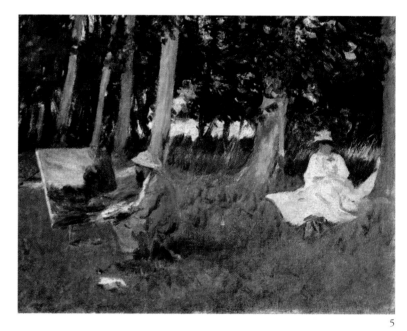

4

5

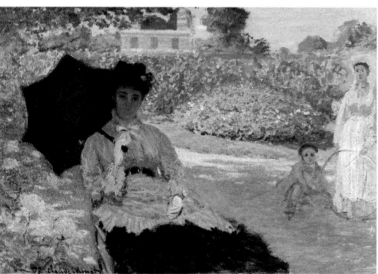

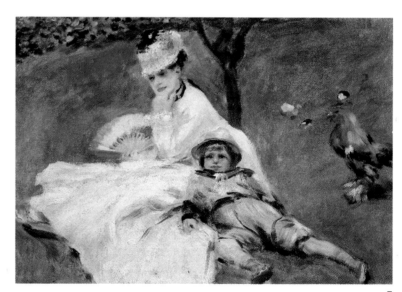

6

7

4. *Woman with Umbrella and Child, c.* 1873. Renoir.
Oil on canvas. 18 x 21½ in. (46 x 55 cm.)
Museum of Fine Arts (gift of John T. Spaulding), Boston.

5. *Monet Painting by the Wood,* 1887. Sargent.
Oil on canvas. 21¼ x 25½ in. (54 x 64.8 cm.) Tate Gallery, London.

6. *Camille Monet with her Son and Nanny in the Garden,* 1873.
Oil on canvas. 23¼ x 31 in. (59 x 79 cm.) H. Anda-Bührle
collection, Zürich.

7. *Madame Monet and her Son,* 1874.
Oil on canvas. 20 x 26¾ in. (50.4 x 68 cm.) National Gallery of Art
(A. Mellon Bruce collection), Washington.

Like *Impression, Sunrise*, *The Boulevard des Capucines* caused an uproar when it was shown at the first Impressionist exhibition held at Nadar's premises in 1874. The rapid brushstrokes depicting carriages and the figures reduced to "commas", scandalized and enraged the art critic Louis Leroy: "Could you tell me what those numerous black shavings are at the bottom of the painting?" We do not know for

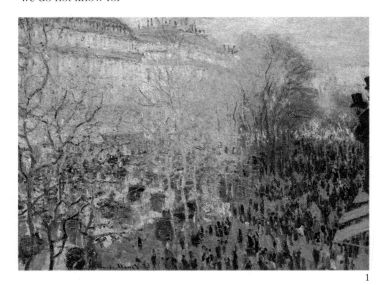

certain which of the two views of the Boulevard des Capucines was shown at the exhibition. In one of the versions there are two characters on the right looking down at the crowd from their balcony, and Monet has put the viewer in the same situation. He had already used this technique in Sainte-Adresse and Bennecourt (pp. 46–47). The impression of instantaneity, of the fleeting moment barely seized created by these views of the Boulevard des Capucines has often been compared to photography, where moving subjects are sometimes also blurred because of the long exposure time. But Monet's art is infinitely more evocative of the impression of an animated crowd on a boulevard.

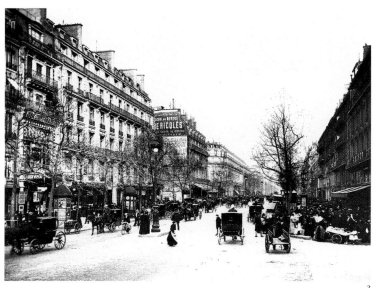

3 *Boulevard des Capucines, Paris*

1. *Carnival, Boulevard des Capucines, Paris*, 1873.
Oil on canvas. 24 x 31½ in. (61 x 80 cm.)
Pushkin Museum, Moscow.

2. *Rue de Paris, Rain*, 1877. Caillebotte.
Oil on canvas. 21¼ x 25½ in.)54 x 65 cm.)
Musée Marmottan, Paris.

4. *Boulevard des Capucines*, 1873.
Oil on canvas. 31¼ x 24 in. (79.4 x 60.6 cm.)
Nelson-Atkin Gallery (K. A. and H. F. Spencer foundation), Kansas City.

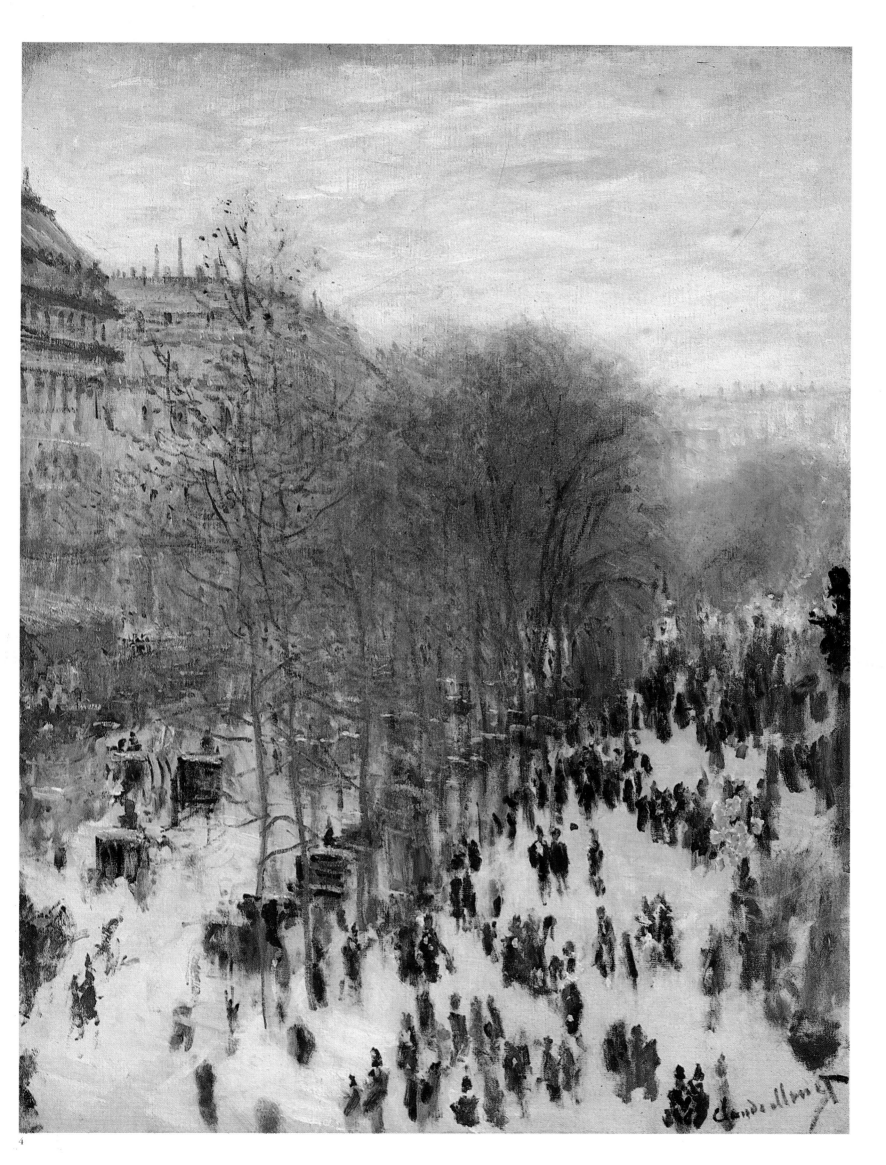

In the Rue de Rivoli there was a shop unlike any other: La Porte Chinoise ("The Chinese gateway"). Writers, poets, and artists went there if not for opium certainly to buy exotic fragrances. Baudelaire, Whistler, Zola, Manet and many others were regulars at La Porte Chinoise. This was "the place where the great movement that today influences the various arts from painting to fashion was born," wrote Edmond de Goncourt; he also boasted that he had been the promoter of enthusiasm for things Japanese in France "first with his brother then with the group of Impressionists." Monet claimed that he had first discovered Japanese engravings in Le Havre in 1856 when he only 16 years old. But it was in Zaandam that he bought his first Japanese engravings from a dealer who used them to wrap up his china. Monet, like many other artists also frequented La Porte Chinoise. The portrait of *Camille as a Japanese* shows her dressed in a scarlet kimono decorated with the head of a Samurai at thigh level, and wearing a blond wig.

La Japonaise

It caused a general outcry when it was shown at the second Impressionist exhibition in 1876. For Albert Wolff, of the Figaro, "an exhibition of what are said to be paintings has just opened at Durand-Ruel… Five or six lunatics, one of them a woman, making a group of wretched artists driven by ambition, have gathered there to show their work. Some people laugh at this. But I am sick at heart when I see it."

Nevertheless *La Japonaise* created a sensation. Zola wrote that the painting "is striking with its bright colors and strangeness." It was sold a little later for 2,020 francs, an enormous amount when one remembers that the previous year, in an auction in the same Hôtel Drouot, the Monets did not fetch more than 200 francs.

2.
Utamaro produced thousands of engravings on wood including numerous portraits of courtesans. With Hokusaï and Hiroshige, he was one of the three masters of Japanese engraving, a technique that so fascinated Impressionists with the linear simplicity of the drawing, the asymmetric arrangement of the subject, the familiar themes, and the bright colors.

3.
This *Portrait of Madame Camus in Red* heralds the preponderance of color over drawing in the work of Degas. The Japanese fan that the model is holding in her hand is a reminder of the importance of "Japanism," not only in the work of the Impressionist painters but in the fashion, decoration and everyday objects of the period.

4.
This painting is unique in Monet's work, a "whim" as he later described it. In 1876, a critic was stunned by "this craze for anything Japanese that is exploding, blazing and spinning everywhere like fireworks… The picture shows a magnificent kimono of red cloth, decorated with a large green floral pattern. From the top of this dress, a head and a hand emerge. The head, from the display window of a Paris hairdresser, is thrown back with a smile, and it appears to be making vain efforts to free itself from the inverted part of the dress. The hand holds a three-colored fan. Other fans, decorated with bizarre patterns, seem to be floating against a blue background."

1 (detail) and 4. *La Japonaise*, 1876.
Oil on canvas. 91 x 56 in. (231.6 x 142.3 cm.)
Museum of Fine Arts, Boston.

2. *Make-up after the Bath*,
7–8th year of the Kansei era. Utamaro.
Nishiki-e print. "Ôban" format. 14½ x 9 in. (37 x 22.8 cm.)
Musée Guimet, Paris. RMN.

3. *Portrait of Madame Camus in Red*, 1869–70. Degas.
Oil on canvas. 28½ x 36¼ in. (72.7 x 92.1 cm.)
National Gallery of Art (Chester Dale collection),
Washington.

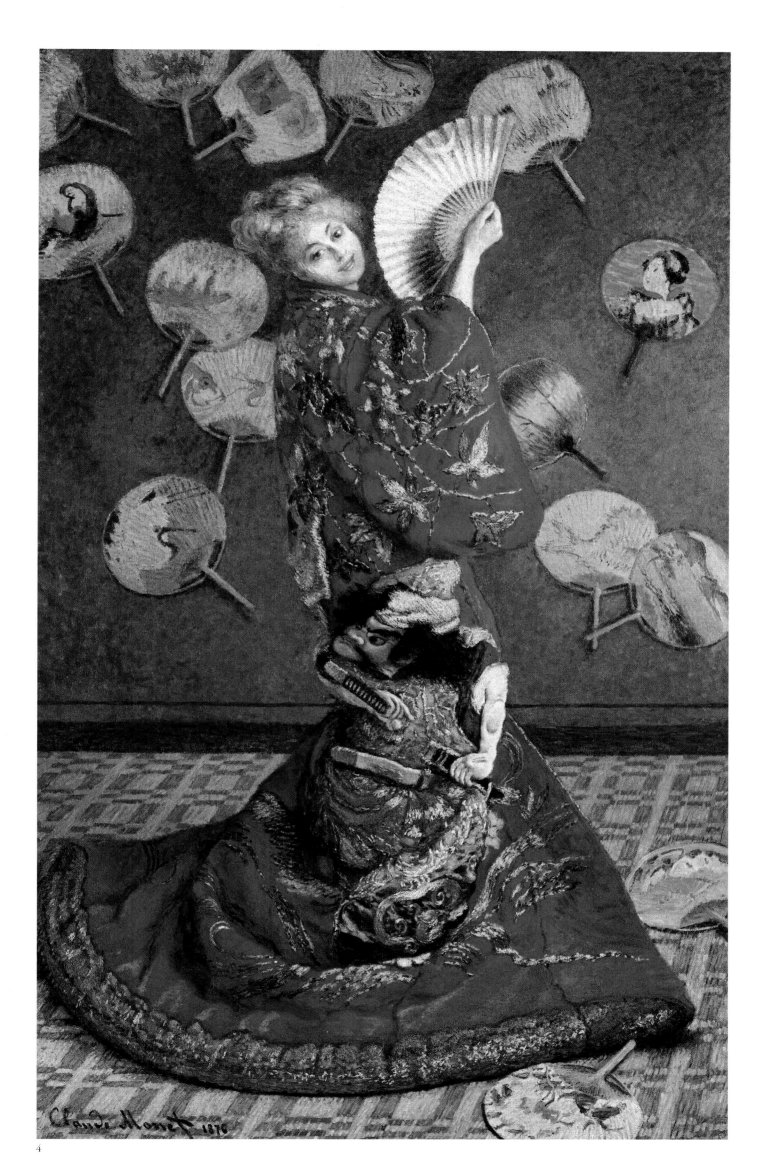

Smoke and steam

At the end of 1876, determined to follow his inspiration without listening to the critics, Monet started painting Paris in the fog, until he discovered a theme that reflected the subject of his research even better: the Gare Saint-Lazare. He had noticed that the light that he found most interesting appeared there half-an-hour after the Rouen train had left, so Monet asked the Gare Saint-Lazare stationmaster—just like that—to make a few changes to the way the station was run and… the latter agreed! To please Monet, platforms were put out of bounds, trains were delayed, and engines were stoked so that they produced as much smoke as possible. With these different representations of a same station, Monet originated the concept of the "series" that was to become so very important in his work. The "series" enabled the viewer to see any object or any phenomenon in changing light and at different times, in order to grasp its very essence. Each one revealed an instant, a different moment

1.
Caillebotte depicts three characters in close-up, caught by surprise in their pose at that instant. Like the metal geometry of the *Pont de l'Europe*, they are partly cropped out of the frame, which did not fail to irritate conventional critics.

3. and following pages:
In 1873, Manet had been on on the Pont de l'Europe where a little girl was watching the maneuvers of the trains below through a vast cloud of steam. The smoke of the locomotives enveloped this bridge overlooking the railway tracks of the Gare Saint-Lazare. It was precisely

1

2 *The Gare Saint-Lazare from the Pont de l'Europe in 1850*

in the time which was passing. The concept of the series perfected the "revealing" of reality that is the aim of much artistic activity.

The third Impressionist exhibition took place in April 1877 in Durand-Ruel's gallery like the previous one. Monet showed about 30 paintings, including *The Gare Saint-Lazare* and *The Arrival of the Normandy Train, Gare Saint-Lazare*. On April 19 Emile Zola wrote in a Marseilles paper: "Monsieur Claude Monet is the strong personality in the group. This year he showed some magnificent interiors of railway stations. We can hear the roaring of trains as they rush into the station, we can see the thick smoke hanging inside the vast hangars. This is what painting is about today, in these modern contexts of such beautiful dimensions. Today our artist must find the poetry of stations just as their fathers discovered that of forests and rivers."

In 1876, Monet made several new acquaintances including Ernest Hoschedé, a financier and art collector, and his wife Alice with whom he was to fall in love. In the autumn of that year, the Hoschedés invited the artist to spend some time at their Château de Rottenbourg in

1. *On the Pont de l'Europe*, 1876–80. Caillebotte.
Oil on canvas. 41½ x 51 in. (105.3 x 129.9 cm.)
Kimbell Art Museum, Fort Worth, Texas.

3. *The Pont de l'Europe, Gare Saint-Lazare*, 1877.
Oil on canvas. 25¼ x 32 in. (64 x 81 cm.)
Musée Marmottan, Paris.

Following pages:
The Gare Saint-Lazare, 1877.
Oil on canvas. 29¾ x 41 in. (75.5 x 104 cm.)
Musée d'Orsay, Paris. RMN.

this aerial, cottony, fleecy matter of white steam and black smoke that Monet was trying to transfer to canvas in his series of Gare Saint-Lazare paintings. On pages 84–85, the glass roof of the railway station, is like a lid over the swirls of smoke, giving an impression of confinement, while beyond the Pont de l'Europe the lights in the windows of the buildings on the Boulevard Haussmann can be seen. Before being allowed to paint inside the station itself, Monet made many sketches (page 86). In order to work on his paintings, Monet had rented an apartment near the station in the Rue de Moncey, whose rent was paid by Caillebotte.

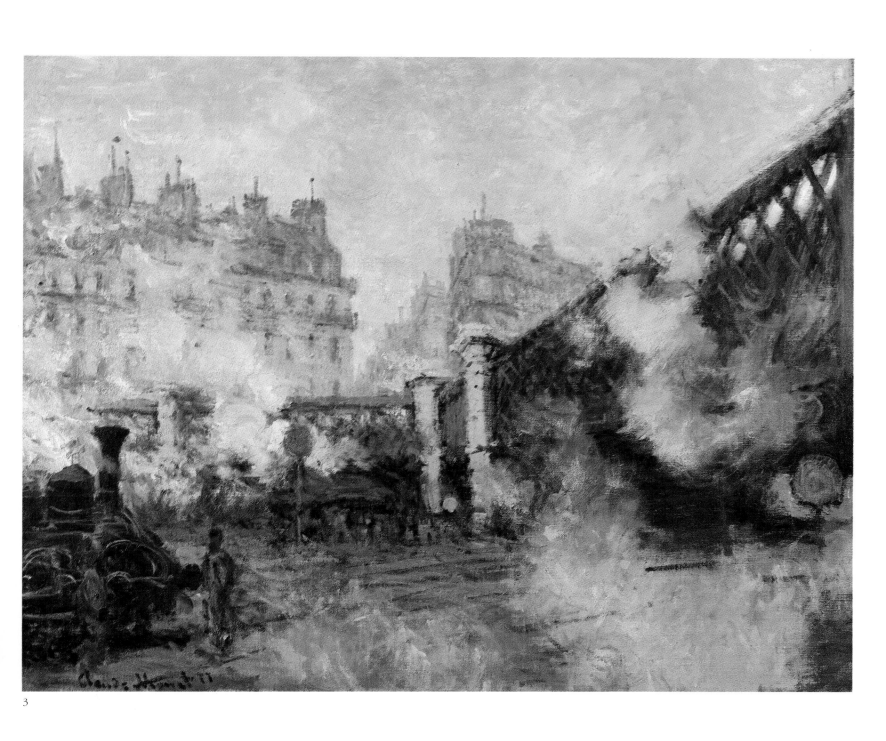

3

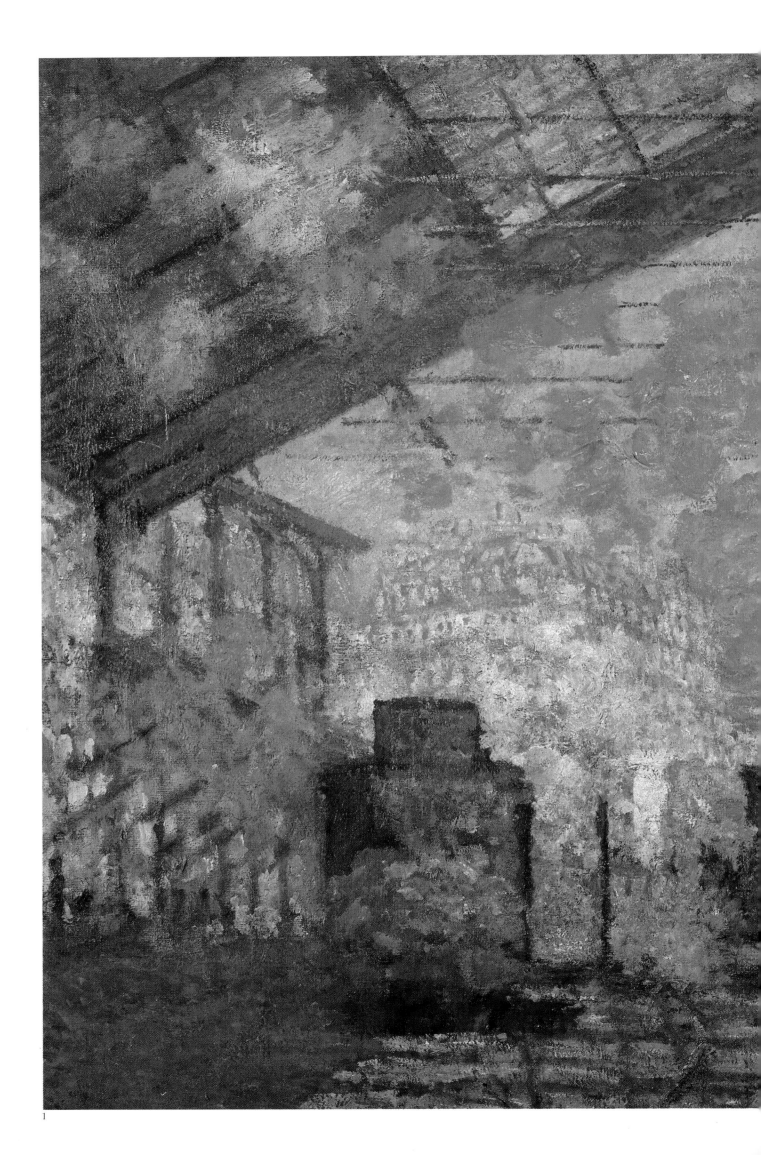

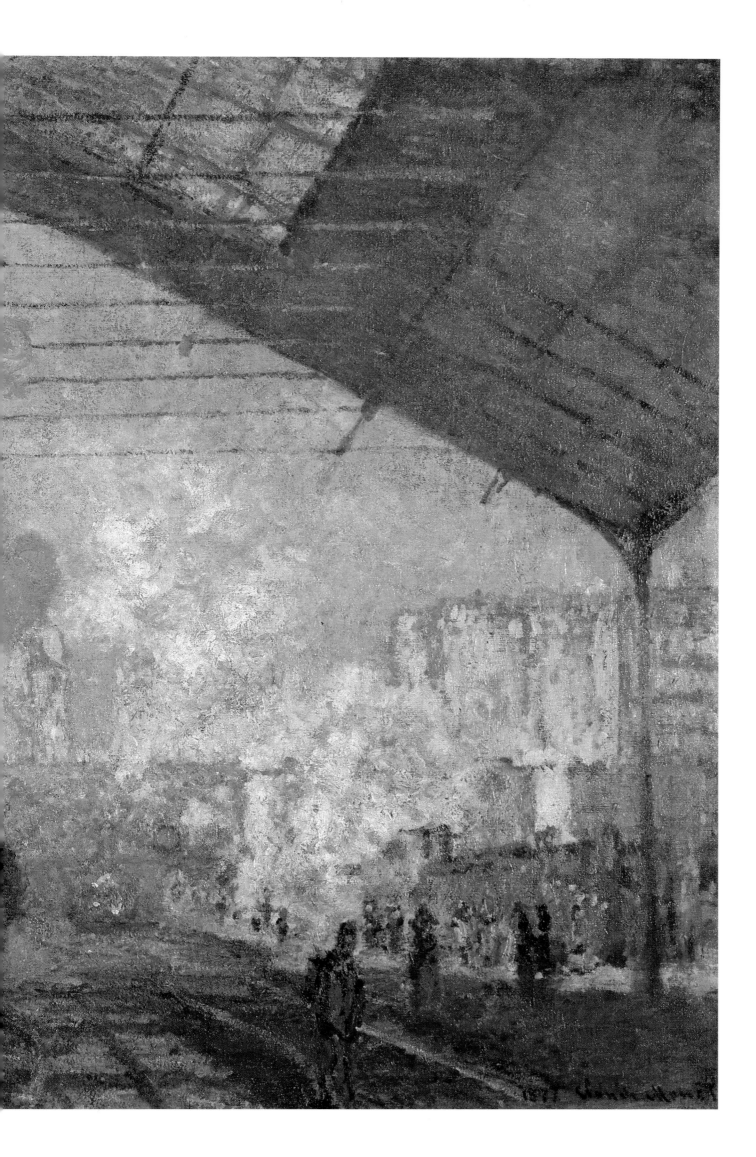

Montgeron, where they also offered him the use of a studio in the park. Later Monet also met Dr de Bellio, a great art collector and patron of the Impressionists: Renoir remembered how "every time one of them needed two hundred francs urgently, he would go the Café Riche because he was certain to meet Monsieur de Bellio there who would buy the painting brought to him without even looking at it." During 1877, Monet

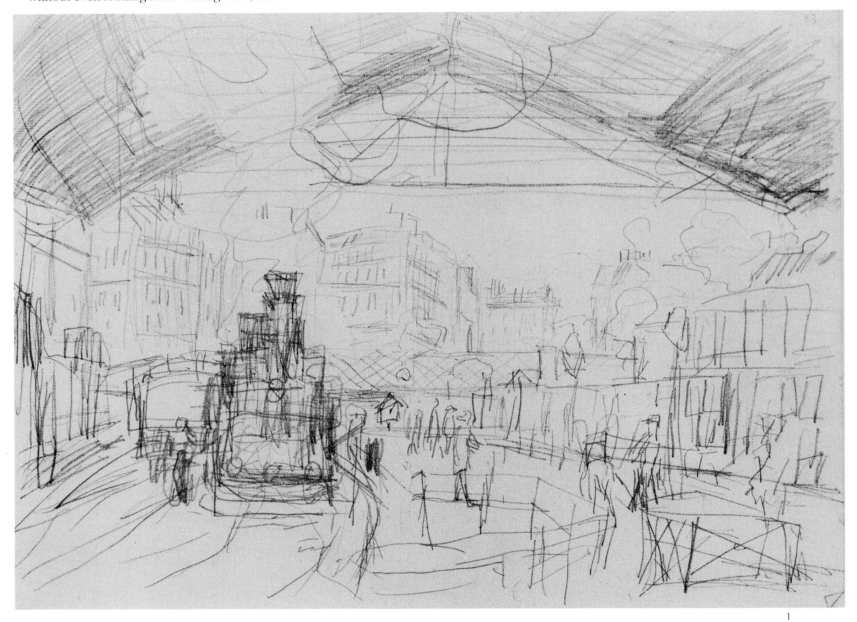

1

sold paintings for more than 15,197 francs. Yet he was still up to his neck in debts and he could no longer count on Hoschedé's help since his business was doing badly; he was declared bankrupt on the following August 25. Monet was consequently obliged to leave Argenteuil and go to Paris. At the end of 1878 he moved to the Rue d'Edimbourg, having given the large canvas of the *Déjeuner sur l'herbe* to the landlord as security.

1. *The Gare Saint-Lazare*, 1877.
Drawing. 10 x 13½ in. (25.5 x 34 cm.)
Musée Marmottan, Paris.

2. *Arrival of the Normandy Train*, 1877.
Oil on canvas. 23½ x 31½ in. (59.6 x 80.2 cm.)
Art Institute (M. A. Ryarson collection), Chicago.

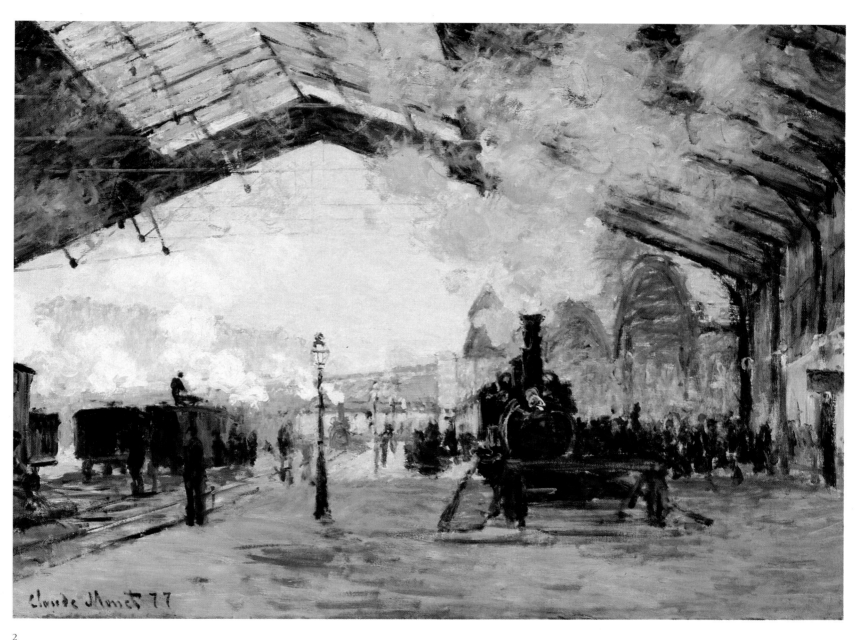

2

In May 1878, Théodore Duret, critic and independent collector, published a brochure entitled *Les Peintres Impressionists* which looked at Monet, Sisley, Pissarro, Renoir and Morisot. He showed the readers that "this new school" had quite a few admirers, among them critics (Castagnary), writers (Daudet and Zola) and art collectors (de Bellio, Charpentier, and Chocquet). Théodore Duret's study looked first at

1

the antecedents of Impressionism, which was believed to have originated in the painting of Corot, Courbet and Manet. He emphasized the significance of Japanese art, the importance of research into nuances of light and shade, and finally the use of bright colors in painting. Monet and the older members of the "groupe des Batignolles" had found a powerful ally in him, and Monet soon asked him for money.

Meanwhile, the Exposition Universelle was being prepared amidst great excitement. There were festivities, crowds and flags in the streets. Later, Monet evoked this joyous day: "I loved the flags. On June 30, the first Fête Nationale, I was walking along the Rue Montorgeuil with my painting equipment. The street decorated with flags was teeming with people. I noticed a balcony, climbed the stairs and asked for permission to paint there. They agreed…" The painting conveys an instant impression, and the excitement and the crowd in the street are perfectly rendered, almost with passion. *The Rue Montorgueil* was a success. Shown at the fourth impressionist exhibition in 1879, it was bought by Doctor de Bellio before later becoming the property of Prince Wagram.

2

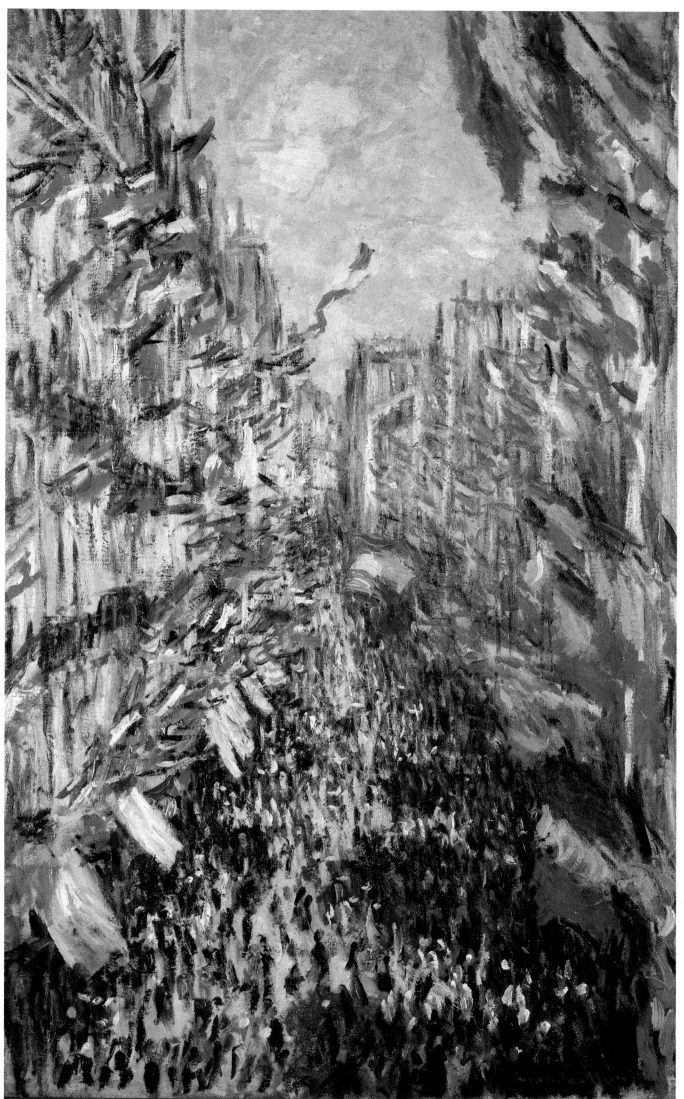

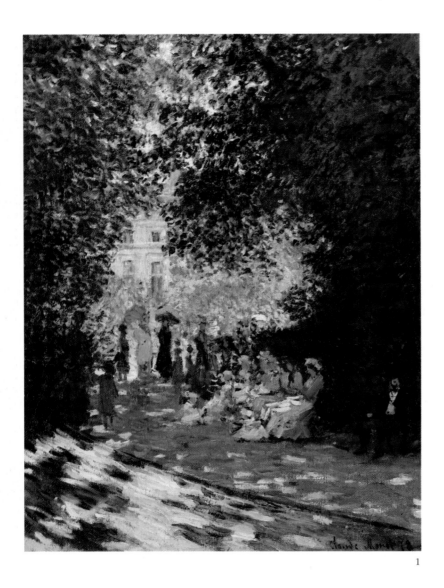

Monet was still living in Argenteuil when in 1876 he painted several views of the Tuileries. He was painting from a window of the apartment of Victor Chocquet, who was indefatigable defender of the Impressionists and an enlightened collector. Two years later, living in the rue d'Edimbourg, between the Gare Saint-Lazare and the Parc Monceau, Monet returned to the gardens after the series of the *Gare* paintings. He had never stopped loving these gardens and always would. The flowery masses splashed with light and the greenery consisting of countless brushstrokes were his last Paris canvases. Shortly thereafter, he moved to Vétheuil.

1

2

1. *Parisians in the Parc Monceau*, 1878.
Oil on canvas. 28½ x 21½ in. (72.7 x 54.3 cm.)
The Metropolitan Museum of Art
(Mr & Mrs Henry Ittleson fund), New York.

2 and 3 (detail). *The Tuileries*, 1876.
Oil on canvas. 23¼ x 30¾ in. (59 x 78 cm.)
Musée Marmottan, Paris.

The Death of Camille

After only a few months in Paris, Monet was literally suffocating. City life was definitely not for him and he was desperately missing the countryside and fresh air. His precarious financial situation was another good reason for him to leave Paris. So in 1878 he moved to the charming little village of Vétheuil that he had discovered a few years earlier when he was staying near Bonnières. There he discovered once more the pleasure of having a permanent open-air studio. "My studio? But I have never

1.

2. *Vétheuil, the main street looking towards the church* 2

1, 2, 3.
Vétheuil was a small village on the banks of the Seine, built around an 18th century church. Monet had settled there with the Hoschedé family; this was to be the most painful period of his life. The winter was particular harsh and Monet complained that he could

no longer paint because he could afford no paints, they had no food, no fuel to keep warm and cook, and no money to ease the suffering of the dying Camille. The views of Vétheuil in the snow reflect the sad harshness of this period.

3. *Vétheuil, the banks of the Seine* 3

4.

had one! This is my studio", he told a journalist pointing to the garden and, beyond, to the Seine.

Michel, Monet's second son, had been born five months earlier, and Camille was growing weaker by the day. During that period, Monet painted his wife's face over and over again as if he sensed her imminent death. In *Woman with an Umbrella*, dating from 1875, Camille was beautiful, with an ethereal, mysterious quality and already almost absent. It is possible that

1. *Church at Vétheuil*, 1879.
Oil on canvas. 25¾ x 120 in. (65.3 x 50.5 cm.)
Musée d'Orsay, Paris. RMN.

4. *Camille on her Deathbed*, 1879.
Oil on canvas. 35½ x26¾ in. (90 x 68 cm.
Musée d'Orsay, Paris. RMN.

"One day, as I stood near the bedside of the dead person who had always been and still was so dear to my heart, staring at the tragic forehead I surprised myself in the act of automatically looking for the successive shading off of colors brought onto the rigid face by death, blue, yellow, gray hues and others, what can I say? Had I come to that…"

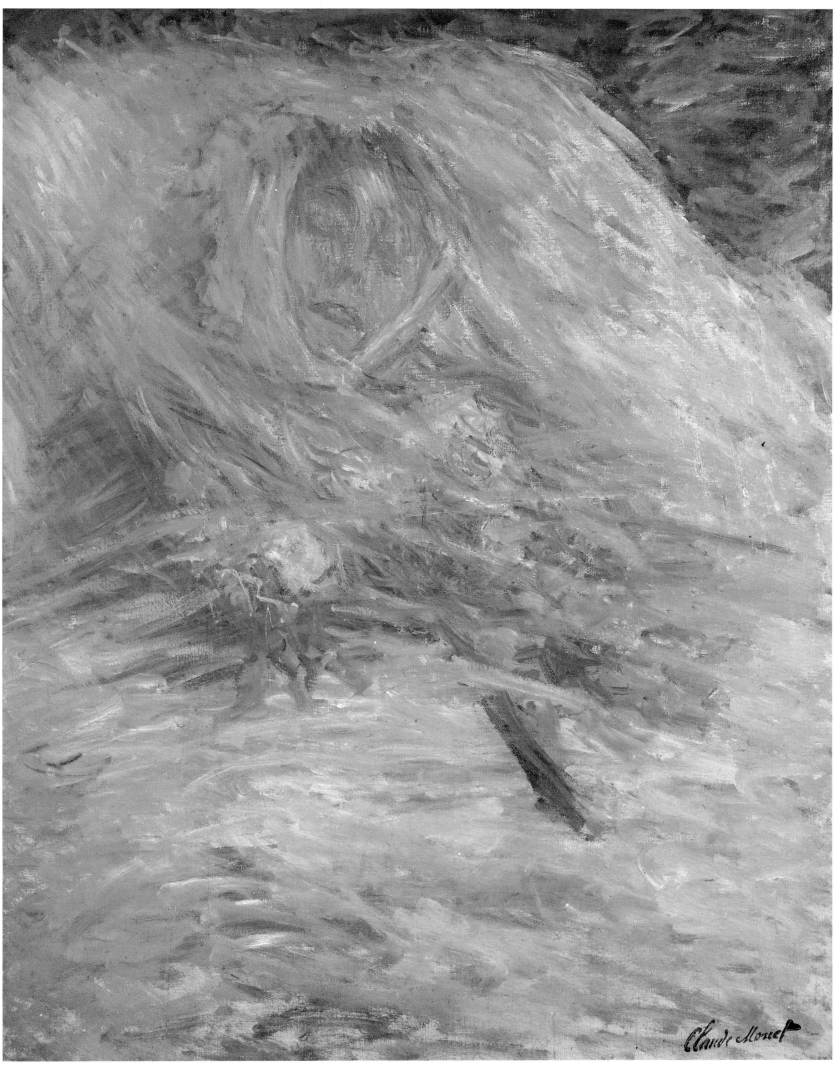

4

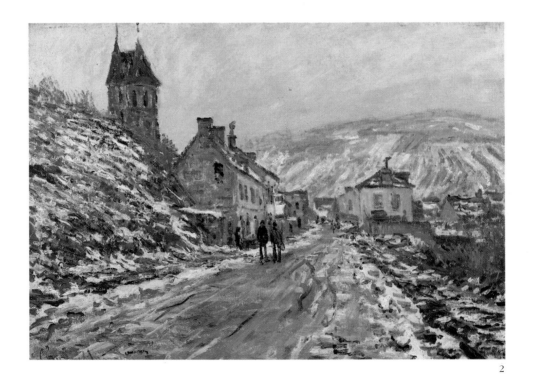

1.
Poppy Field near Vétheuil is made up of three distinct horizontal zones, each one based on a dominant color: a threatening yellow amber sky, a dark green middle ground and the bright red touches of the innumerable poppies in the foreground.

1

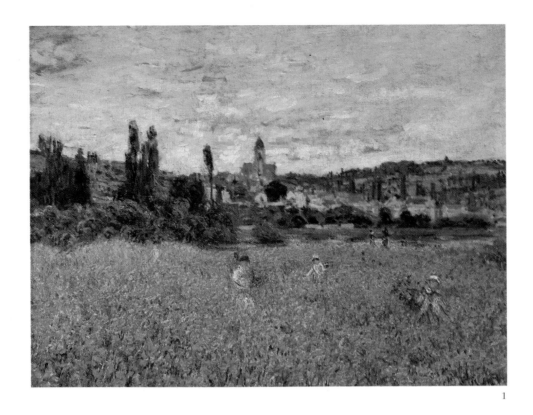

2.
The Road to Vétheuil, Winter, covered by dirty snow and emanating a deep sadness, shows the Monet's house on the left. A few months later, Camille was to die there.

2

1. *Poppy Field near Vétheuil*, c. 1880.
Oil on canvas. 27½ x 35½ in. (70 x 90 cm.)
Emile Bührle collection, Zurich.

2. *The Road to Vétheuil, Winter*, 1879.
Oil on canvas. 20½ x 28 in. (52.5 x 71.5 cm.)
Konstmuseum, Gothenburg

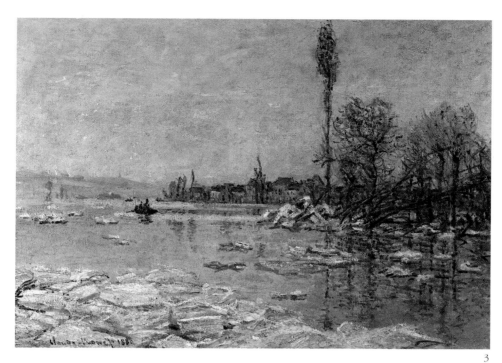

"Monet has produced some weak things as well as some excellent works, especially his winter landscapes, such as the river with ice floes. Absolutely beautiful."
(Manet)

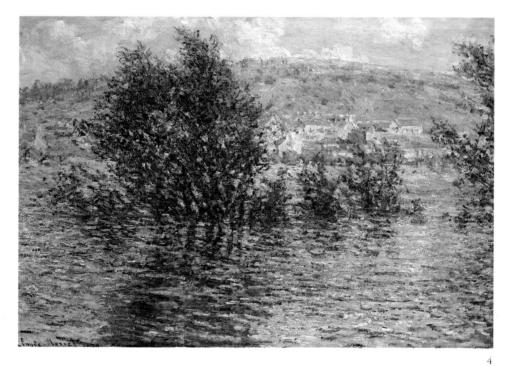

3, 4.
Monet tirelessly explored the surroundings of Vétheuil to discover the changes in nature and the seasons. That winter the Seine froze when the temperature dropped to 13° F (-25° C). The result was shown in *Breakup of the Ice* , on the night of 4–5 January. In spring Monet painted *The Effect of the Sun after Rain* with splashes of light shimmering on the river.

3. *Breakup of the Ice*, 1880.
Oil on canvas. 28¼ x 39½ in. (72 x 100 cm.)
Deposited at the Musée des Beaux-Arts, Lille. RMN.

4. *The Seine at Vétheuil, the Effect of Sun after Rain*, 1879.
Oil on canvas. 23½ x 32 cm.
Musée d'Orsay, Paris. RMN.

"this enormous effort towards light and truth" described by the art critic Castagnary in 1876 in connection with the "new Impressionist school" is most evident in this fascinating painting. The Hoschedés and their six children had moved to Vétheuil with the Monets. Their situation was not brilliant either. Completely ruined, they had lost everything, including their Paris apartment and the Montgeron property. Monet's position was not much better, except that he, who had always loved comfort and the pleasures of life, continued to eat well and employed servants whose wages he could not pay: a maid, nanny and cook who finally took him to court to get paid.

The fourth Impressionist exhibition was organized in March 1879 without Monet's help; he was by then extremely depressed. On March 10 he wrote to Doctor de Bellio: "(...) I am sick at heart and completely demoralized by the life I have been leading for so long. When you are

1

2

3

1, 2, 3, 4.
Monet's work does not include many still lives. He was not interested in the realistic representation of the fruit or flowers he loved so much. They were only a vehicle for color and, more importantly, light. *Sunflowers* is a perfect example of this: the contrasting red and green, complemented by orange and blue. Monet's *Sunflowers* strongly influenced Van Gogh (3), and foreshadowed the paintings he made in the 1880s during the last year of his life.

my age, there is not much to look forward to. We are poor and unhappy and we shall remain so. Every day brings its pains and sorrows and every day we are faced with problems we cannot solve. I have therefore given up the fight and all hope, and I no longer have the strength to work under such conditions. I have learnt that my friends have organized a new exhibition this year but I cannot take part because I have nothing worth exhibiting." But Caillebotte decided to get together and exhibit several of Monet's paintings, borrowed from collectors, friends and dealers such as Durand-Ruel

In spite of everything, Monet actually worked very hard during the autumn and winter of 1878–79. The paintings he produced during this period seem to be full of reminiscences of Daubigny and rather classical in style. But they were not understood and appreciated by the critics. Zola remarked that Monet seemed "exhausted by an excessively hasty production." Meanwhile Hoschedé was looking after Camille with great devotion. Her husband had returned

1 and 4 (detail). *Pears and Grapes*, 1880.
Oil on canvas. 32 x 25½ in. (981 x 65 cm.)
Kunstahalle, Hamburg.

2. *Sunflowers*, 1880.
Oil on canvas. 39¾ x 32 in. (101 x 81.3 cm.)
The Metropolitan Museum of Art
(Mrs H. O. Havemeyer bequest), New York.

3. *Sunflowers*, 1889. Van Gogh.
Oil on canvas. 39¾ x 30 in. (100 x 76 cm.)
Private collection, London.

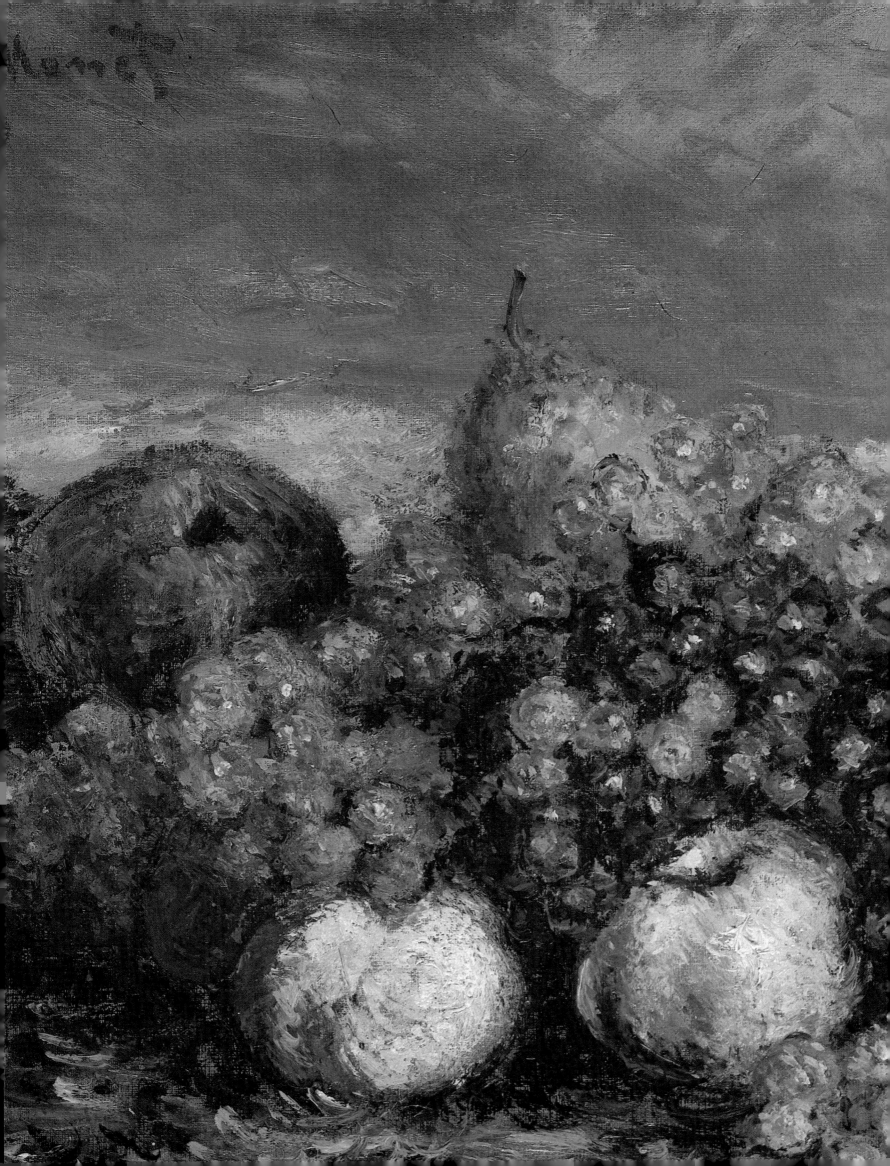

to Paris to try and put his business in order. In August Monet wrote to Doctor de Bellio: "Dear Monsieur de Bellio, I have been looking forward for things to improve for a long time but, unfortunately, I have now given up all hope. My poor wife is suffering more and more, I do not believe she can get any weaker. She no longer has the strength to stand or walk, nor can she keep any food down although she does have a good appetite. We must be at her bedside at all times to try and do what we can to allay her suffering, and the saddest thing is that we cannot always help her because of lack of money. (…)"

On September 5, 1879, Camille died in Vétheuil, exhausted after months of continuous suffering. Driven by a sudden impulse, Monet painted the face of his dead wife, producing an astonishing portrait.

In 1886, Zola described an Impressionist painter, Claude Lantier, in *L'Œuvre*, who behaved in a similar way when his young son died. Monet had found this very embarrassing.

On the advice of Théodore Duret and the art dealer Georges Petit with whom he now worked, having abandoned Durand-Ruel, Monet refused to take part in the fifth Impressionist exhibition in order to exhibit at the 1880 Salon. He was encouraged in this by Renoir's example whose *Portrait of Madame Georges Charpentier* had been very successful at the 1879 Salon. Monet submitted two paintings to the jury, a *View of Lavacourt*, not particularly original, which was accepted, and a painting showing ice floes floating on the Seine, more daring, which was rejected. But his Impressionist friends reproached him for his defection. Degas fell out with Monet and they did not speak for a long time, while Pissarro turned towards Georges Seurat and Neo-Impressionism. In June 1880, more independent than ever, Monet exhibited alone on the premises of Georges Charpentier's magazine, *La Vie Moderne*. The success of this exhibition enabled him to settle some of his debts.

1

1.
Monet's Garden at Vétheuil with its brightly colored sunflowers was sadly reminiscent of the garden of the house at Argenteuil. But Camille was dead. Little Michel Monet and Jean-Pierre Hoschedé are showing standing still for a fleeting moment in the garden, as Camille and Jean had done in the past.

2 *Pages from Monet's account book*

3.
Woman Seated beneath the Willows. Is this Alice Hoschedé, who was by now Monet's companion? In the last summer at Vétheil, after a terrible winter, Monet was still haunted by creditors. He could not pay the rent and the family had to leave Vétheuil.

1. *Monet's Garden at Vétheuil*, 1880.
Oil on canvas. 59½ x 47½ in. (151.4 x 121 cm.
National Gallery of Art
(A. Mellon Bruce collection), Washington

3. *Woman Seated beneath the Willows*, 1880.
Oil on canvas. 32 x 23½ in. (81.1. x 60 cm.)
National Gallery of Art (Chester Dale collection), Washington.

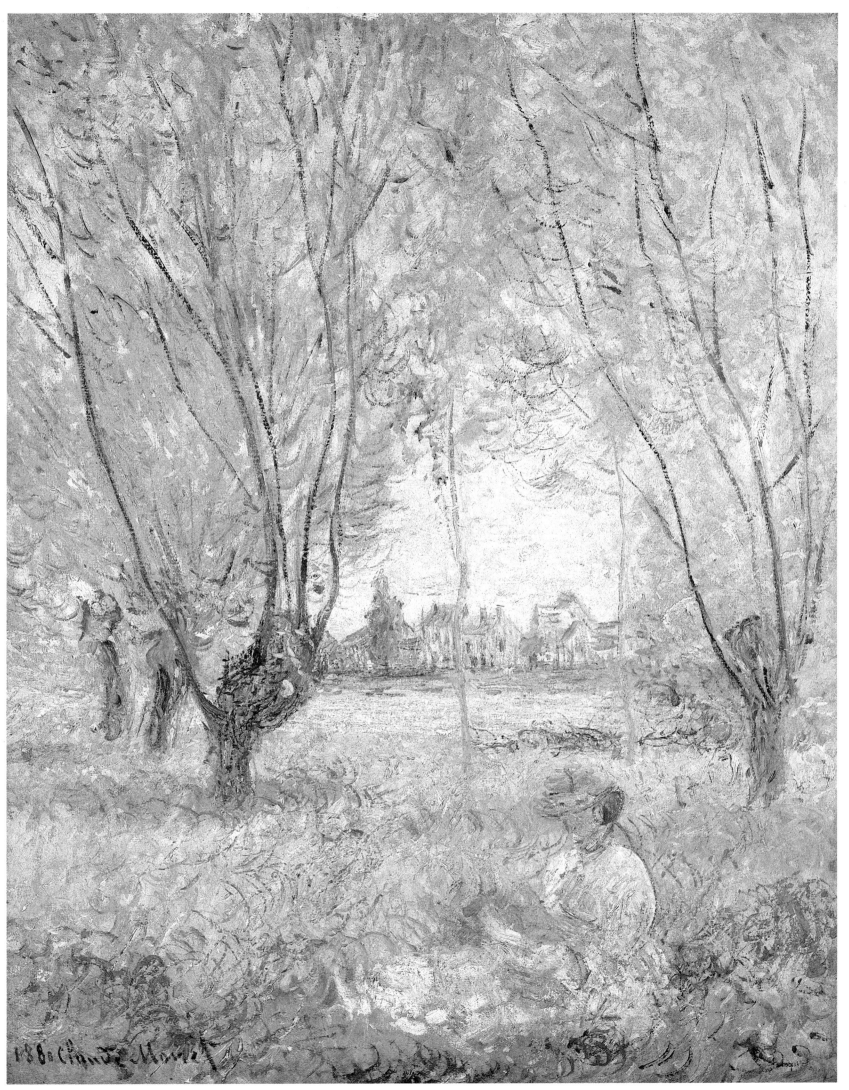

1886 Claude Monet

3

By December 1881 Monet had finally left Vétheuil and settled in Poissy with Alice and the eight children. Already in Vétheuil, His cohabitation with a married woman and their many children while Ernest Hoschedé lived alone in Paris was to say the least unusual, and it had led to some gossip in Vétheil. At least there it could be explained by Camille's illness and death. But how could it be explained in Poissy? Ernest Hoschedé tried to persuade his wife to return to Paris, but she found endless reasons to stay with the Monet family, and he was unable to put an end to what was by all accounts an embarrassing situation.

By this time Monet had resumed contact with Durand-Ruel whose business had picked up again. The dealer offered Monet a contract that guaranteed the regular purchase of paintings, giving Monet a sense of security and peace of mind that he had never known before. He had also rediscovered the pleasure of the Normandy countryside. He spent some time in Trouville and revisited Sainte-Adresse. To the artist who did not like Poissy and painted very little there, the region of Normandy offered the possibility of reviving old themes and also of rediscovering his first inspirations, returning to the precepts advocated by Courbet. He painted in Fécamp in 1881, then in Varengeville and Dieppe in 1882, the year when he met Pissarro again at the inauguration of the Société de l'Exposition Internationale in Paris at the Galerie Georges Petit. Ill-feelings and disagreements had added to the difficulties of organizing such an exhibition, but it did take place: there were 30 paintings by Monet but they were shown under a pseudonym. There were views of Vétheuil, seascapes and flowers. In a letter to his wife Manet wrote about Monet's contribution as follows: "… Monet has produced some weak things but also some excellent ones, especially winter landscapes, such as the river full of ice floes. Absolutely beautiful…"

1

1. *Custom's Cabin at Pourville*, 1882.
Oil on canvas. 23½ x 32 in. (60 x 81 cm.)
Museum of Fine Arts, Philadelphia.

2. *Walk on the Cliff, Pourville*, 1882.
Oil on canvas. 25½ x 32 in. (65 x 81 cm.)
Art Institute, Chicago.

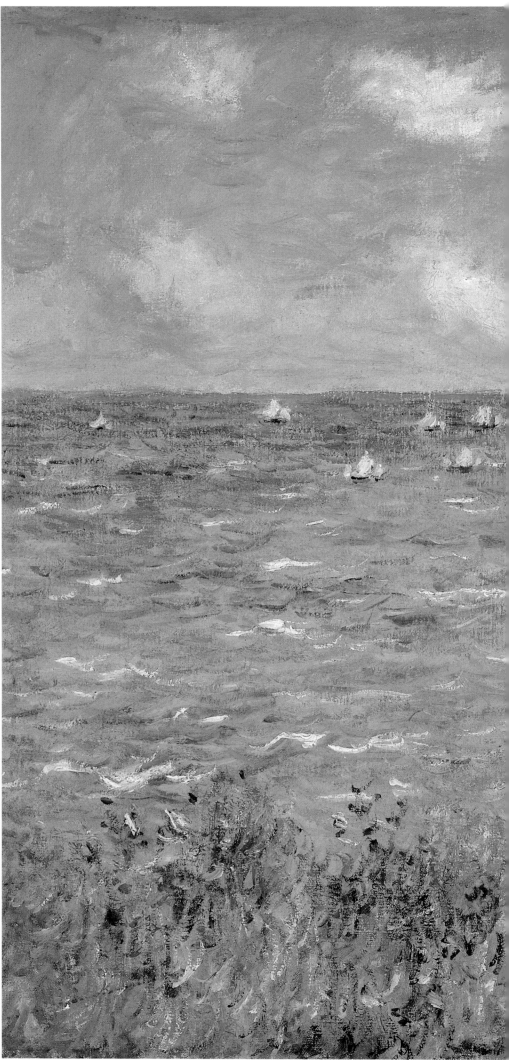

2

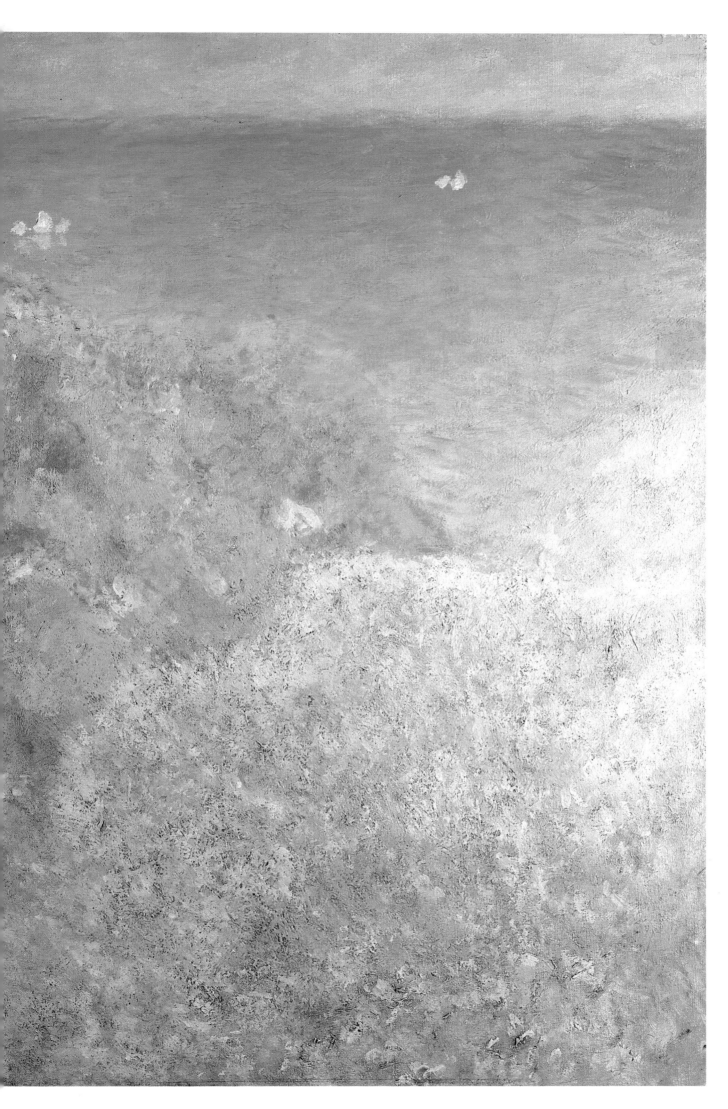

The little shacks along the coast had been built for customs officers under the reign of Napoleon I at the time of the blockade. Since then, they had been taken over by fishermen. This is why Monet's paintings depicting these sheds are indiscriminately entitled *Customs Cabin* or *Fisherman's Cabin*. Monet was working relentlessly on works for Durand-Ruel, painting subjects such as cliffs, and landscapes at Trouville, Varangeville or Dieppe with the sea as background. From Dieppe he wrote to Alice: "I have crossed the area in all directions, and walked all the roads running above and below the cliffs, I have seen beautiful views and I have been fortunate that the weather was wonderful." From Pourville he wrote: "I must bring back many paintings." But he was discouraged: "I am fearful because I have so much to do. I have spent so much time on some of the paintings that I am becoming more and more difficult: nothing is ever good enough, and nature is constantly changing at this time of the year."

"I am planning to paint a large canvas of the cliffs of Etretat, although this is rather bold on my part, especially after Courbet who did it so well, but I shall try and do it differently…"
Etretat, February 1, 1883.

A surprising and fugitive effect…

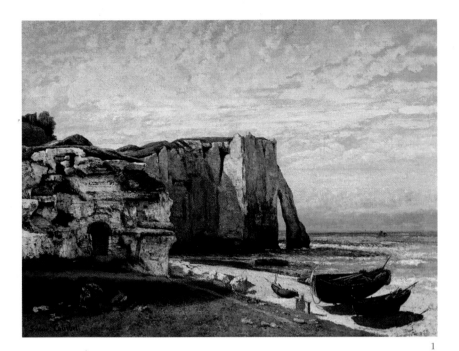

1

In 1882, having returned from Dieppe, Monet settled with Alice and the children in a small inn in the hamlet of Pourville, run by Monsieur and Madame Graff who were known as Père Paul and Mère Paul. Père Paul made excellent pastries that the many Monet-Hoschedé children loved. To thank them for their generosity to his family, Monet painted his portrait and that of his wife, and offered the paintings to them as a gift.

In February 1883, the painter spent some time in Etretat. Courbet had died six years earlier but his teaching was still alive in Monet's mind when he wrote to Alice Hoschedé: "Dear Madame (…) I have worked really well today and I am very pleased. Also, the weather is wonderful although a little cold. I am planning to paint a large canvas of the cliffs of Etretat, although this is quite bold on my part, especially after Courbet who did it so well, but I will try and do it differently (…)".

Etretat had always attracted painters: Corot, Boudin, Delacroix and Diaz all painted there. *Rough Sea, Etretat*, painted in 1883, is reminiscent of Delacroix's watercolor painted in 1852, which Monet owned at the time. Like all his paintings of Etretat, Pourville and Varengeville, this one also revealed the artist's love of monumental subjects, the elements unleashed, and the tragic face of nature.

When Monet returned to Etretat years later, he met Guy de Maupassant and dined with him several times at *La Belle Ernestine*. Maupassant understood Monet's art extremely well, and he

1, 3.
In 1883, 14 years after Courbet, Monet also tackled the cliffs of Etretat. He was aware of the boldness of such a project. But his declared aim was to use the same subject as the master of Ornans in order to "treat it differently." He modified the point of view, placed the horizon line higher, and added an impression of violence to the painting, unlike Courbet's more realistic rendering. In this respect Monet was very close to Delacroix, whom he so much admired and some of whose paintings were in his possession. *Etretat, Rough Sea* is in fact quite reminiscent of a water-color by Delacroix dating from 1852, which Monet owned.

2.
In Pourville, Père Paul, the local pâtissier, used to make cakes for Alice's and Monet's children. To thank him, Monet painted this portrait of him and gave it to him as a present, as well as its pair, *Portrait of Mère Paul*. Monet was so pleased with the *Portrait of Père Paul* that he asked Durand-Ruel to include it in the private exhibition of Monet's work that he was organizing.

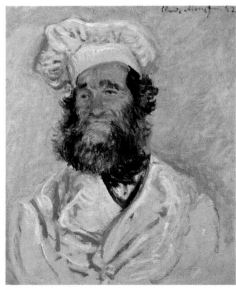

2

Previous pages:
Cliff at Varengeville, 1897.
Oil on canvas. 25½ x 36¼ in. (65 x 92 cm.)
Musée des Beaux Arts, Le Havre. RMN.

1. *The Cliff at Etretat after the Storm*, 1869. Courbet.
Oil on canvas. 52¼ x 63¾ in. (133 x 162 cm.)
Musée d'Orsay, Paris. RMN.

2. *Portrait of the Cook Père Paul*, 1882.
Oil on canvas. 25¼ x 20 in. (64 x 51 cm.)
Kunsthistorisches Museum, Vienna.

3. *Etretat, Rough Sea*, 1883.
Oil on canvas. 32 x 39¼ in. (81 x 100 cm.)
Musée des Beaux-Arts, Lyon. RMN.

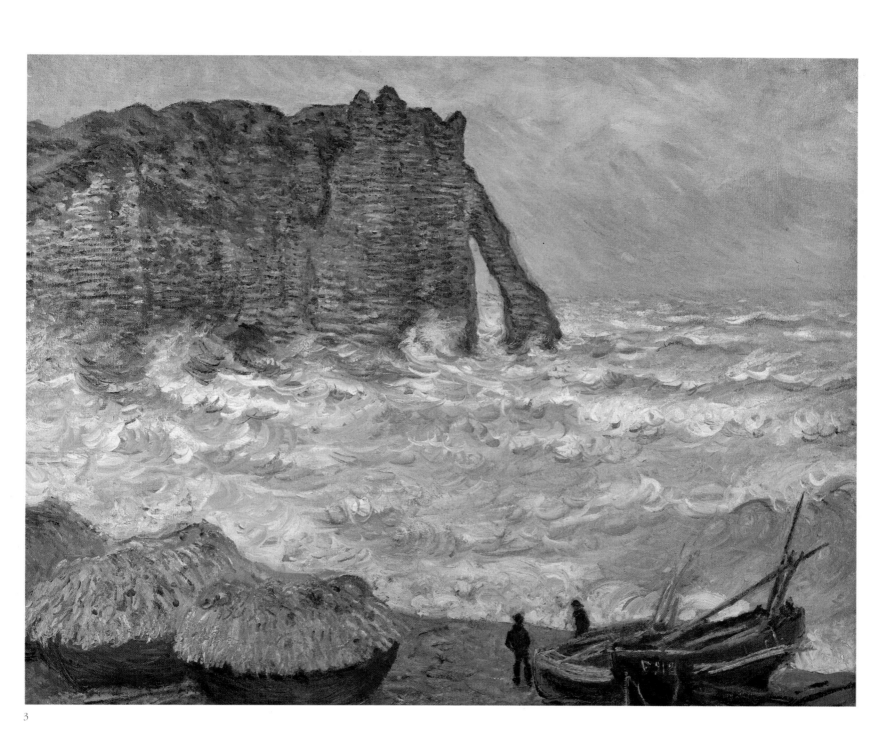

3

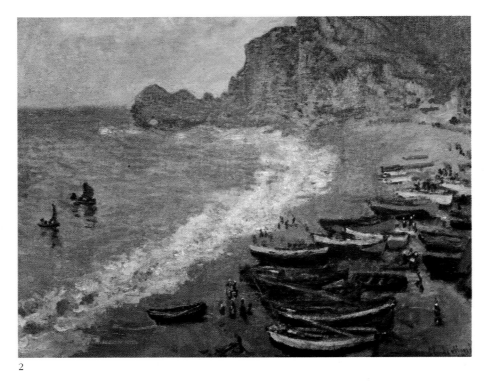

1

The rocky arch of the cliff anchors the composition of the *The Manneporte* (3) with a power reminiscent of the paintings of the bridges of Argenteuil. But Monet's approach was now different. It was no longer a matter of showing general views as he had done in *The Downstream Promontory, Etretat* (1) and *The Upstream Promontory, Etretat* (2). Rather he was using the sharp edges of the rock and the changing reflections of the water to convey the shimmering, vibrating light.

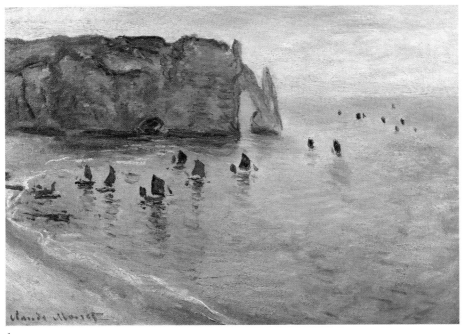

2

1. *The Downstream Promontory, Etretat*, undated.
Oil on canvas. 23½ x 32 in. (60 x 81 cm.)
Musée des Beaux-Arts, Dijon. RMN.

2. *The Beach and the Upstream Promontory, Etretat*, 1883.
Oil on canvas. 26 x 32 in. (66 x 81 cm.)
Musée d'Orsay, Paris. RMN.

3. *The Manneporte, Etretat I*, 1883.
Oil on canvas. 25¾ x 32 in. (65.4 x 81.3 cm.)
The Metropolitan Museum of Art
(W. Church Osborn bequest), New York.

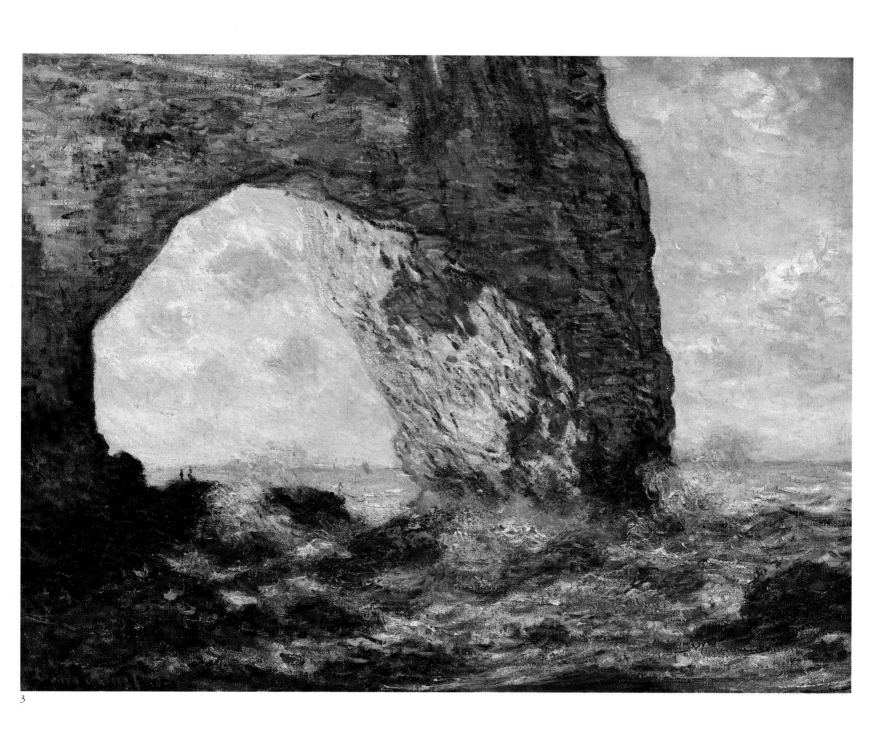

3

1

3

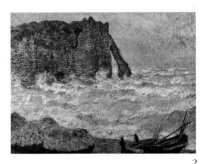

2

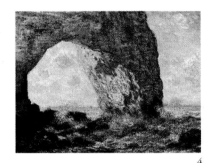

4

When the sea changes with every passing moment...

devoted an article to him in *Gil Blas* in 1886: "Last year, in this part of the country, I often followed Claude Monet in pursuit of impressions. He was no longer a painter but a hunter. He would go about followed by children carrying his canvases, five or six of them depicting the same subject at different times and with different reflections. He took them up and left them in turn, following every change in the sky. The painter waited before his subject and watched the sun and shadows, seizing the ray of the sun or the passing cloud with a few brushstrokes and, despising what is untrue and expected, he did so very quickly. Thus, I saw him seize a sparkling ray of light on the white cliff and fix it with a flurry of yellow tones that surprisingly conveyed the sudden, fleeting effect of this blinding, elusive dazzling light.

"On another occasion, he caught a sudden cloudburst on the sea with both hands and hurled it at his canvas. And it was indeed the rain that he was painting, the rain alone that was blurring the waves, the rocks and the sky, rendering them barely distinguishable from each other in the deluge."

5

7

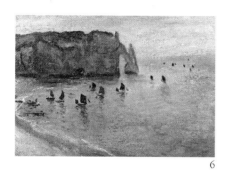

These details from the paintings of the Normandy coast reveal Monet's continuing obsession, held since 1882, that led to the series of paintings of the *Cathedrals* and the *Waterlilies*. This obsession was to catch the changing light from instant to instant as the moments passed.

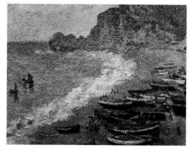

6

8

"He would go about followed by children carrying his canvases, five or six of them depicting the same subject at different hours and with different reflections..."
(Guy de Maupassant)

1 (detail) and 2. *Etretat, Rough Sea*, 1883.
Oil on canvas. 32 x 39½ in. (81 x 100 cm.)
Musée des Beaux Arts, Lyon. RMN.

3 (detail) and 4. *The Manneporte, Etretat I*, 1883.
Oil on canvas. 25¾ x 32 in. (65.4 x 81.3 cm.)
The Metropolitan Museum of Art
(W. Church Osborn bequest), New York.

5 (detail) and 6. *The Downstream Promontory, Etretat*, undated.
Oil on canvas. 23½ x 32 in. (60 x 81 cm.)
Musée des Beaux-Arts, Dijon. RMN.

7 (detail) and 8. *The Beach and the Upstream Promontory,
Etretat*, 1883. Oil on canvas. 26 x 32 in. (66 x 81 cm.)
Musée d'Orsay, Paris. RMN.

Giverny

In April 1883, Monet rented a small house in Giverny because he had fallen in love with its garden full of flowers. Shortly afterwards, he bought a small island at the junction of the Seine and the Epte where he could work in peace. Later, having become its owner, he turned his house and garden in Giverny into an enchanting place of historical importance. He had only just moved in when he learnt that Manet had died on April 30; Monet immediately went to Paris to attend his friend's funeral.

During the summer, Durand-Ruel organized an Impressionist exhibition in London: Monet had contributed several paintings whose prices ranged from £100 to £160. The exhibition's lack of success prompted the artist to ask Pissarro some questions about Durand-Ruel's situation because he was concerned about it. But this did not prevent Monet from working on the decoration of the Durand-Ruel's apartment in the Rue de Rome in Paris. Pissarro wrote back that "business is bad both in London and in Paris … Like you I only know what I can see around me since the crash".

The crash of the Union Générale bank the previous year had had dramatic consequences for Durand-Ruel, who had built up his stock

1

of Impressionist paintings with the help of advances from its director, the banker Feder.

Meanwhile, Monet and his extended family were gradually becoming organized in Giverny: people spoke of the Monet-Hoschedé family. But the artist was finding it increasingly difficult to paint, being less and less satisfied with the results. In December 1883 he decided to travel to the South of France with Renoir, then to Bordighera in Italy, ending his journey with a visit to Cézanne at Estaque in Provence. He returned

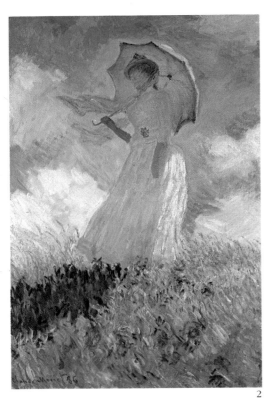

2

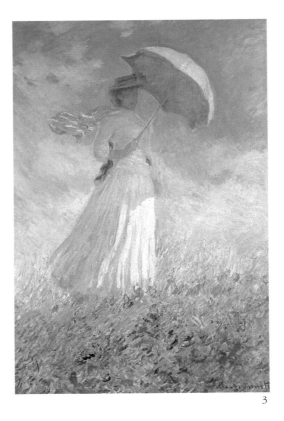

3

2, 3.
Monet had not been pleased to see the birth of a romance betweene Blanche and the young American painter Breck, who was one of the founders of the little American colony at Giverny. He was not averse to the destruction of this idyll. When Suzanne fell in love with another painter, Theodore Earl-Butler, he resigned himself to their marriage. At that time Suzanne was his favorite model. In these two Studies she is harmoniously arranged against the wind-blown sky. The pictures are reminiscent of the Camille of the *Woman with an Umbrella* that Monet had painted in 1875, and the face which cannot be seen clearly seems to have been rubbed out by the recollection of Camille.

1. *The Church at Jeufosse*, undated. Blanche Hoschedé.
Oil on canvas. 19¼ x 23¼ in. (49 x 59 cm.)
Private collection.

2. *Woman with Umbrella, Turned to the Left*, 1886.
Oil on canvas. 51½ x 34½. Musée d'Orsay, Paris. RMN.

3. *Woman with Umbrella, Turned to the Right*, 1886.
Oil on canvas. 51½ x 34½. Musée d'Orsay, Paris. RMN.

4. *Suzanne Reading and Blanche Painting*, c. 1887.
Oil on canvas. 38 x 51 in. (97 x 130 cm.) Private collection.

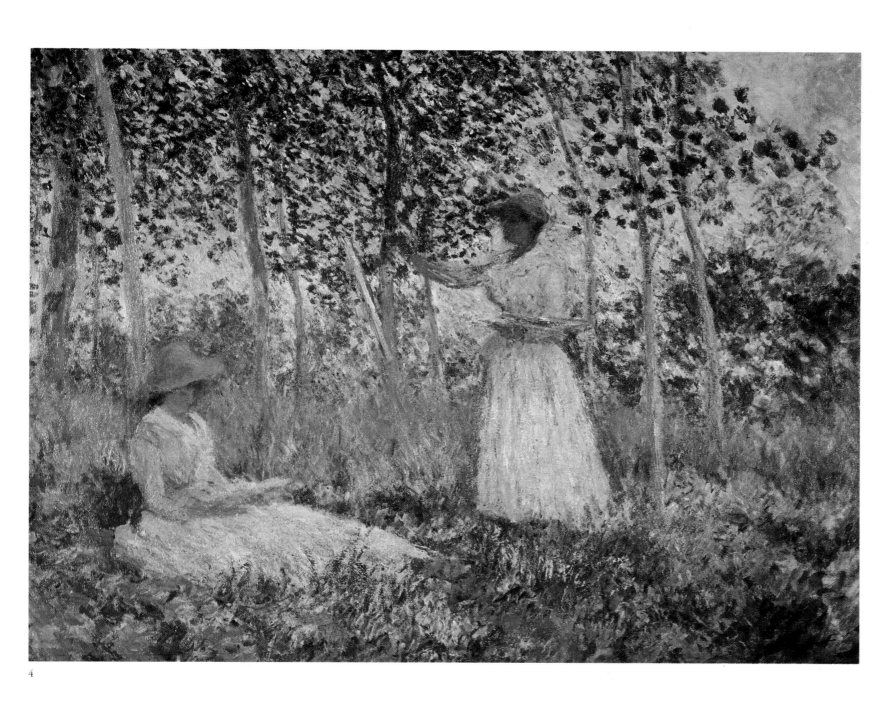

4

1, 4.
When Monet and Alice Hoschedé settled in Giverny with their eight children, Blanche Hoschedé was eighteen years old. Of all the children she was the most devoted and the most helpful to the painter who was to become her step-father. She developed painting skills that her father encouraged with great kindness, and it was perhaps about the church of Jeufosse that Monet asked, in a letter to Alice: "Does Blanche still work outside, has she managed to sort out her famous church?" In Giverny, she sat for him, painting at her easel, while her younger sister, the pretty Suzanne, read next to her, sitting at the foot of a tree. The dilution of figures as Impressionist touches in the landscape, so typical of Monet, is palpable in this painting. Blanche's face seems part of the foliage, and Suzanne merges into the flowery foreground.

1 *Boats on the Epte, about 1883*

Figures disappeared early from Monet's work. But in the first period at Gierny, they made an appearance, sometimes still in what Berthe Morisot called "watercolor clothes". Here, on the peaceful, shady Epte, Germaine and Blanche (or Suzanne) in a boat or a skiff, seem to be fishing for their own reflection in the watery depths. United with nature, the leaves are at the same time surrounding them and in the water itself.

to Paris for the Manet retrospective, this time alone: "(…) As much as I enjoyed travelling as a tourist with Renoir, I would find it very difficult to do so when working. I have always worked better on my own with my own impressions. (…) If Renoir knew I was about to travel he would probably want to come with me and it would be disastrous for both of us," he wrote to Durand-Ruel.

Back from Italy in April 1884, Monet spent the rest of the year in Giverny, except for a short period in Etretat during August. In November he met Octave Mirabeau, a naturalist writer and friend of Zola, Gustave Geffroy, and the Goncourt brothers, and also of symbolists like Verlaine and Mallarmé. Like Monet, Mirabeau loved gardening, which became an important subject of discussion and correspondence. The Impressionist group organized its eighth and last exhibition in 1886, but Monet did not take part in spite of Pissarro's insistence. His contact with his friends was now limited to "good cossacks' dinners," or "monthly suburban dinners," presided over by the Goncourts , or "Impressionist dinners" at the Café Riche. He had begun to travel again, to Brittany, Normandy, London, and Antibes.

2

3. *The Boat at Giverny,* 1887.
Oil on canvas. 38½ x 51½ in. (98 x 131 cm.)
Musée d'Orsay, Paris. RMN.

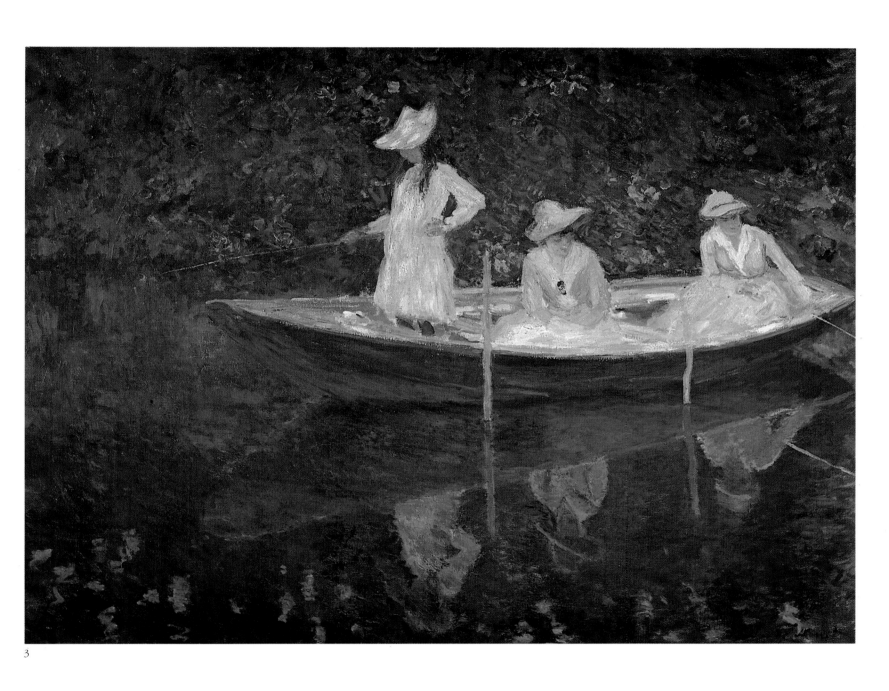

3

"I have undertaken to do things that are impossible: water with grass undulating at the bottom… It is a beautiful sight but it drives you mad trying to render it. Well, I am always trying to do things like that."

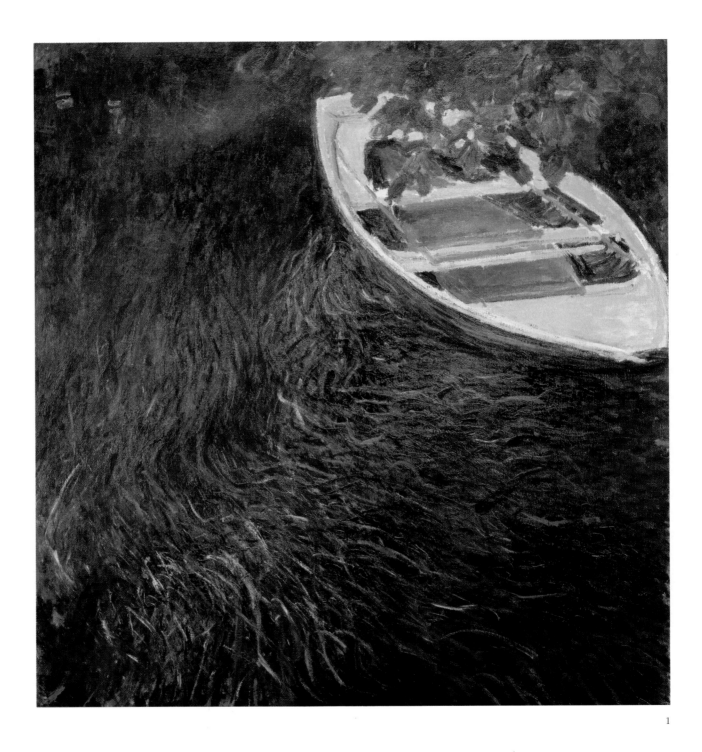

1

In Giverny Monet expanded and embellished his garden, painting the surrounding sites. He looked on the Hoschedé children as his own, and the freshness and youthfulness of Alice's daughters inspired him. He painted them sitting in a boat in several paintings, full of "impressionist poetry": the shimmering reflections in the water, the movements of the undulating grass on the bottom of the river, everything interested him. Gustave Geffroy who noticed this wrote:

"He also included figures boating on the narrow, fast-flowing Epte river, among the reeds, in the light shadow of the green vault of overhanging foliage. A small boat carrying two young girls dressed in pink, one at the rudder, the other rowing. A harmony of dark green and bright pink, the portrait of young girls in the bloom of youth, delicious, fleeting apparitions, a poetic vision that Monet expressed in an unexpected image of radiating beauty."

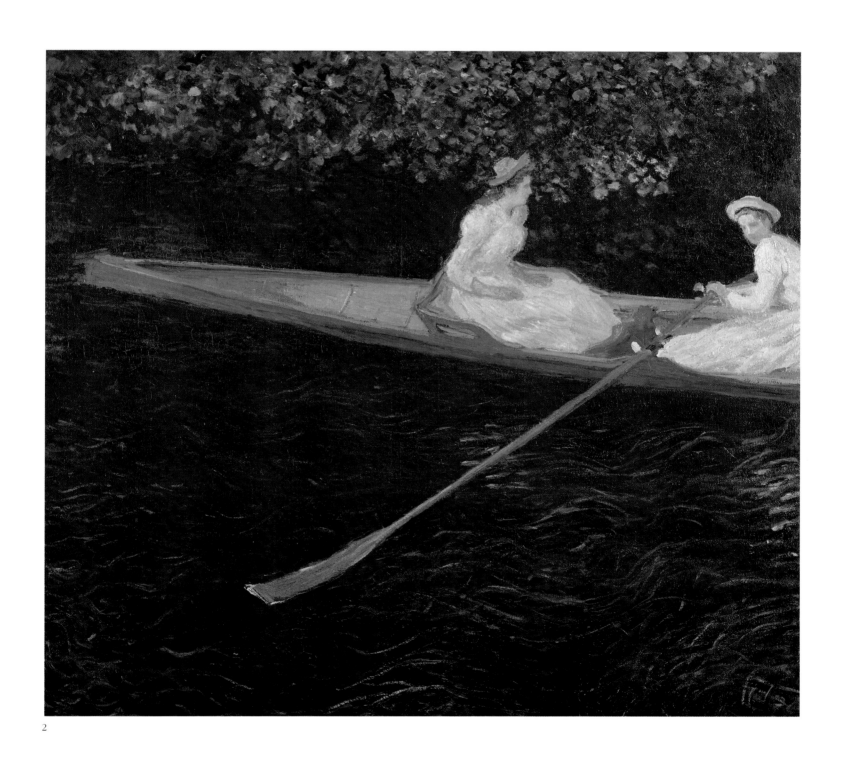

2

1. *The Skiff*, 1887.
Oil on canvas. 23¼ x 52½ in. (59 x 133 cm.)
Musée Marmottan, Paris.

2. *Boat on the Epte*, 1890.
Oil on canvas. 52½ x 57 in. (133 x 145 cm.)
Museu de Arte, São Paulo.

"The exhibition that has just opened in Monsieur Georges Petit's gallery, Rue de Sèze, was a colossal, overwhelming success for the wonderful artists who took part in it: Claude Monet and Auguste Rodin" reported *L'Echo de Paris* on June 25, 1889. The press in Paris and in the provinces was unanimous, while the public jostled in Georges Petit's luxurious gallery at 8 Rue de Sèze to admire the double retrospective of the two artists who dominated their period. The project had been conceived the year before and it was originally intended to include Monet, Rodin, Renoir and Whistler. But the idea of a foursome was later abandoned, thus enabling Monet to exhibit a large number of paintings: 145 paintings, representing 25 years of work, compared to

GALERIE GEORGES PETIT
8, rue de Sèze, 8

CLAUDE MONET

A. RODIN

PARIS
—
1889

1.

"I shall only be able to exhibit a few things, almost nothing; my name will be with Monet's, that's all." (Rodin)

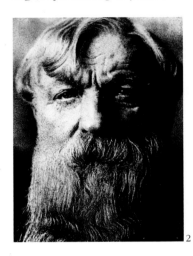

2.

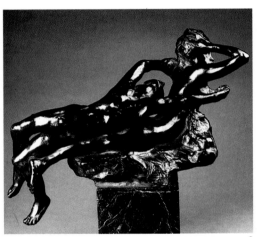

3.

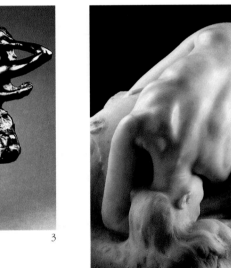

4.

sculptures by Rodin. The authors of the catalog introductions were close friends of both artists. Octave Mirbeau wrote about Monet and Geffroy about Rodin, and their passionate, complex study of the two artists helped the public understand their work. But an incident which took place on June 21 nearly caused a serious misunderstanding between the two men. When setting up his sculptures, Rodin had the unfortunate idea of putting his *Burghers of Calais* in front of one of Monet's paintings, thus concealing a large part of the canvas. Monet was quite hurt by this: "I arrived this morning to find out what I feared, that the canvas at the back of the room, my best painting in the exhibition, was completely hidden because of the way Rodin had placed his sculpture. But it is too late, the harm has been done. I am very disappointed. Rodin should have realized that if we exhibited together we must agree about the placing … If he had consulted me and cared about my work, it would have been easy to come to some agreement that would have suited both…" he wrote to Georges Petit on June 21,1889. However, this episode did not affect Monet's admiration for Rodin. Nine years later he stood by him during the controversy surrounding his *Balzac*.

3, 4.
Among his 36 sculptures, Rodin presented *Fugit Amor* and the first marble sculpture of *The Danaid*. In the first, the legendary lovers Paolo and Francesca are chained together in Hades for eternity. It was probably Camille Claudel who posed for *The Danaid*.

3. *Fugit amor*, 1887. Rodin.
Bronze. 15 x 19 x 8 in. (38 x 48 x 20 cm.)
Musée Rodin, Paris.

4. *The Danaid*, 1889. Rodin.
Marble. 14 x 28 x 21 in. (36 x 71 x 53 cm.)
Musée Rodin, Paris.

6. *White Turkeys*, 1877.
Oil on canvas. 683/4 x 68 in. (174.5 x 172.5 cm.)
Musée d'Orsay, Paris. RMN.

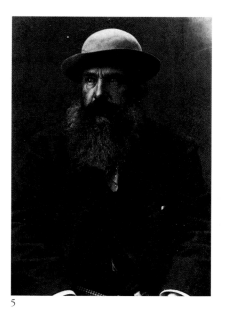

5.
In autumn 1876, after Manet, Monet was invited by Ernest Hoschedé to spend some time at the Château of Rottenbourg, his estate in Montgeron. Hoschedé, a generous patron of the arts, commissioned four decorative panels, including these *White Turkeys*, which Monet painted on the spot. This masterpiece was among the paintings exhibited by Monet at the retrospective organized at the Georges Petit gallery in 1894. Sold in 1894, it was finally bequeathed to the Louvre by the Princesse de Polignac.

5

6

The Haystacks

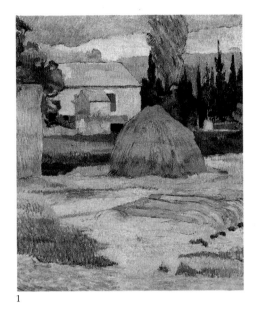

1.
In 1888, when Gauguin painted *Landscape near Arles*, Monet produced his first of his studies of haystacks. Gauguin's style went beyond Impressionism and already heralded the Nabis for whom "a painting (…) is essentially a flat surface covered with color arranged in a particular order."

Duringthe autumn of 1888 Monet noticed a group of haystacks in a nearby field. He made several studies of these haystacks, and he took up the subject again the following summer when the haystacks had been built again. The result of this work was a series of twenty-five paintings on the same subject, represented at different times of the day. Fifteen of these canvases were exhibited at Durand-Ruel in May, and were an overwhelming success, fetching between 4,000 and 6,000 francs. "Everyone wants Monets," commented Pissarro. "The awful thing is that they all want haystacks in the setting sun." Monet no longer had financial problems. He could now afford to buy the house in Giverny. His fame spread as if the conceptual audacity of the series had overcome the last obstacle to the recognition of his genius. Gustave Geffroy wrote that "never has art been able to suggest subtler, yet stronger impressions, never has painting appeared so devoid of artifice, contrasts, method, or skillful marks, never has it presented itself to our charmed eyes with such freshness, purity and dazzle. In his search for fleeting illuminations, in his representation of atmospheric phenomena, Monet follows with admirable instinct and rare logic the indications that appear and disappear so swiftly in an ever-moving nature."

Monet was not trying to prove a particular theory when he painted the *Haystacks* series, or the *Poplars* that soon followed them. He said he abhorred theories. Unlike the Neo-Impressionists who applied pointillism with the greatest rigor, Monet was only following an intuition: "I am persisting in painting a series of effects (of haystacks), but at this time of the year, the sun goes down so quickly that I cannot follow it. I despair at how slowly I am working, but the more I progress the more I realize that I have to work hard to find what I am looking for. The instantaneous, especially the outward appearance, and the same light everywhere." The series was thus a solution that imposed

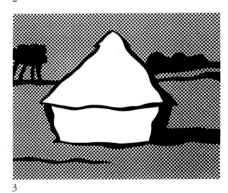

3.

1. *Landscape near Arles*, 1888. Gauguin.
Oil on canvas. 36 x 28 in. (91.4 x 71.2 cm.)
Museum of Art (gift in memory of W. Ray Adams), Indianapolis.

2. *Haystack, Effect of Snow, Overcast Weather*, 1891.
Oil on canvas. 26 x 32½ in. (66.5 x 82.3 cm.)
Art Institute (M. A. Ryarson collection), Chicago.

3. *Haystack*, 1969. Lichtenstein.
Silk screen. 19¼ x 26 in. (49 x 66 cm.)
Private collection.

4 (detail) and 5. *Haystack, Effect of Snow, Morning*, 1890–91.
Oil on canvas. 25¾ x 36¼ in. (65.4 x 92.3 cm.)
Museum of Fine Arts (gift of A. & R. Lamb), Boston.

3.
Since Monet, the idea gradually developed that a subject is no longer necessary in a painting because the latter exists n itself. This solkscreen by Liechtenstein, made in 1969, is a homage to Monet. The haystacks were used to reveal the light changing with the passing of time. Lichtenstein's haystack, reversed out in white and further emphasized by its long shadow, withdraws in a way in order to highlight the texture of the halftone screen, a reference to the printed image of our days and an abiding interest of this artist.

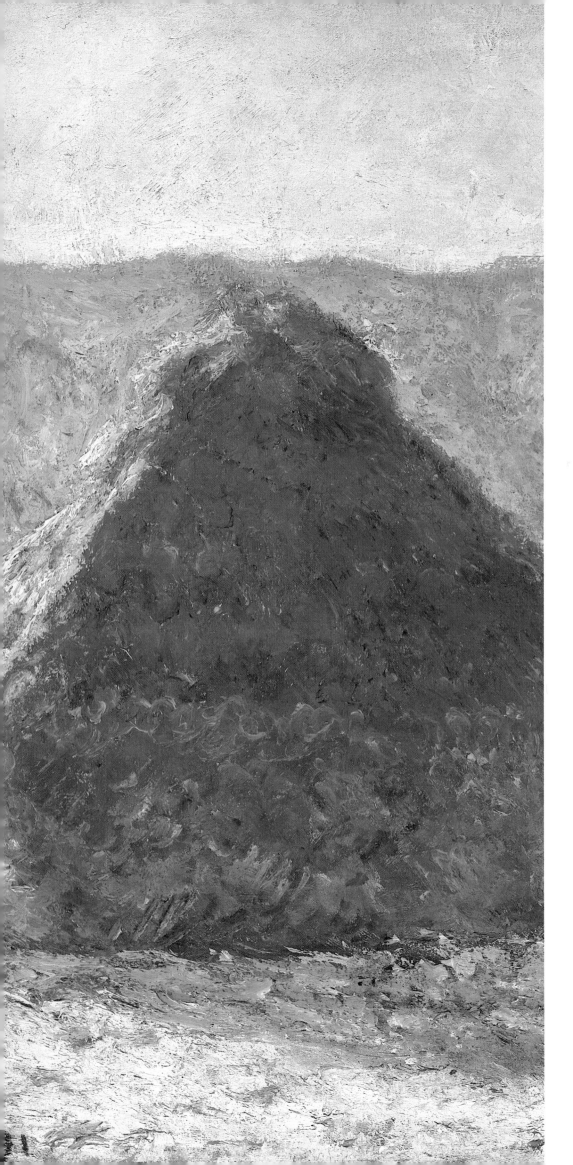

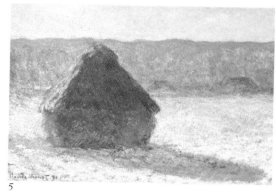

5

"From then on I looked at the art of icons with different eyes: I had acquired an eye for the abstract in art."
(Kandinsky)

2, 4, 5
"… I have experienced two events that marked my entire life, which shook me to the deepest essence of my being. These were the exhibition of the Impressionists in Moscow, particularly the *Haystack* by Monet, and a performance of Wagner at the Théâtre de la Cour: *Lohengrin*… And suddenly I saw a picture… I vaguely sensed that the subject was missing in the picture… All this was very confused in my mind and I was incapable of drawing the most elementary conclusions from this experience. But what was perfectly clear to me was the unsuspected power of color, which I had been unaware of until then and which went beyond all my dreams. As a result, painting gained a wonderful strength and sparkle. But at the same time, unconsciously, the subject as indispensable element in the picture was now discredited."
(Kandinsky, *Regards sur le passé*, 1912)

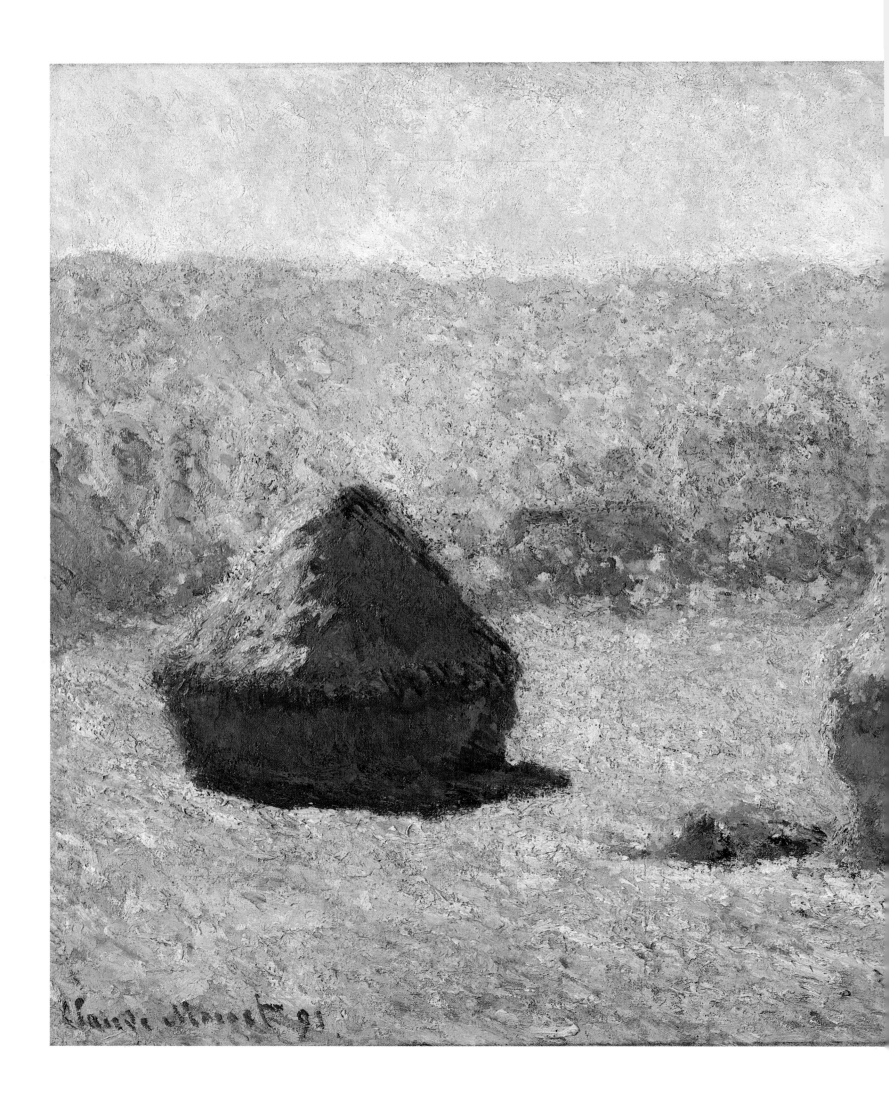

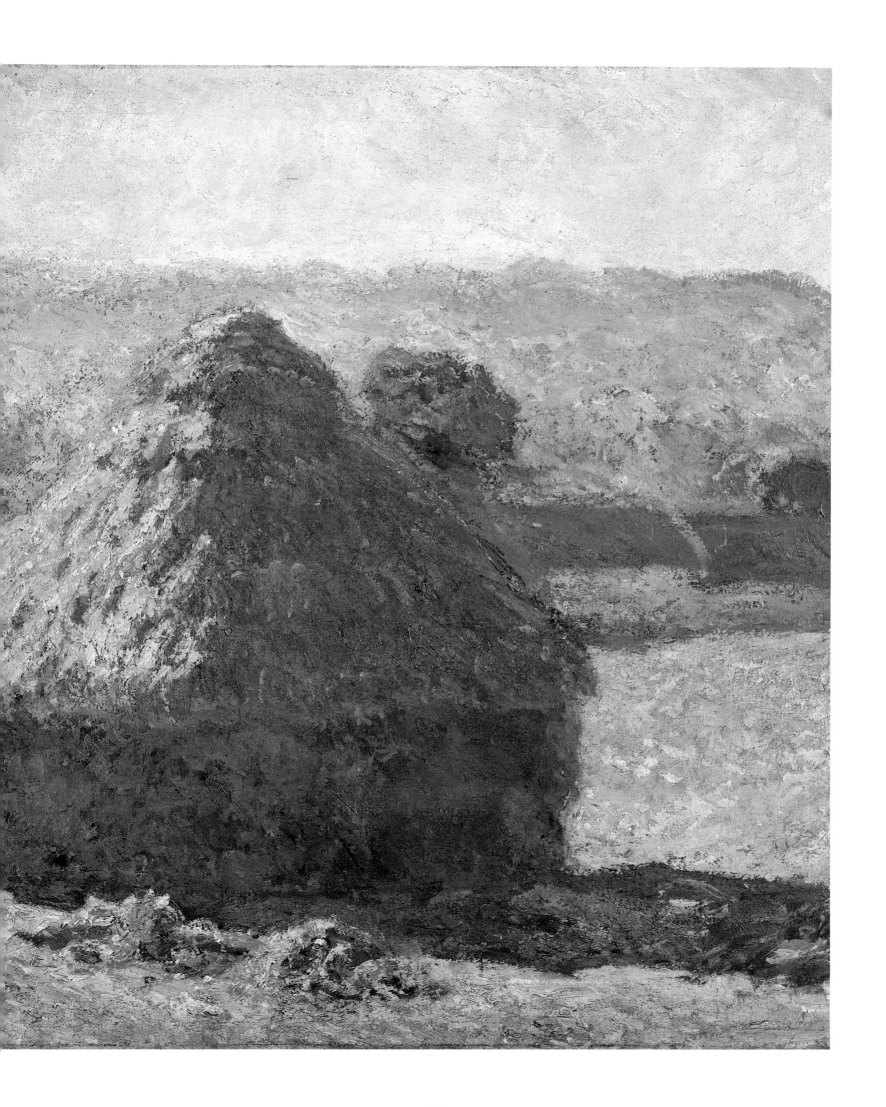

*"Light surprises when revealed
by changes." (Clemenceau)*

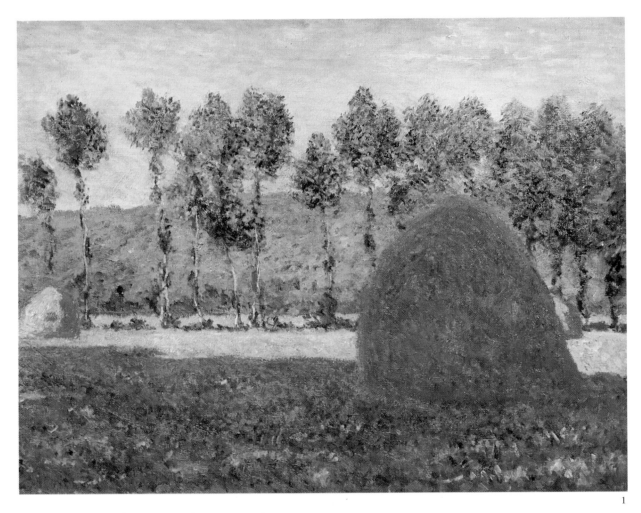

1

"I am more and more enthusiastic about
conveying what I feel."

itself on Monet, which he named himself and
which he used as a title for several exhibitions.
The same subject, represented endlessly, had
now become a pretext, a trap and a vehicle for
the light that changed by the minute. It also
became the means of exploring another man-
ner of painting, reworked in the studio, in
which "the manner of painting itself becomes
the real object of his act" (J. M. Guillaud).

Previous pages:
Haystacks, Late Summer, Effect of Morning, 1891.
Oil. 23½ x 39¼ in. (60 x 100 cm.)
Musée d'Orsay, Paris. RMN.

1. *Haystacks near Giverny, c.* 1884–89.
Oil on canvas. 51 x 71¼ in. (130 x 181 cm.)
Pushkin Museum, Moscow.

2. *Haystack in Sun*, 1891.
Oil on canvas. 23½ x 39¼ in. (60 x 100 cm.)
Kunsthaus, Zürich.

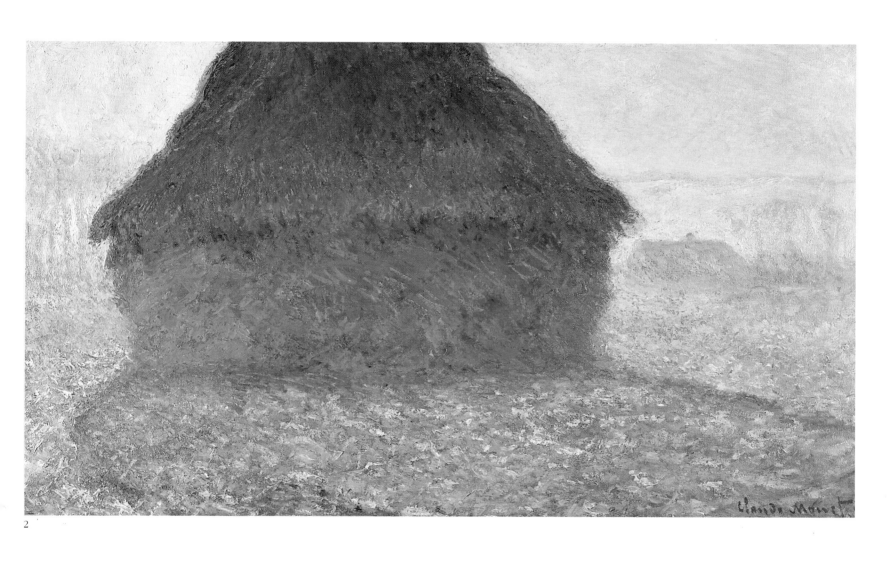

2

The poplars

In March 1892, ten months after the exhibition of the *Haystacks*, Durand-Ruel presented a series of fifteen paintings, poplars this time, which was also overwhelmingly successful. In order to produce this series, Monet had borrowed his friend Caillebotte's boat, which was roomier than his rowboat, and moored at Limetz on the right bank of the river Epte. The river gave him wonderful reflections such as the tall trunks of the poplars, the shimmering atmosphere, and the mirror of the water that reflected everything in the same dazzling light, separated by the horizontal line of the bank.

Monet was painting these poplars when the *commune* of Limetz decided to sell them. Not to be interrupted in his painting, Monet resorted to a rather clever stratagem which he explained himself: "It was a funny business! I had to buy the poplars so that I could finish painting them (…) The commune of Limetz had

1

1.
Daubigny introduced Monet to Durand-Ruel in London in 1871. He was at the time the most important dealer in Impressionist paintings, arranging several exhibitions in his galleries in London and New York. Among others he organized the large exhibitions of the *Haystacks* in 1891, the *Poplars* in 1892, and the *Cathedrals* in 1895, although he had not had represented Monet exclusively since 1886.

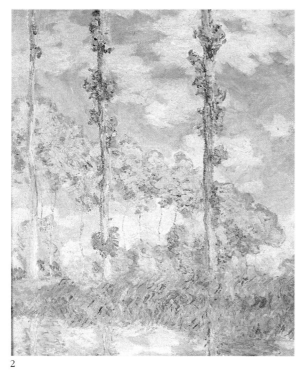

2

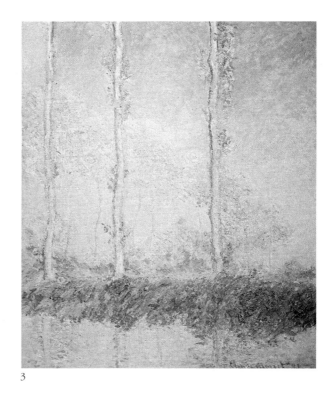

3

decided to auction the poplars. I went to see the mayor. He understood my reasons but was unable to delay the sale. The only solution was to go to the auction myself, which was something I did not look forward to. Because I thought I might have to pay dearly for this whim! Then I suddenly thought of approaching a wood merchant whom I knew would be interested in the wood. I asked him how much he would go up to and asked if he would buy in my place. I promised him that I would pay the difference if the trees fetched a higher price, but on the condition that he left the trees standing for a few more months. And this is what happened, not without damage to my purse."

1. *Paul Durand-Ruel*, 1910. Renoir.
Oil on canvas. 25½ x 21¼. (65 x 54 cm.)
Collection Durand-Ruel, Paris.

2. *Poplars in the Sun*, 1891.
Oil on canvas. 36½ x 29 in. (93 x 73.5 cm.)
National Museum of Western Art, Tokyo..

3. *Poplars, Three Pink Trees*, 1891.
Oil on canvas. 36½ x 29 in. (93 x 74.1 cm.)
Museum of Art, Philadelphia.

4. *The Four Trees*, 1891.
Oil on canvas. 32¼ x 32 in. (81.9 x 81.6 cm.)
The Metropolitan Museum of Art
(Mrs H. O. Havemeyer bequest), New York.

2, 3, 4.
Monet set up his easel on the large boat that Caillebotte had lent him. His eyes were no more than a yard above the surface of the water. The composition of these *Poplars* is almost geometric, with vertical trunks and the horizontal river bank. The brushstroke consists of pairs of complementary colors, blue-violet or yellow-orange for instance, and of light liquefying in the shimmering reflections of the water.

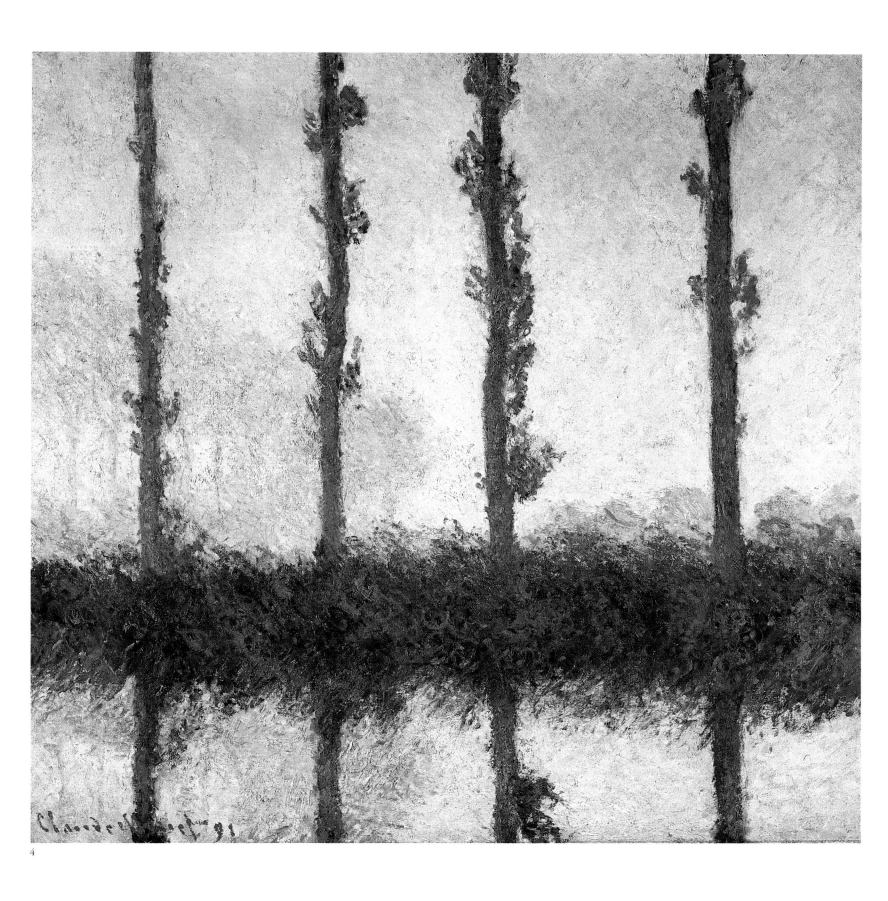

4

Monet had known Rouen since childhood. Subsequently, he went back several times to visit his brother Léon who ran a chemistry laboratory there. His first paintings inspired by Rouen date from 1872, during his Argenteuil period, ten years before he started the *Cathedrals* series.

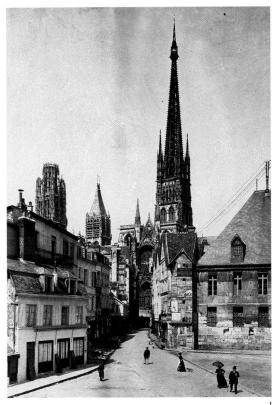

1 *The spire of the cathedral*
1

Pissarro's fascination with Rouen, often discussed by the two artists, certainly played an important part in Monet's impression of the town. He had also read Flaubert who had described the mist in Rouen so beautifully. In one of his letters to Alice in which he expressed his doubts, he said that he had started examining his canvases again, "that is, continuing to be tortured. Well, if Flaubert had been a painter, would he have written so well, I wonder!"

Monet went back to Rouen in 1892 to settle some family business: Marie, his half-sister had died, and the two brothers had to buy her share of the inheritance, which consisted mainly in paintings by Monet himself, at the best price possible. He stayed at the Hôtel d'Angleterre, near the cathedral, and walked about the town in search of subject. But he became bored and displeased with himself. On February 12, he wrote to Alice: "I have been able to move into an empty flat overlooking the cathedral, but it will be a difficult task." Monet started painting immediately but was constantly interrupted. This went on for two years. In March 1893, he wrote to Gustave Geffroy: "I have been here for quite a while now, but that is not to say that I have almost

The Cathedrals

2

3

2. 3. *Rouen Cathedral* (2 out of 3 panels from Series no. 2), 1969. Roy Lichtenstein. Oil and magna on canvas. 63 x 42 in. (160 x 107 cm.) Museum Ludwig, Cologne.

4. *Rouen Cathedral, Effect of Morning, White Harmony*, 1894. Oil on canvas. 41¾ x 28¾ in. (106 x 73 cm.) Musée d'Orsay, Paris. RMN.

Pissarro admired the *Cathedrals* unreservedly. The Post-Impressionists were not over-enthusiastic, doubting that Monet's painting was strong enough to do without composition. In contrast, Malévitch declared that "*Rouen Cathedral* has been of fundamental importance in the history of art, and by the power of its action it has forced whole generations to change their conception of pictorial works." We already know that the *Haystacks* led Kandinsky towards abstraction, and Jackson Pollock, one of the masters of American non-figurative painting, produced a work entitled *Cathedral*. In 1970 Roy Liechtenstein said: "Although Monet painted his Cathedrals as a series, which was a very modern idea, the image was always slightly different on each canvas. That's what led me to believe that it would be more interesting to use three slightly different images and slightly different colors to evoke the different moments of the day."

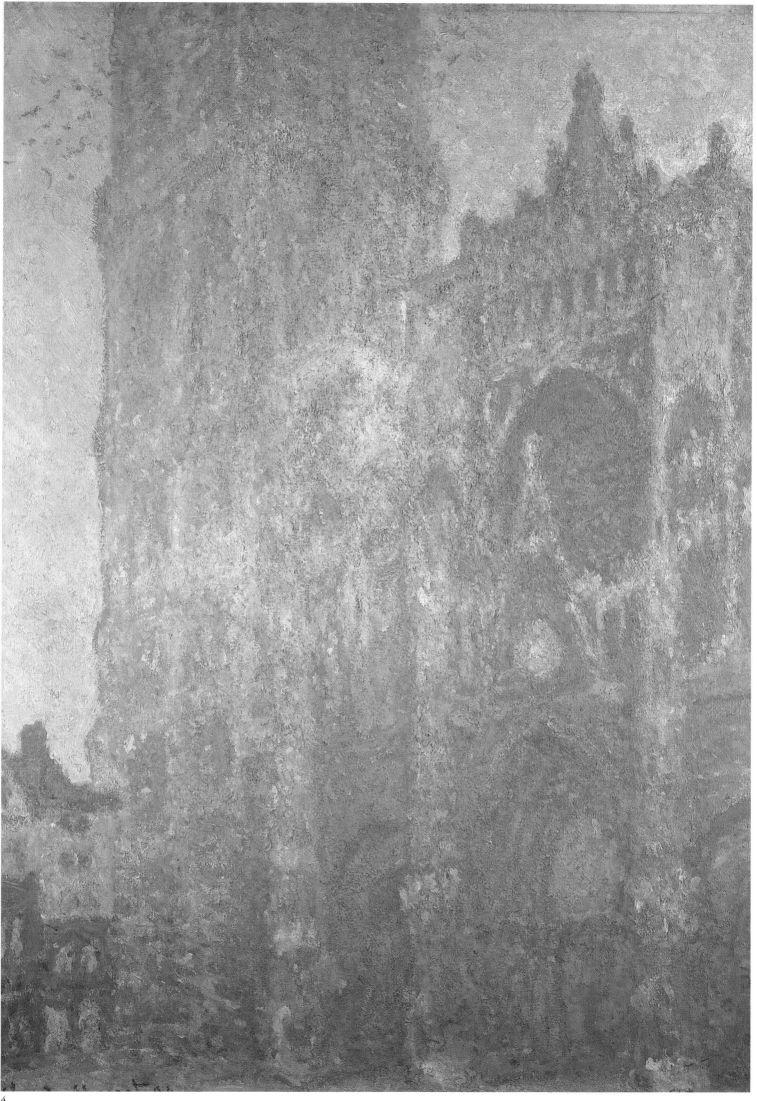

4

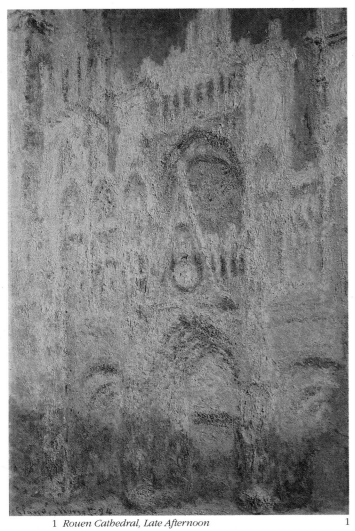

1 *Rouen Cathedral, Late Afternoon* 1

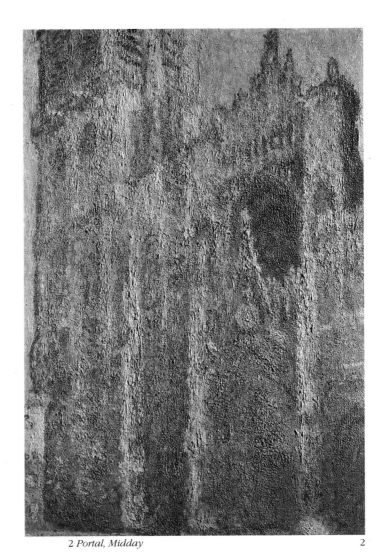

4 *Rouen Cathedral, Effect of Sun, End of the Day*

2 *Portal, Midday* 2

3 *Portal, Overcast Weather*

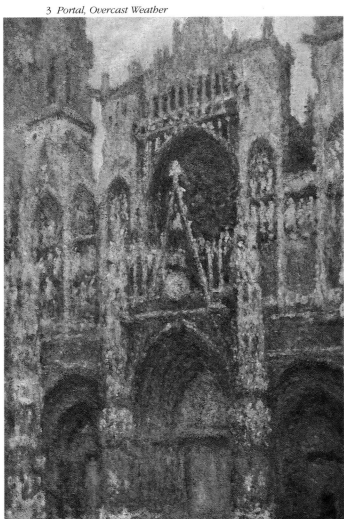

3

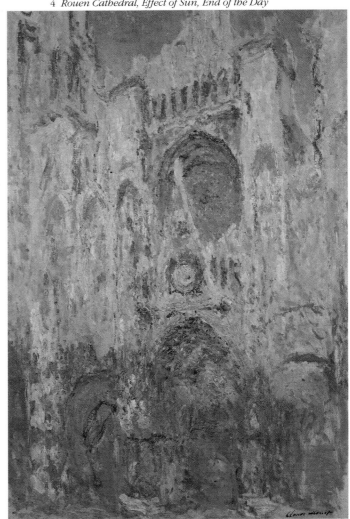

4

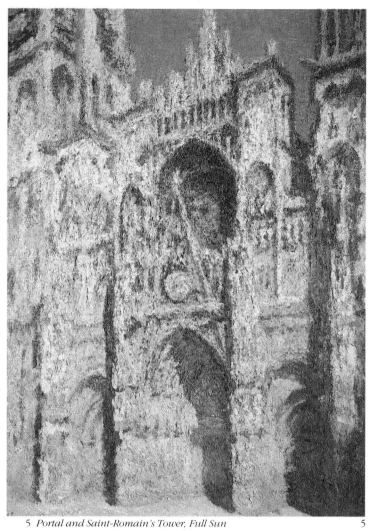

5 *Portal and Saint-Romain's Tower, Full Sun* 5

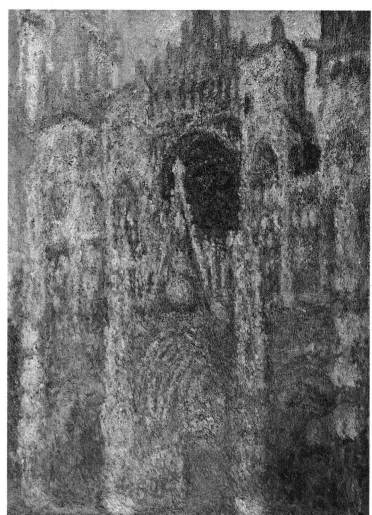

6 *Portal and Saint-Romain's Tower, Dawn* 6

7 *Portal from the Front, Brown Harmony*

8 *Portal, Blue Harmony*

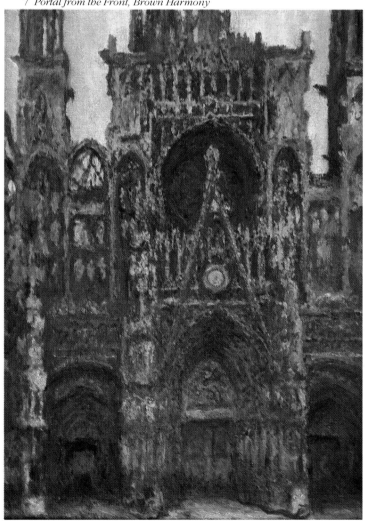

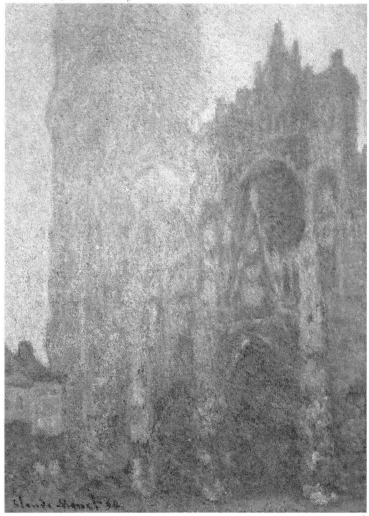

7

8

finished my cathedrals. Unfortunately, I can only say this: the more I progress the greater the difficulty in rendering what I feel; in fact, I believe that any one who claims to have finished a painting is incredibly arrogant. Finished meaning complete, perfect, and I continue to work without progressing, searching, groping in the dark without ever achieving much but what leaves me completely exhausted." At the time, Monet believed that a work of art was never completed but always in motion. The series should therefore never stop, being always "in the process of taking shape". Therefore each one of Monet's *Cathedrals* must considered in relation to the others and no painting should be taken outside the series. Eternity and instant are the two poles of his painting. Each moment is unique: the cathedral changes every instant and it must be shown in every one of its states. Today some experts believe that this idea of the never-finished painting and rejection of detail which characterizes Monet's painting are connected: it is thought that the artist tried to oppose "the preliminary sketch" which allows perception an unlimited field of expansion to the "finished" painting which would restrict this field.

In April 1893, Monet was back in Giverny, down-hearted, not certain that he had achieved what he had set out to do. He was reluctant to show his paintings and started retouching them from memory, ruthlessly discussing prices with Durand-Ruel. However, the news of the new series spread and the whole of Paris waited with bated breath to catch a glimpse of the *Cathedrals*. They were first exhibited in the spring of 1895 at the Durand-Ruel gallery and soon became the subject of numerous debates and articles. Clemenceau and Geffroy were enthusiastic. Clemenceau admitted that he was quite "obsessed" by this series. He saw it as the manifestation of a rather unchristian vision of life which could only appeal to him, the anticlerical passionate about Hellenism. In contrast to the "weak curate" who had to make considerable efforts to be amazed by improbable miracles, he realized that he only needed to open his eyes to perceive the real miracle, the wonders of the world revealed to him by Monet, mediator and magician: "I, myself, live in the midst of perpetual wonders which excite me and exalt me with their miraculous realities. Yes, humanity lives in a real miracle which is a permanent source of great joy: But humanity does not perceive it or more precisely, it has only just started to formulate the notion of this reality."

1. *My little yellow basket*, 1956. Jean Fautrier. Oil on oaoer. 20 x 24½ in. (51 x 62 cm.)

Previous pages:
1. *Rouen Cathedral, Late Afternoon*, 1894. Oil on canvas. 39¼ x 25½ in. (110 x 65 cm.) Pushkin Museum, Moscow.

2. and detail page 131: *Portal, Midday*, 1894. Oil on canvas. 39¼ x 25½ in. (110 x 65 cm.) Pushkin Museum, Moscow.

3. *Portal, Overcast Weather*, 1894. Oil on canvas. 39¼ x 25½ in. (110 x 65 cm.) Musée d'Orsay, Paris. RMN.

4. *Rouen Cathedral, Effect of Sun, End of the Day*, 1892. Oil on canvas. 39¼ x 25½ in. (110 x 65 cm.) Musée Marmottan, Paris.

5. *Portal and Saint-Romain's Tower, Full Sun*, 1894. Oil on canvas. 42 x 28¾ in. (107 x 73 cm.) Musée d'Orsay, Paris. RMN.

6. *Portal of Sant-Romain's Tower at Dawn*, 1894. Oil on canvas. 41¾ x 29 in. (106 x 74 cm.) Museum of Fine Arts (Tompkins collection), Boston.

7. *Portal from the Front, Brown Harmony*, 1894. Oil on canvas. 42 x 28¾ in. (107 x 73 cm.) Musée d'Orsay, Paris. RMN.

8. *Portal, Blue Harmony*, 1893. Oil on canvas. 36 x 25 in. (91 x 63 cm.) Musée d'Orsay, Paris. RMN.

The comparison of a detail (opposite) of *Cathedral: Portal, Midday*, page 128 no. 2), and Fautrier's informal painting confirms Malévitch's premonition that the *Cathedrals* would lead entire generations to change their pictorial conceptions. Monet dated his *Cathedrals* 1894. Fautrier was born in 1898. Persecuted by the Gestapo during the Second World War, he painted the poignant series of the *Otages* during the German occupation and after the war, he became one of the masters of informal art. The parallel between these two artists is quite obvious,. They display a similar richness in the paint, capturing the light.

1

Before the *Cathedrals* were shown to the public, Monet spent the winter in Norway. He then traveled to the Normandy coast, to Brittany and other locations that had been the source of inspiration for so many of his paintings. Later he traveled in his Panhard car, or by train, to Madrid and Venice. 1898 was marked by his reconciliation with Emile Zola; they had been on less than friendly terms since the publication of *L'Œuvre* whose main characters in many respects resembled some of the members of the Impressionist group, including Monet. But their reconciliation had started earlier, at the time of the Dreyfus Case. In December 1894, Captain Alfred Dreyfus, a Jew from Alsace, was

Travels

2

accused—as it turned out, falsely—of passing military secrets to Germany. He was tried, found guilty, and sentenced to be deported to Guyana. He was only rehabilitated in 1906. Convinced of Dreyfus's innocence, Emile Zola protested by publishing his famous article *J'accuse* in Clemenceau's paper *L'Aurore* in order to obtain a retrial. He did not hesitate to denounce the "faussaires of the Etat-Major" ("forgers of the military officers") so that he too was taken to court. "Well done and well done again. You alone have said and done what had to be done," wrote Monet to Zola.

Meanwhile Manet had been dreaming of another series of views of London, which he visited, but he only started working on them the following year. When the changing weather forced him to put off painting, he completed his canvases in Giverny. Between 1899 and 1904, Monet claimed that he was working on as many as 100 canvases. Thirty-seven of them were exhibited at Durand-Ruel's gallery in 1904. The prices of his paintings were constantly rising.

3

3. *The Trial of Zola* (with Clemenceau and the lawyer Labori), 1898. Giraudon. Drawing.

4. *Norway, the Red Houses at Björnegaard*, 1895. Oil on canvas. 25½ x 32 in. (65 x 81 cm.) Musée Marmottan, Paris.

5. *Waterloo Bridge*, 1900. Pastel, 12¼ x 19 in. (31.3 x 48.5 cm.) Musée du Louvre (drawings collection), Paris, RMN.

6. *Houses of Parliament, London, under a Stormy Sky*. Oil on canvas. 32 x 19 in. (81 x 92 cm.) Musée des Beaux-Arts, Lille. RMN.

4.
Monet's step-son, Jacques Hoschedé, lived in Norway, and Monet decided to go and visit him. He was received with great honors and, although flattered, he complained to Alice that "people are making too much fuss." The working conditions were exhausting "but I see so many beautiful things and beautiful effects that I did not see at the beginning… In France we know nothing about such effects of snow."

5.
Waterloo bridge is swathed in fog or mist, and thick smoke darkens the sky, which is even darker than its own reflection in the Thames.

4

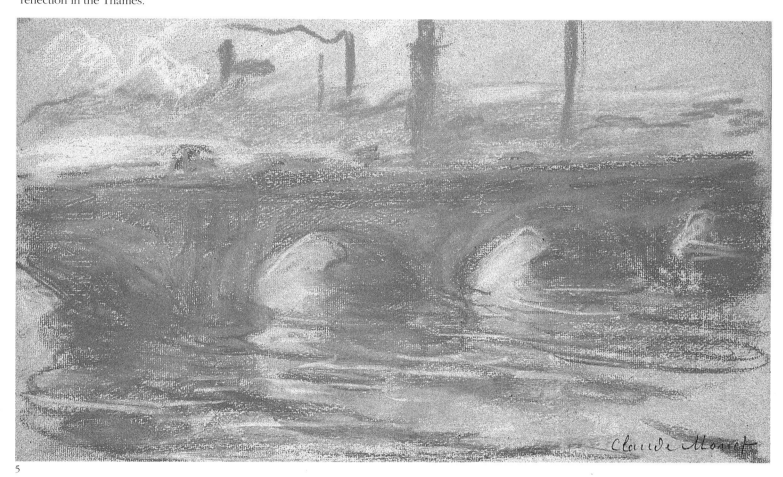

5

6
If only because of the title chosen by Monet, *Houses of Parliament under a Stormy Sky*, the painting reminds us that the subject is less important to the artist than the atmosphere, the "envelope" that he evokes. The mass of the Parliament iself and the bridge at Charing Cross in the distance no longer form the structure of the composition as they did in 1871, but they are dissolved into the reflections of the threatening storm.

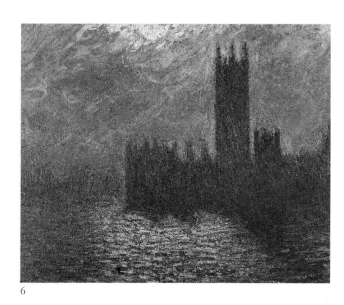

6

133

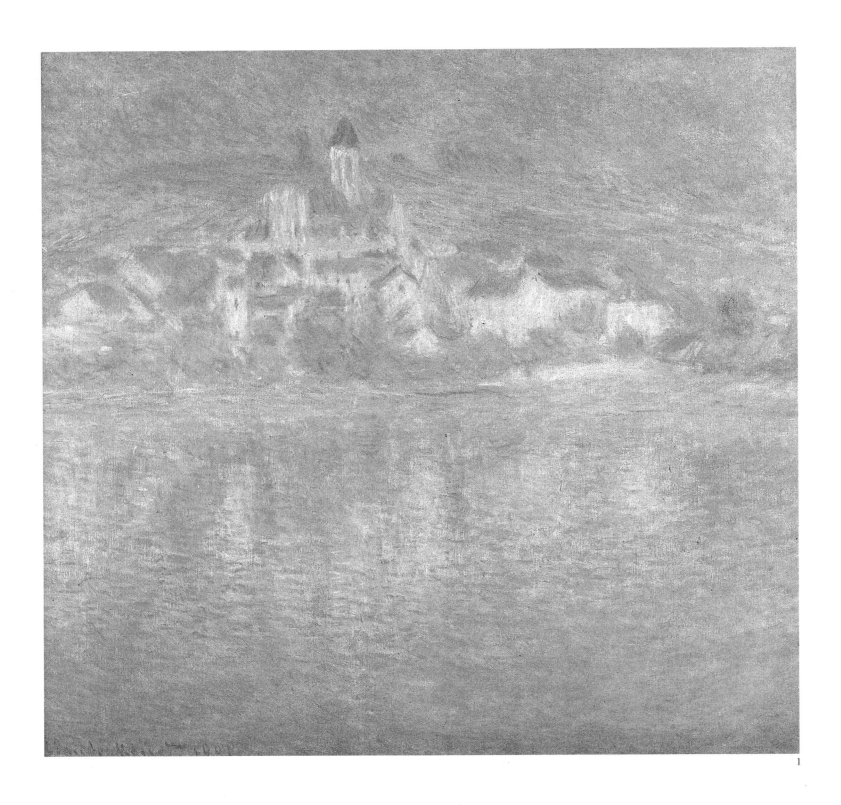

1

2 Vétheuil, seen from Lavacourt

2

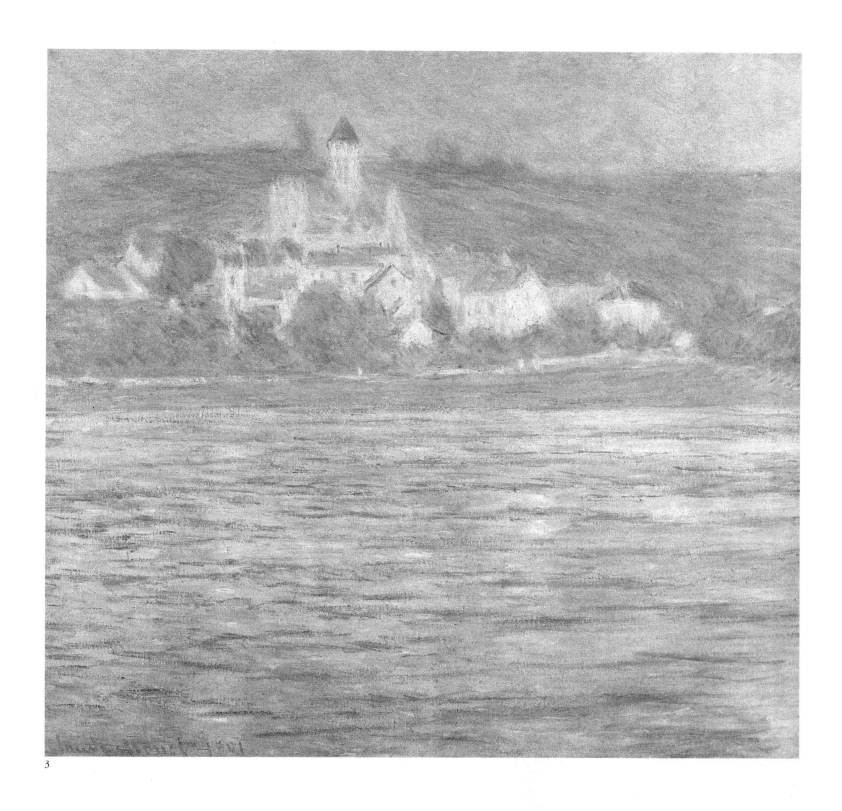

3

1. *Vétheuil, Setting Sun*, 1901.
Oil. 35 x 36¼ in. 89 x 92 cm.
Musée d'Orsay, Paris. RMN.

3. *Vétheuil, Morning*, 1901.
Oil on canvas. 35 x 36¼ in. (89 x 92 cm.)
Musée des Beaux-Arts, Lille. RMN.

From Giverny to Vétheuil, the journey was not long. A drive in the car helped Monet make up his mind. He asked his children to take his boat to Lavacourt, opposite Vétheuil. They even rented a little chalet, moved in some furniture and bought some food. Alice was delighted: "How wonderful to row on the river in the same places as 20 years ago!". Monet started working on a new series of views of Vétheuil. Compared to those produced between 1879 and 1881, these works reveal the painter's present approach to painting: the changing of the atmosphere with the passing of time, and the dissolution of shapes in the light and against the light.

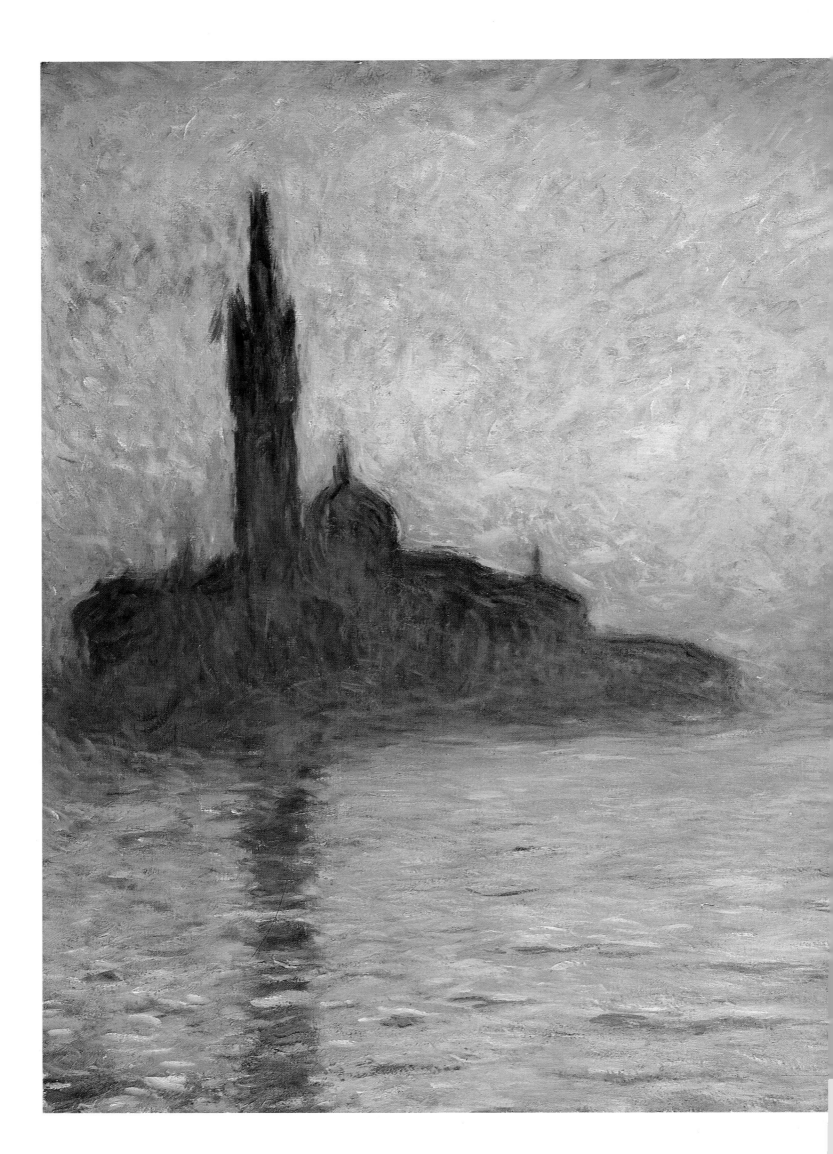

Mary Hunter, an English friend of Sargent, invited Alice and Monet to Venice. After spending a few days at her house, they moved into the Hotel Britannia at the beginning of October 1908. They stayed there for more than two months "in a perpetual state of enchantment." Monet had not expected them to stay that long in Venice. However, he sat down to work and wrote to Durand-Ruel that he had "painted a few canvases at random to keep the memory alive," and that he hoped to return to Venice one day. But he never went back. He came back from Venice with about 30 paintings, which he completed in his studio. Exhibited in 1912 at the Bernheim Jeune gallery, they were greeted with enthusiasm: painted in the now traditional Impressionist style, they met the expectations of the critics as well as the public.

Twilight in Venice, 1908.
Oil on canvas. 28¾ x 36¼ in. (73 x 92 cm.)
Bridgestone Museum of Art,
Ishibashi Foundation, Tokyo.

The Water Lilies

Having bought the house in Giverny, Monet built a pond in which he planned to grow water lilies whose seeds he had ordered from Japan. In 1893, he bought a small plot of land on the far side of a railway line that ran alongside the house. A small tributary of the river Epte, the Ru, crossed his land and he wanted to divert its course to provide the needs of his water lilies, which required running water. But the villagers were opposed to Monet's plan, thus drawing the artist into a prolonged but finally victorious battle with the local administration. These problems did not stop Monet who, surrounded by his Hiroshige and Hokusai engravings, continued to plan further changes in his garden. The little bridge across the lily pond was probably

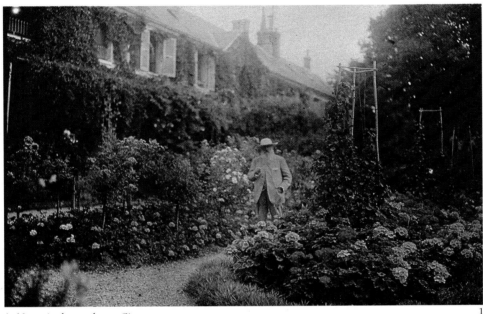

1 *Monet in the garden at Giverny*

inspired by the Japanese engravings. People came and visited his garden from all over the world: from Germany, the United States and Japan. American painters bought properties in Giverny, attracted by Monet's presence although he refused to receive them. Unwilling to teach, he claimed to have no "painting recipe" to pass on, and he spent most of his time painting. In the 1890s, Pissarro, Renoir, Cézanne, Caillebotte, and Sisley were regular visitors to Giverny. Except for Renoir they had all died before the beginning of this century, and it was a new generation of friends who now visited Monet in Giverny, such as Clemenceau, Gustave Geffroy, Théodore Duret, Octave Mirabeau, and Lucien and Sacha Guitry. With time, Monet and Giverny became synonymous.

Life was sweet but the family still suffered several blows. Suzanne Hoschedé died in 1899. Her mother who had married Monet in 1892, a year after Ernest Hoschedé's death, died in 1911. The artist's eldest son, Jean, died from a serious illness in 1914 just before World War I broke out.

Monet started work on a new series that kept him occupied until his death: the *Water Lilies*.

The light in *Irises in Monet's Garden* seems to emerge from the irises themselves. The sky is out of the picture, and the pond looks as if it has been inserted like a piece of mirror among the vermilions, mauves, pinks, browns and ranges of green "arranged in acertain order."

2. *Irises in Monet's Garden*, 1900.
Oil on canvas. 32 x 36¼ in. (81 x 92 cm.)
Musée d'Orsay, Paris. RMN.

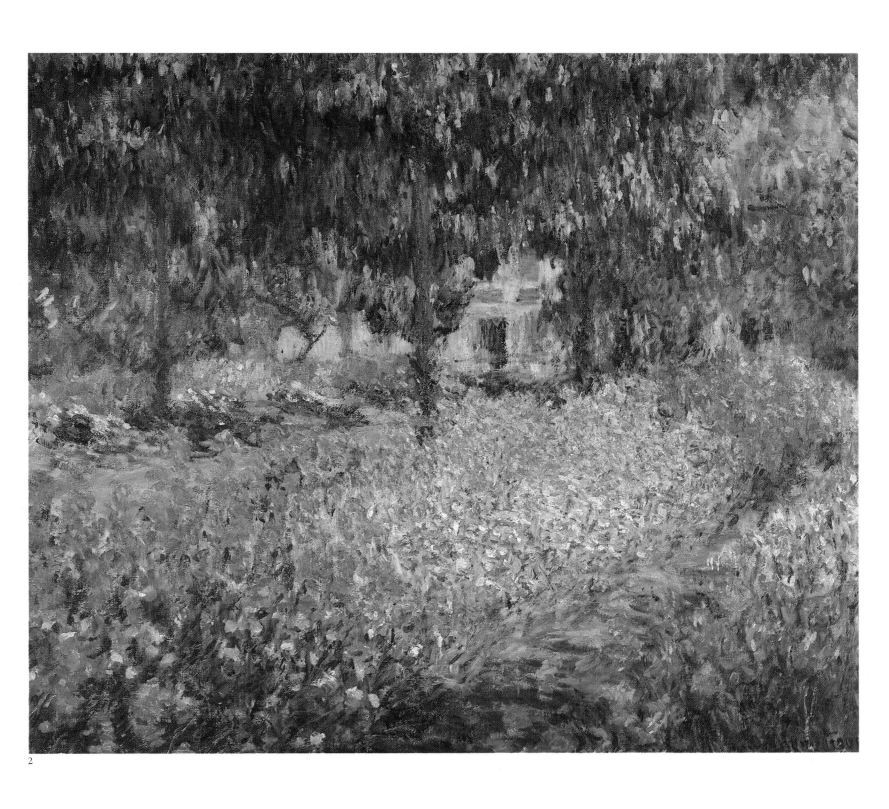

2

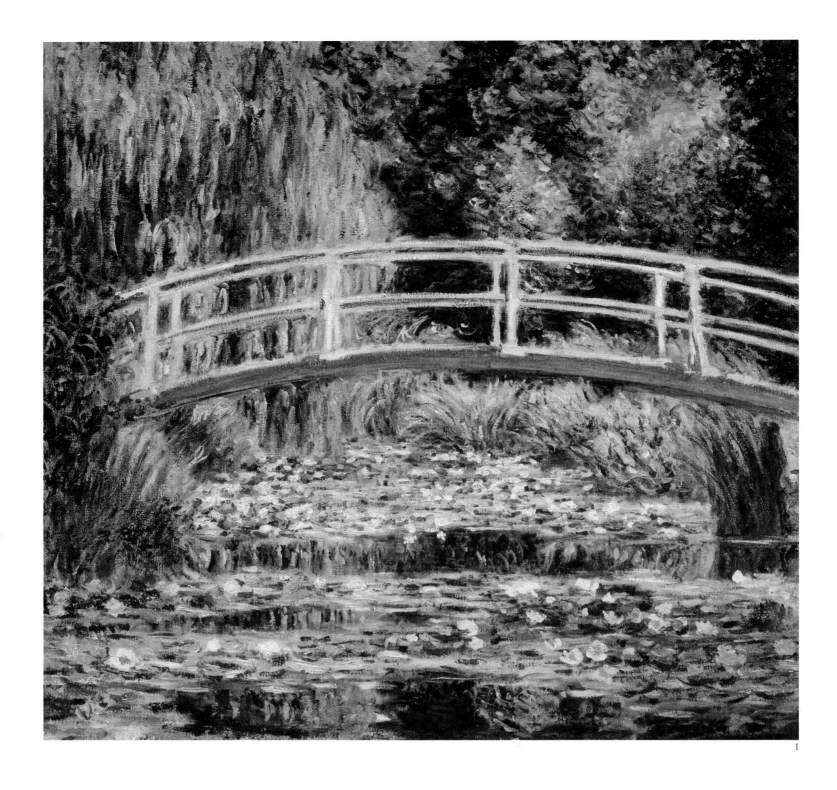

1

Started in 1899, the first continuous series consisted of six paintings. Monet's sight began to deteriorate 1908. Suffering from a double cataract, the painter feared he might go blind. He was finding it increasingly difficult to appreciate the different values of the same color, and he suffered from sudden destructive bouts during which he destroyed his paintings. But his friend Clemenceau and his step-daughter Blanche continued to encourage him in his painting. In 1921, after a few reversals due to Monet's hesitation, the State made the decision to organize a permanent presentation of the *Water Lilies* in two rooms of the Musée de l'Orangerie. But in September 1922 Monet informed Durand-Ruel that he could no longer work. Clemenceau persuaded him to have a cataract operation. The operation was carried out, on one eye only, in January 1923. The artist recovered partial sight, but he was then distraught to find out that his colors were not what he thought, and he destroyed more paintings. Nevertheless, Monet adapted to his new situation and gradually started working again. In 1924, new glasses greatly helped his sight and Monet started work again on the *Water Lilies* project in the Orangerie. But time was running out. He died on December 6, 1926, probably from lung cancer. The *Water Lilies* project was inaugurated in May 1927.

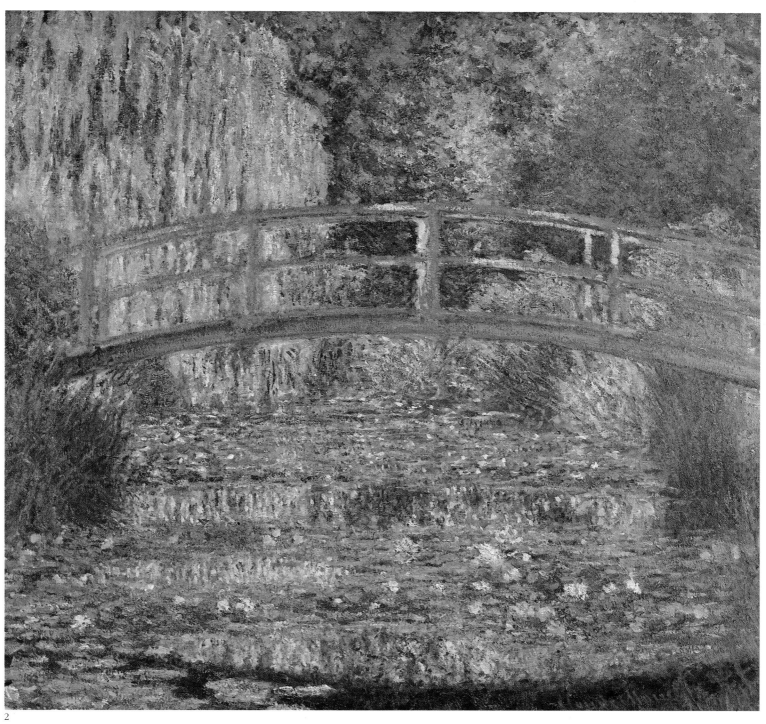

2

The first series of *Water Lily Ponds* highlights the artist's new chromatic perceptions. For the first time, he painted landscapes without a horizon, saturated by the reflections of willow-trees and the grass undulating underwater.

3. Monet's second studio at Giverny, photographed at the time of Durand-Ruel's visit in 1900.

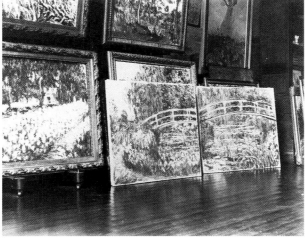

3

1. *The Water Lily Pond*, 1899.
Oil on canvas. 35 x 36½ in. (89 x 93 cm.)
Pushkin Museum, Moscow.

2. *The Water Lily Pond, Green Harmony*, 1899.
Oil on canvas. 5 x 36½ in. (89 x 93 cm.)
Musée d'Orsay, Paris. RMN.

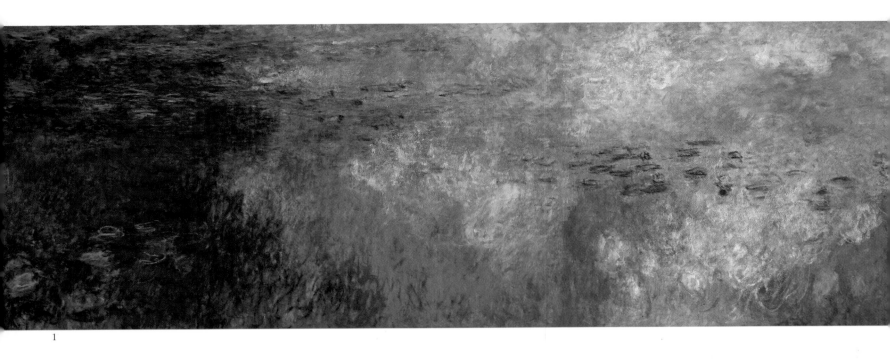

1

The place of the Water Lilies
in the art of the 20th century...

1900: Edvard Munch exhibited *The Dance of Life* in Oslo. Expressionism would reach its apogee in Germany after World War I, but Munch was an early precursor.

1901: Toulouse-Lautrec died. His technique of flat tints, stylized drawing, and sharpness of line already heralded Art Nouveau (Jugendstil) and the Viennese Secession.

1902: In Vienna, the architect Otto Wagner integrated the requirements and tools of contemporary life into his style, here using aluminum and globe electric lights. In New York, the Flatiron Building consisted of a metal framework with electricity and elevators.

1904: *Luxe, calme et volupté* by Matisse was still pointillist in treatment, but the following year, at the 3rd Autumn Salon in Paris, Matisse exhibited *The Woman in the Hat* with the Fauves.

2. *The Dance of Life*, 1899. Edvard Munch.

3. *Yvette Guilbert Acknowledging her Public*, 1894. Toulouse-Lautrec.

4. Design for *Die Zeit*'s dispatch office,1902. Otto Wagner.

5. The Flatiron Building, 1902

6. *Luxe, calme et volupté*, 1904, Henri Matisse.

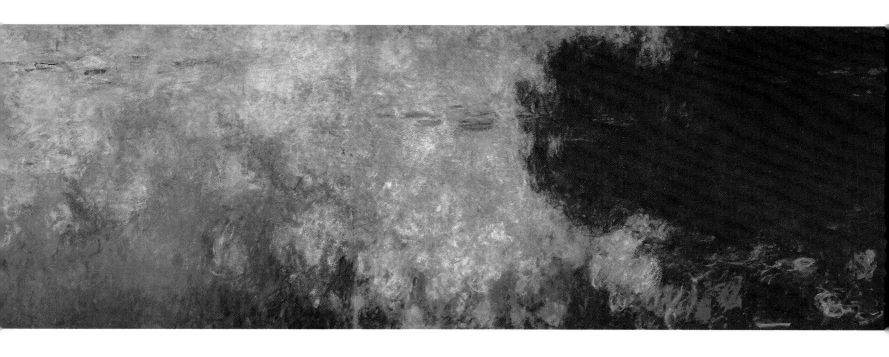

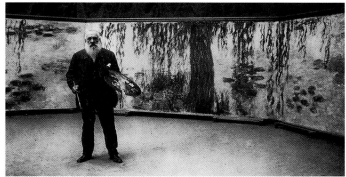

7. *Claude Monet in his studio, February 1921.*

1. *Water Lilies, Study of Water and Clouds,* 1916–26. Oil on canvas. Each panel 6 ft 7 in x 14 ft (200 x 425 cm) Musée de l'Orangerie, Paris. RMN.

1905: With Matisse, Derain was also a member of the Fauves, a style known for wide brushstrokes and the use of pure, violent colors.

8. *The Harbor of Collioure*, 1905. André Derain.

1906: Van Dongen was a neighbor of Picasso at Bateau-Lavoir,. He added a sensuality to Fauvism that was quite his own.

9. *Portrrait of Mme Bordenave,* 1905. Van Dongen.

1907: Cubism was born with Picasso's *Les Demoiselles d'Avignon*, a painting initially denounced by Matisse, Derain and Braque. But to Apollinaire "it was a revolution," and Kahnweiler saw it as an expression of "unbelievable heroism."

10. *Sketch for the Demoiselles d'Avignon,* 1907. Picasso.

1908: With his close friend Picasso, Braque evolved from Fauvism to Cubism. But this *House at Estaque* still recalls Cézanne.

11. *House at Estaque.* 1908. Braque.

1911: Kandinsky published *Du spirituel dans l'art et dans la peinture en particulier* ("Of the spiritual in art and in particular in painting"). In it he expressed "the inner need" of the painter, which drew him away from the figurative.

12. *Design with a Horseman,* 1911. Kandinsky.

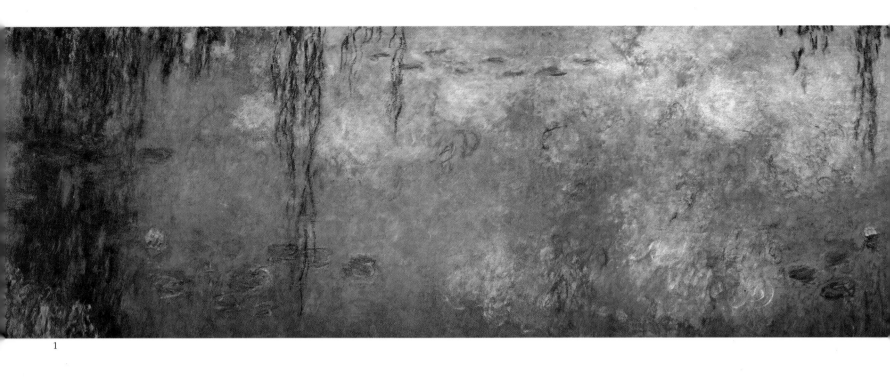

1

1912: Robert Delaunay conceived non-objective art. Color had become the only *raison d'être* of the painting, with the complementary contrasts of circular zones. The Italian Futurists exhibited in Paris. Their aim was to express the technological future, with its machines and speed. Giacomo Balla was a signatory of the Futurist Manifesto, but he did not contribute to the exhibition. His *Girl Running on a Balcony* expresses the movement of the subject in the same way as a sequence of photographic shots.

1913: De Chirico introduced the painting of dreams, heralding Surrealism.
1915: Malévitch proclaimed the Suprematist movement, which claimed the "supremacy" of the abstract form as the only means of achieving the absolute.
1916: The Dada movement was started at the Café Voltaire in Zurich, with its manifesto signed by Tristan Tzara. It was a rallying point for revolt and protest against the massacres of the war. Dada proclaimed that "art is not serious," that "the artist must try everything," and that plastic forms must be given over to chance.

2

3. *Simultaneous disk,* 1912. Delaunay.

4. *Girl Running on a Balcony,* 1912. Giacomo Balla.

5. *The Enigma of a Day,* 1913. De Chirico.

6. *Suprematism,* 1915. Malevitch.

7. *Head of Tzara,* 1916. Arp.

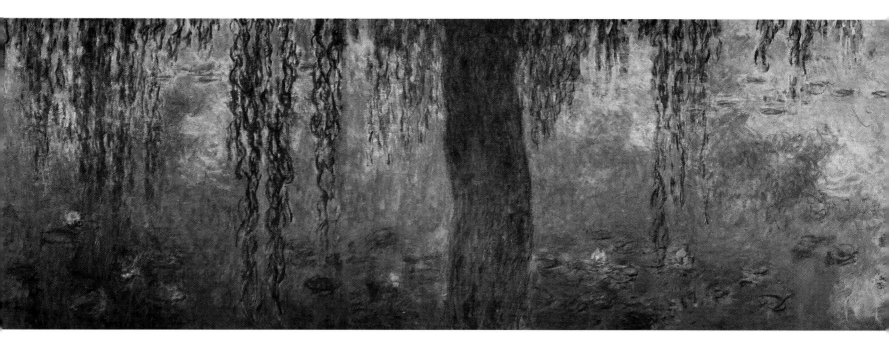

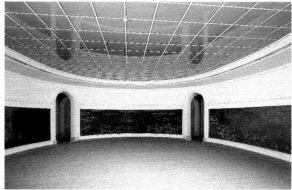

8. *Water Lilies, Musée de l'Orangerie*

1. *Water Lilies, Morning with Weeping Willows*, 1916–26. Oil on canvas. Each panel 6 ft 7 in x 14 ft (200 x 425 cm) Musée de l'Orangerie, Paris. RMN.

1917: "A controllable precision, a conscious penetration of reality, a precise beauty" led Mondrian to the rigorous abstraction of his *Compositions*. Mondrian wrote in *De Stijl* that this plastic style (Neo-Plasticism) "must find its expression in the abstraction of all form and color, that is in the straight line and in a clearly defined primary color."
Scandal in New York: Duchamp dared to exhibit an ordinary urinal at the Salon des Indépendants. Provocative as it was, it was also a reaffirmation of the "Ready-mades" shown in 1913, which included a bicycle wheel. Any object was a work of art if the artist described it as such, at a time chosen by him.

1919: The Swiss painter Johannès Itten studied the rhythms of color, and he taught these at the Bauhaus in Weimar.

1920: Max Ernst had first met Arp in 1914. He met him again after the War, and his encounter with the Dada movement played a decisive part in his development as an artist. He became the emblematic figure of Surrealism. In 1914 he developed an individual technique of collage based on the "chance encounter of two distinct realities on an inappropriate surface."

1923: Le Corbusier was as much a painter as an architect. He published the Manifesto of Purism, which claimed that plastic perfection could be reached by removing all decorative and structural indulgence in favor of the functional.

9. *Composition No. 10*, 1915. Mondrian.

10. *Fountain*, 1917. Duchamp.

11. *Colored squares*. Johannes Itten.

12. *It is the Hat that Makes the Man*. 1920. Max Ernst.

13. House of Amédée Ozenfant designed by Le Corbusier.

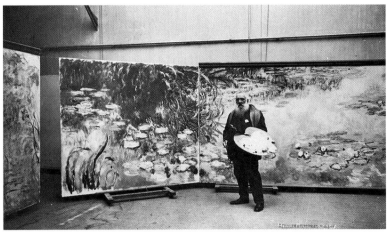

1. Monet with the Water Lilies

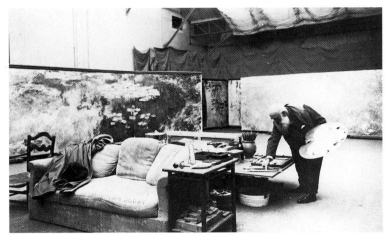

2. Monet working on the Water Lilies in the studio at Giverny

3. Monet in his house at Giverny

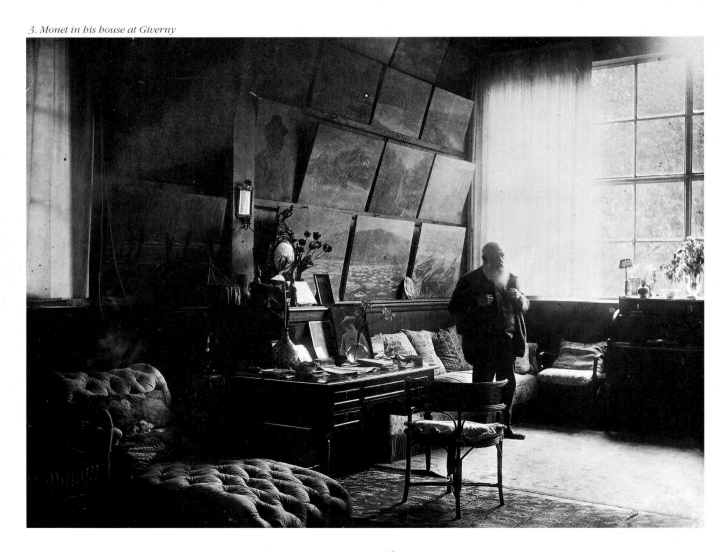

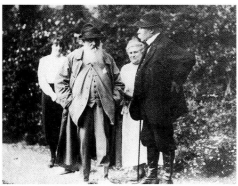

4. *Monet, Clemenceau, and
Blanche Hoschedé in the summer of 1921*

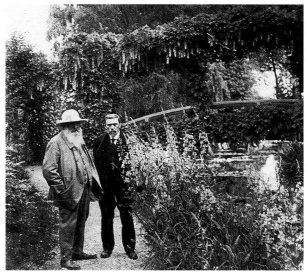

5. *Monet and Gustave Geffroy in the garden at Giverny, pho-
tographed by Sacha Guitry.*

6. *Germaine Hoschedé (on the left), Mme Joseph Durand-Ruel, and Jim and Lili Butler, pho-
tographed at Giverny by Durand-Ruel in September 1900*

8. *Clemenceau and Monet at Giverny*

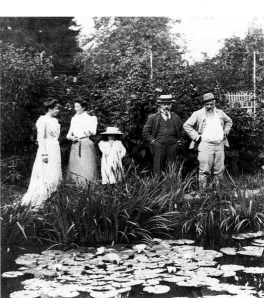

7. *From left to right: Germaine Hoschedé, Mme Joseph
Durand-Ruel, Lili Butler, Georges Durand-Ruel, and
Monet, photographed at Giverny by Joseph Durand-Ruel
in January 1900*

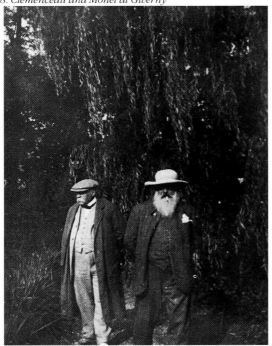

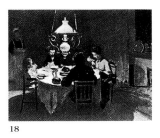

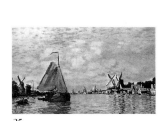

1. *Still Life with Pheasant,* 1861. Oil on canvas. 76 x 62 cm. Musée des Beaux-Arts, Rouen.

2. *Hunting Trophies,* 1862. Oil on canvas. 104 x 75 cm. Musée d'Orsay, Paris.

3. *Boat Yards near Honfleur,* 1864. Oil on canvas. 57 x 81 cm. Sold at Christie's, London, 1971.

4. *Rue de la Bavolle, Honfleur,* 1864. Oil on canvas. 56 x 51 cm. Museum of Fine Arts, Boston.

5. *The Hospice Lighthouse,* 1864. Oil on canvas. 54 x 81 cm. Private collection, Zurich.

6. *La Pointe de la Hève,* 1864. Oil on canvas. 41 x 73 cm. Woolworth sale, London, 1964.

7. *The Mouth of the Seine at Honfleur,* 1865. Oil on canvas. 90 x 150 cm. Private collection, USA.

8. *The Road at Chailly,* 1865. Oil on canvas. 42 x 59 cm. Musée d'Orsay, Paris.

9. *Camille with her Dog,* 1866. Oil on canvas. 73 x 54 cm. Private collection, Switzerland.

10. *Road to Saint-Siméon farm, Effect of Snow,* 1867. Oil on canvas. 56 x 81 cm. Fogg Art Museum, Cambridge.

11. *The Quai du Louvre,* 1867. Oil on canvas. 65 x 92 cm. Gemeentemuseum, The Hague.

12. *The Garden of the Infanta,* 1867. Oil on canvas. 91 x 62 cm. Allen Art Memorial Museum, Oberlin.

13. *Beach at Ste-Adresse,* 1867. Oil on canvas. 75 x 101 cm. Art Institute, Chicago.

14. *Still Life, Pears and Grapes,* 1867. Oil on canvas. 46 x 56 cm. Astor collection, New York.

15. *Portrait of Camille Monet,* 1868. Sanguine. Private collection.

16. *Fishing Boats at Sea,* 1868. Oil on canvas. 96 x 130 cm. Hill-Stead Museum, Farmington.

17. *Rough Sea at Etretat,* 1868. Oil on canvas. 66 x 131 cm. Musée d'Orsay, Paris.

18. *The Luncheon,* 1868. Oil on canvas. 52 x 65 cm. Bührle collection, Zurich.

19. *Interior after Dinner,* 1868. Oil on canvas. 50 x 65 cm. collection Mellon, USA.

20. *Route de Louveciennes, Effect of Snow,* 1870. Oil on canvas. 55 x 65 cm. Nelson-Harris collection, USA.

21. *The Bridge at Bougival,* 1869–70. Oil on canvas. 63 x 91 cm. Currier Gallery of Art, Manchester.

22. *The Beach at Trouville,* 1870. Oil on canvas. 54 x 65 cm. Wadsworth Atheneum, Hartford.

23. *The Beach at Trouville,* 1870. Oil on canvas. 48 x 74 cm. Goerg collection, USA.

24. *Windmills near Zaandam,* 1871. Oil on canvas. 40 x 72 cm. Walters Art Gallery, Baltimore.

25. *The Zaan at Zaandam,* 1871. Oil on canvas. 42 x 73 cm. Acquavella Galleries, USA.

 1

 6

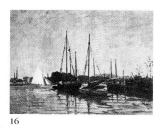 11

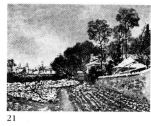 16

 21

 2

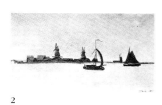 7

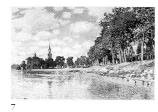 12

 17

 22

 3

 8

 13

 18

 23

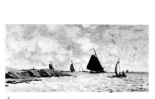 4

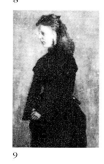 9

 14

 19

 24

 5

 10

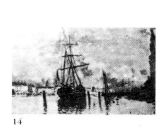 15

 20

 25

1. *Boats on the Zaan,* 1871. Oil on canvas. 35 x 71 cm. Private collection, Great Britain.

2. *The Voorzan,* 1871. Oil on canvas. 39 x 71 cm. Private collection, Great Britain.

3. *Windmill at Zaandam,* 1871. Oil on canvas. 48 x 73 cm. Private collection, USA.

4. *Seascape,* 1871. Oil on canvas. 34 x 74 cm. Nationalmuseum, Stockholm.

5. *Windmills in Holland,* 1871. Oil on canvas. 46 x 71 cm. Björkman collection, New York.

6. *Windmills near Zaandam,* 1871. Oil on canvas. 47 x 73 cm. Private collection, New York.

7. *Zaandam,* 1871. Oil on canvas. 47 x 73 cm. Musée d'Orsay, Paris.

8. *The Port of Zaandam,* 1871. Oil on canvas. 47 x 74 cm. Private collection, Paris.

9. *Portrait of Gurtjie van de Stadt,* 1871. Oil on canvas. 73 x 40 cm. Private collection, Holland.

10. *The Pont-Neuf, Paris,* 1872. Oil on canvas. 52 x 73 cm. Reves collection, Paris.

11. *Argenteuil. The Bridge under Repair,* 1872. Oil on canvas. 60 x 80 cm. Buttler collection, London.

12. *Lilacs, Overcast Weather,* 1872. Oil on canvas. 48 x 64 cm. Musée d'Orsay, Paris.

13. *Fishing Boat at Anchor,* 1872. Oil on canvas. 48 x 75 cm. Musée d'Orsay, Paris.

14. *The Seine at Rouen,* 1872. Oil on canvas. 50 x 78 cm. Private collection, USA.

15. *The Promenade at Argenteuil,* 1872. Oil on canvas. 50 x 65 cm. National Gallery of Art, Washington.

16. *Pleasure Boats,* 1872. Oil on canvas. 47 x 65 cm. Musée d'Orsay, Paris.

17. *The Barque, Argenteuil* 1872. Oil on canvas. 49 x 65 cm Musée d'Orsay, Paris.

18. *Saint-Denis Quarries,* 1872. Oil on canvas. 61 x 81 cm. Musée du Louvre, Paris.

19. *Jean Monet on his Mechanical Horse,* 1872. Oil on canvas. 73 x 59 cm. Cummings collection, Chicago.

20. *Still Life with Melon,* 1872. Oil on canvas. 53 x 73 cm. Museu Gulbenkian, Lisbon.

21. *The Thaw.* 1873. Oil on canvas. 55 x 73 cm. Private collection, USA.

22. *The Red Hat,* 1873. Oil on canvas. 100 x 80 cm. Museum of Art, Cleveland.

23. *Spring,* 1873. Oil on canvas. 60 x 100 cm. Metropolitan Museum, New York.

24. *Apple Tree in Flower,* 1873. Oil on canvas. 61 x 100 cm. Private collection, France.

25. *Monet's Garden at Argenteuil (Dahlias),* 1873. Oil on canvas. 61 x 82 cm. Levin collection, USA.

1

6

11

16

21

2

7

12

17

22

3

8

13

18

23

4

9

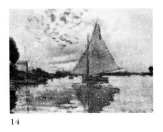

14

19

24

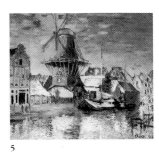

5

10

15

20

25

1. *Camille Monet at the Window*, 1873. Oil on canvas. 60 x 49 cm. Mellon collection, USA.

2. *Effect of Autumn*, 1873. Oil on canvas. 56 x 75 cm. Courtauld Institute Galleries, London.

3. *Le Havre, Fishing Boat Leaving the Hrabour*, 1874. Oil on canvas. 60 x 101 cm. Herman collection, USA.

4. *The Geldersekade at Amsterdam*, 1874. Oil on canvas. 55 x 65 cm. Private collection, France.

5. *The Windmill of Onbekende Gracht*, 1874. Oil on canvas. 56 x 65 cm. Neelands sale, 1972, New York.

6. *View from the Montalbaan Tower*, 1874. Oil on canvas. 60 x 81 cm. Private collection, Switzerland.

7. *Canal in Amsterdam*, 1874. Oil on canvas. 55 x 65 cm. Comte d'Arschott collection, Belgium.

8. *The Road Bridge, Argenteuil*, 1874. Oil on canvas. 54 x 73 cm. Private collection, Paris.

9. *The Railway Bridge*, 1874. Oil on canvas. 14 x 23 cm. Musée Marmottan, Paris.

10. *Boats at Argenteuil*, 1874. Oil on canvas. 60 x 81 cm. Private collection, Paris.

11. *The Lake at Argenteuil*, 1874. Oil on Canvas. 54 x 73 cm. Museum of Art, Providence.

12. *The Lake at Argenteuil*, 1874. Oil on canvas. 55 x 73 cm. Private collection, France.

13. *The Water's Edge, Argenteuil*, 1874. Oil on canvas. 55 x 65 cm. Destroyed by fire in 1950.

14. *Yacht at Petit-Gennevilliers*, 1874. Oil on canvas. 56 x 74 cm. Simons collection, USA.

15. *Yachts*, 1874. Oil on canvas. 60 x 100 cm. Musée d'Orsay, Paris.

16. *Prairie at Bezons*, 1874. Oil on canvas. 57 x 80 cm. Nationalgalerie, Berlin.

17. *Woman Seated on a Bench*, 1874. Oil on canvas. 74 x 58 cm. Tate Gallery, London.

18. *Snow at Argenteuil*, 1875. Oil on canvas. 55 x 65 cm. National Museum of Western Art, Tokyo.

19. *Boulevard de Pontoise*, 1875. Oil on canvas. 60.5 x 81.5 cm. Kunstmuseum, Basel.

20. *Effect of the Snow, Setting Sun*, 1875. Oil on canvas. 53 x 64 cm. Musée Marmottan, Paris.

21. *The Red Boats*, 1875. Oil on canvas. 60 x 81 cm. Fogg Art Museum, Cambridge.

22. *Summer, Poppy Field*, 1875. Oil on canvas. 60 x 81 cm. Trüssel collection, Switzerland.

23. *Poppies*, 1875. Oil on canvas. 54 x 73 cm. Haupt collection, USA.

24. *Camille Monet and Child in the Garden*, 1875. Oil on canvas. 55 x 66 cm. Webster collection, Boston.

25. *The Artist's Family in the Garden*, 1875. Oil on canvas. 61 x 80 cm. Private collection, USA.

1. *The Epinay Road, Effect of Snow (Road to Argenteuil)* 1875. Oil on canvas. 65 x 105 cm. Albright-Knox Gallery, Buffalo

2. *The Ball-Shaped Tree, Argenteuil,* 1876. Oil on canvas. 60 x 81 cm. Private collection, Switzerland.

3. *The Parc Monceau,* 1876. Oil on canvas. 60 x 81 cm. Metropolitan Museum, New York.

4. *The Tuileries Gardens,* 1876. Oil on canvas. 50 x 74 cm. Musée d'Orsay, Paris.

5. *In the Meadow,* 1876. Oil on canvas. 60 x 82 cm. Private collection, Paris.

6. *Gladioli, c.* 1876. Oil on canvas. 60 x 81 cm. Institute of Art, Detroit.

7. *Roses in the Garden,* 1876. Oil on canvas. 60 x 81 cm. Harris Collection, USA.

8. *Corner of the Garden at Montgeron.* 1876. Oil on canvas. 172 x 193 cm. Hermitage Museum, Saint Petersburg.

9. *The Pond at Montgeron,* 1876. Oil on canvas. 172 x 193 cm. Hermitage Museum, Saint Petersburg.

10. *The Shoot,* 1876. Oil on canvas. 140 x 173 cm. Private collection, Paris.

11. *The Gare Saint-Lazare, Train Arriving,* 1877. Oil on canvas. 82 x 101 cm. Fogg Art Museum, Cambridge.

12. *The Gare Saint-Lazare,* 1877. Oil on canvas. 54 x 72 cm. McLaren collection, London.

13. *Exterior of the Gare Saint-Lazare,* 1877. Oil on canvas. 60 x 80 cm. Private collection, USA.

14. *Argenteuil, the Bank in Flower,* 1877. Oil on canvas. 54 x 65 cm. Col. Bethard, USA.

15. *Spring through the Branches,* 1878. Oil on canvas. 52 x 63 cm. Musée Marmottan, Paris.

16. *Banks of the Seine, Île de la Grande-Jatte,* 1878. Oil on canvas. 54 x 65 cm. Private coll.

17. *La Grande-Jatte,* 1878. Oil on canvas. 56 x 74 cm. Norton- Simon sale, 1971, New York.

18. *La Rue Saint-Denis, Fête of 30 June 1878,* 1878. Oil on canvas. 76 x 52 cm. Musée des Beaux-Arts, Rouen.

19. *Apple Trees, Vétheuil,* 1878. Oil on canvas. 55 x 66 cm. Dixon collection, USA.

20. *Chrysanthemums,* 1878. Oil on canvas. 54 x 65 cm. Musée d'Orsay, Paris.

21. *The Bank at Lavacourt,* 1878. Oil on canvas. 65 x 80 cm. Gemäldegalerie, Dresden.

22. *Lavacourt,* 1878. Oil on canvas. 60 x 90 cm. Findlay collection, USA.

23. *Portrait of Jean Pierre Hoschédé, Known as Baby Jean,* 1878. Oil on canvas. 41 x 33 cm. Gould collection, USA.

24. *Portrait of Michel Monet as a Baby,* 1879. Oil on canvas. 46 x 37 cm. Musée Marmottan, Paris.

25. *The Church of Vétheuil,* 1879. Oil on canvas. 53 x 71 cm. Musée d'Orsay, Paris.

1. *The Road to Vétheuil, Effect of Snow,* 1879. Oil on canvas. 61 x 81 cm. Private collection, New York.

2. *Lavacourt, Sun and Snow,* 1879. Oil on canvas. 59 x 81 cm. National Gallery, London.

3. *The River at Lavacourt,* 1879. Oil on canvas. 54 x 65 cm. Museum of Art, Portland.

4. *Landscape, Vétheuil,* 1879. Oil on canvas. 60 x 73 cm. Musée d'Orsay, Paris.

5. *The Seine at Vétheuil,* 1879. Oil on canvas. 43 x 70 cm. Musée d'Orsay, Paris.

6. *Bowl of Fruit (Apples and Grapes),* 1879. Oil on canvas. 68 x 90 cm, Metropolitan Museum, New York.

7. *Still Life, Apples and Grapes,* 1879. Oil on canvas. 65 x 82 cm. Art Institute, Chicago.

8. *Pheasants,* 1879. Oil on canvas. 68 x 90 cm. Private collection. France.

9. *Frost,* 1879. Oil on canvas. 61 x 100 cm. Musée d'Orsay, Paris.

10. *Breakup of the Ice, Overcast Weather,* 1880. Oil on canvas. 68 x 90 cm. Museu Gulbenkian, Lisbon.

11. *Breakup of the Ice at Vétheuil,* 1880 Oil on canvas. 60 x 100 cm. Private collection, France.

12. *Ice Floes,* 1880. Oil on canvas. 61 x 100 cm. Musée d'Orsay, Paris.

13. *Ice Floes,* 1880. Oil on canvas. 97 x 150 cm. Shelburne Museum (Webb collection), Shelburne.

14. *Breakup of the Ice,* 1880. Oil on canvas. 61 x 100 cm. Hoffmann collection, USA.

15. *The Island of Flowers,* 1880. Oil on canvas. 65 x 81 cm. Metropolitan Museum, New York.

16. *The Seine at Vétheuil,* 1880. Oil on canvas. 60 x 105 cm Metropolitan Museum, New York.

17. *Vétheuil in Summer,* 1880. Oil on canvas. 60 x 100 cm. Metropolitan Museum, New York.

18. *Portrait of André Lauvay,* 1880. Oil on canvas. 46 x 38 cm. Private collection, USA.

19. *Bouquet of Mallows,* 1880. Oil on canvas. 100 x 81 cm. Courtauld Institute Galleries, London.

20. *Asters,* 1880. Oil on canvas. 83 x 68 cm. Hal Wallis collection, USA.

21. *Portrait of Jean Monet,* 1880. Oil on canvas. 46 x 37 cm. Musée Marmottan, Paris.

22. *Portrait of Monsieur Coquerel fils,* 1881. Oil on canvas. 46 x 38 cm. Art Institute, Chicago.

23. *The Sea: View of the Rocks,* 1881. Oil on canvas. 60 x 75 cm. Private collection, Great Britain.

24. *Calm Weather, Fécamp,* 1881. Oil on canvas. 60 x 73 cm. Kunstmuseum (deposit of the Staechelin collection), Basel.

25. *On the Coast at Trouville,* 1881. Oil on canvas. 60 x 81 cm. Museum of Fine Arts, Boston.

1. *Low Tide, Pourville.* 1882. Oil on canvas. 60 x 81 cm. Maxwell-Cummings collection, Canada.

2. *Low Tide, Pourville,* 1882. Oil on canvas. 60 x 81 cm. Museum of Art, Cleveland.

3. *Church at Varengeville, Setting Sun;* 1882. Oil on canvas. 65 x 81 cm. Private collection, France.

4. *Varengeville, Fisherman's Hut,* 1882. Oil on canvas. 60 x 78 cm. Musée Boymans Van Beuningen, Rotterdam.

5. *Customs Hut at Dieppe,* 1882. Oil on canvas. 58.4 x 69.8 cm. Metropolitan Museum, New York.

6. *Galettes,* 1882. Oil on canvas. 65 x 81 cm. Private collection, France.

7. *Fishermen on the Seine at Poissy,* 1882. Oil on canvas. 60 x 82 cm. Kunsthistorisches Museum, Vienna.

8. *The Cliff Edge at Pourville,* 1882. Oil on canvas. 60 x 81 cm. Metropolitan Museum, New York.

9. *On the Cliff at Pourville,* 1882. Oil on canvas. 65 x 81 cm. Nationalmuseum, Stockholm.

10. *The Cliff Face at Dieppe,* 1882. Oil on canvas. 65 x 81 cm. Kunsthaus, Zurich.

11. *A Park at Pourville,* 1882. Oil on canvas. 65 x 81 cm. Private collection, Switzerland.

12. *Setting Sun, Hazy Weather,* 1882. Oil on canvas. 60 x 73 cm. Maxwell-Cummings collection, Canada.

13. *Cliffs near Pourville,* 1882. Oil on canvas. 60 x 81 cm. Enschede collection, USA.

14. *Church at Varengeville,* 1882. Oil on canvas. 60 x 73 cm. Sotheby sale, 1971, London.

15. *Fisherman's hut, Varengeville,* 1882. Oil on canvas. 61 x 88 cm. Museum of Fine Arts, Boston.

16. *The Manneporte, Downstream View,* 1883. Oil on canvas. 73 x 92 cm. Sotheby sale, London.

17. *The Seine at Port-Villez,* 1883. Oil on canvas. 60 x 100 cm. Acquavella Galleries, USA.

18. *Little Islands at Port-Villez,* 1883. Oil on canvas. 65 x 92 cm. Private collection, USA.

19. *Michel Monet in the Blue Sweater,* 1883. Oil on canvas. 46 x 38 cm. Musée Marmottan, Paris.

20. *Christmas Roses,* 1883. Oil on canvas. 50 x 37 cm. Private collection, France.

21. *View of Bordighera,* 1884. Oil on canvas. 61 x 81 cm. Hammer collection, USA.

22. *Bordighera,* 1884. Oil on canvas. 65 x 81 cm. Art Institute, Chicago.

23. *Under the Lemon Trees,* 1884. Oil on canvas. 73 x 60 cm. Ny Carlsberg Glyptotek, Copenhagen.

24. *The Château of Dolceacqua,* 1884. Oil on canvas. 73 x 92 cm. Private collection.

25. *The Château of Dolceacqua,* 1884. Oil on canvas. 92 x 73 cm. Musée Marmottan, Paris.

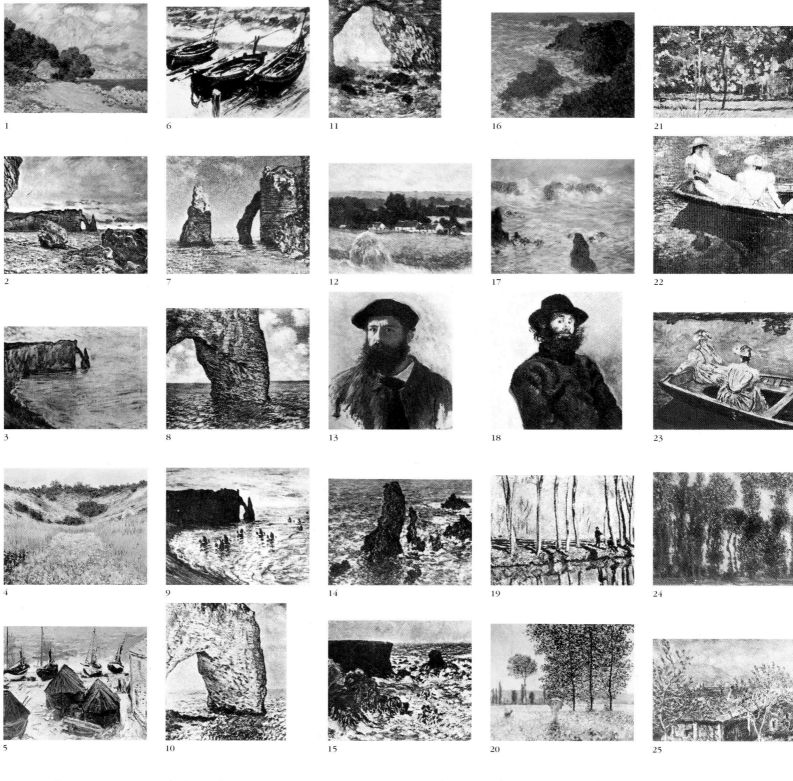

1. *Menton from Cap Martin,* 1884. Oil on canvas. 68 x 83 cm. Museum of Fine Arts, Boston.

2. *Etretat, the Beach and the Downstream Promontory,* 1884. Oil on canvas. 60 x 73 cm. Samuel Dorsky collection, USA.

3. *Downstream Promontory, and Needle.* 1884. Oil on canvas. 60 x 81 cm. Kunstmuseum (deposit of the Dreyfus collection), Basel

4. *Poppy Fields,* 1885. Oil on canvas. 65 x 81 cm. Museum of Fine Arts, Boston.

5. *Boats on the Beach, Etretat,* 1885. Oil on canvas. 65 x 81 cm. Art Institute, Chicago.

6. *Three Fishing Boats,* 1885. Oil on canvas. 73 x 92 cm. Magyar Nemzeti Muzeum, Budapest.

7. *Downstream View of Needle and Cliff,* 1885. Oil on canvas. 65 x 81 cm. Sterling & Francine Clark Art Institute, Williamston.

8. *The Manneporte, High Tide,* 1885. Oil on canvas. 65 x 81 cm. Private collection, Chicago.

9. *Fishing Boats Setting Out,* 1886. Oil on canvas. 66 x 81 cm. Pushkin Museum, Moscow.

10. *The Manneporte,* 1886. Oil on canvas. 81 x 65 cm. Metropolitan Museum, New York.

11. *The Manneporte,* 1886. Oil on canvas. 92 x 73 cm. Private collection, USA.

12. *The Haystack,* 1886. Oil on canvas. 61 x 81 cm. Hermitage Museum, Saint Petersburg.

13. *Self-portrait of Monet in Beret,* 1886. Oil on canvas. 56 x 46 cm. Private collection, France.

14. *Pyramids of Port-Coton, Rough Sea,* 1886. Oil on canvas. 65 x 81 cm. Pushkin Museum, Moscow.

15. *Port-Coton, the Lion,* 1886. Oil on canvas. 60 x 73 cm. Private collection, USA.

16. *The Wild Coast,* 1886. Oil on canvas. 65 x 81 cm. Musée d'Orsay, Paris.

17. *Storm, Coast of Belle-Île,* 1886. Oil on canvas. 60 x 73 cm. Private collection, Switzerland.

18. *Portrait of Poli,* 1886. Oil on canvas. 74 x 53 cm. Musée Marmottan, Paris.

19. *Jean-Pierre Hoschédé and Michel Monet by the Epte,* 1887. Oil on canvas. 76 x 97 cm. Bronfman collection, Canada.

20. *Under the Poplars, Effect of the Sun,* 1887. Oil on canvas. 74 x 93 cm. Gemäldegalerie, Stuttgart.

21. *Peonies,* 1887. Oil on canvas. 65 x 100 cm. National Museum of Western Art, Tokyo.

22. *Young Girls in a Boat,* 1887. Oil on canvas. 145 x 132 cm. National Museum of Western Art, Tokyo.

23. *The Blue Boat,* 1887. Oil on canvas. 109 x 129 cm. Sotheby sale, 1976, London

24. *Poplars at Giverny* 1887. Oil on canvas. 73 x 92 cm. Museum of Modern Art, New York.

25. *Gardener's House at Antibes,* 1888. Oil on canvas. 65 x 92 cm. Museum of Art, Cleveland.

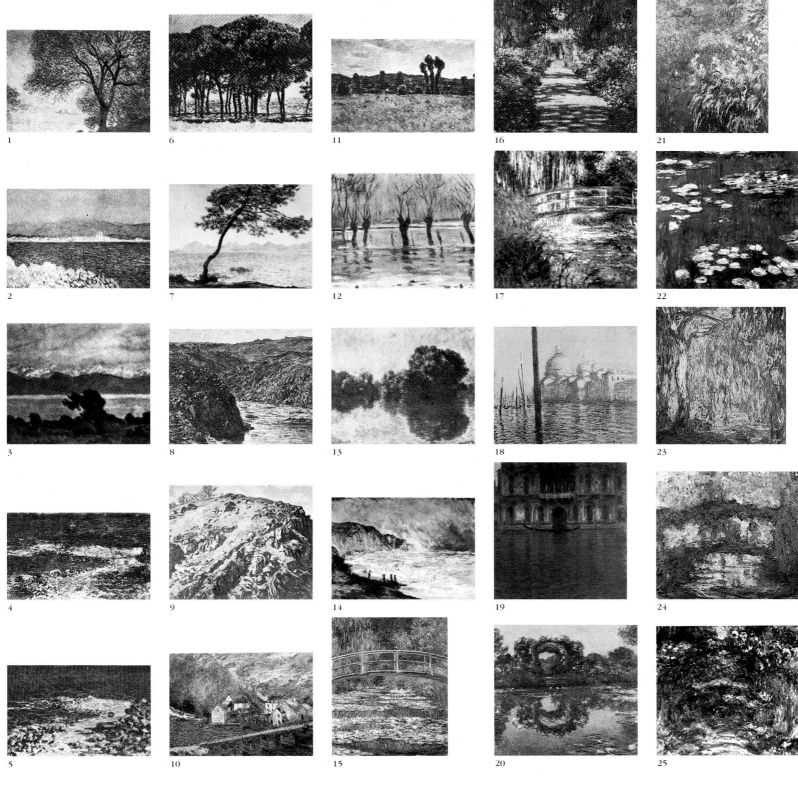

1. *Antibes from La Salis,*
1888. Oil on canvas. 65 x 92 cm.
Location not known.

2. *Bay of Antibes,* 1888.
Oil on canvas. 65 x 92 cm.
Sam Salz collection, USA.

3. *Baie des Anges from Cap
d'Antibes,* 1888.
Oil on canvas. 65 x 81 cm.
Rosensaft collection, USA.

4. *The Sea at Antibes,* 1888.
Oil on canvas. 65 x 81 cm.
Museum der Stadt, Wuppertal.

5. *The Mediterranean,* 1888.
Oil on canvas. 60 x 73 cm.
Parke-Bernet sale, 1976,
London.

6. *Pine Trees, Cap d'Antibes,*
1888. Oil on canvas. 73 x 92 cm.
Private collection, USA.

7. *Hills of the Esterel,* 1888.
Oil on canvas. 65 x 92 cm.
Courtauld Institute Galleries.
London.

8. *Ravine of the Creuse at
Sunset,* 1889.
Oil on canvas. 65 x 81 cm.
Musée des Beaux-Arts, Reims

9. *Le Bloc,* 1889.
Oil on canvas. 73 x 92 cm.
Royal Collection, Great Britain.

10. *The Bridge at Vervy,* 1889.
Oil on canvas. 65 x 92 cm.
Musée Marmottan, Paris.

11. *Poppy Field,* 1890.
Oil on canvas. 60 x 92 cm.
Hermitage Museum, Saint
Petersburg.

12. *The Flood,* 1896.
Oil on canvas. 73 x 92 cm.
National Gallery, London.

13. *The Seine at Giverny,* 1897.
Oil on canvas. 81 x 100 cm.
National Gallery, Washington.

14. *Rough Sea,* 1897.
Oil on canvas. 73 x 100 cm.
National Museum of Western
Art, Tokyo.

15. *The Water Lily Pond,* 1899.
Oil on canvas. 92.7 x 73.7 cm.
Metropolitan Museum, New York.

16. *Garden Walk,* 1901–02.
Oil on canvas. 89 x 92 cm.
Österreichische Galerie,
Vienna.

17. *Water Lily Pond,* 1900
Oil on canvas. 89,2 x 92.8 cm.
Museum of Fine Arts, Boston.

18. *The Church of Santa Maria
della Salute,* Venice, 1908.
Oil on canvas. 73.5 x 92.5 cm.
Museum of Fine Arts, Boston.

19. *Palazzo Contarini,* 1908.
Oil on canvas. 92 x 81 cm.
Kunstmuseum, Saint-Gall.

20. *Floral Arches,* 1913.
Oil on canvas. 81 x 92 cm.
Art Museum, Phoenix.

21. *Irises,* 1914-1917. Oil on
canvas. 199.4 x 150.5 cm.
Virginia Museum of Art,
Richmond.

22. *Water Lilies,* 1914.
Oil on canvas. 200 x 200 cm.
National Museum of Western
Art, Tokyo.

23. *The Weeping Willow,
Giverny,* 1918. Oil on canvas.
130 x 110cm. Private collection.

24. *The Japanese Bridge,* 1918–24.
Oil on canvas. 80 x 100 cm.
Musée Marmottan, Paris.

25. *The Rose Walk,* 1920–22.
Oil on canvas. 89 x 100 cm.
Musée Marmottan, Paris.

Index of Monet's Paintings

Selective bibliography

Salons, Emile Zola 1866–68.

Par les champs et par les grèves (voyage en Bretagne), Gustave Flaubert. 1885.

Eugène Boudin, sa vie et son œuvre, Gustave Cahen. Floury, Paris 1900.

Histoires des peintres impressionnistes, Théodore Duret. Floury, Paris 1906.

Les nymphéas de M. Claude Monet, Roger Marx. Gazette des Beaux-Arts, 4th Series, Vol. 1, pp. 523–31 (June 1909).

Lettres à Claude Monet, Octave Mirbeau. Les Cahiers d'aujourd'hui Vol. 5, pp. 161–76 (November 29, 1922).

Claude Monet: sa vie, son temps, son œuvre, Gustave Geffroy. G. Crès, Paris 1922.

Le Pèlerinage à Giverny, Duc de Trévise. La Revue de l'Art Ancien et Moderne, Vol. 51, pp. 42–50 and 121–34. (January/February 1927).

Claude Monet: les Nymphéas, Clemenceau. Plon, Paris 1928.

La Vie de Claude Monet, Marthe de Fels. Paris 1929.

Les Archives de l'Impressionnisme, L. Venturi. 1939

Les Nymphéas ou les surprises d'une aube dicté, G. Bachelard. Verve Nos. 27 and 28, 1952.

History of Impressionnism, John Rewald. 1955, 1973.

Claude Monet, ce mal connu (2 vols), Jean-Pierre Hoschedé. Pierre Cailier Editeur, Geneva 1960.

Journal d'un collectionneur, René Gimpel. Calmann-Lévy, Paris 1963

Les Grands peintres racontés par eux-mêmes, Michel Ragon. Albin Michel, Paris 1965.

Lettres à une amie, 1923–1929, Clemenceau. Pierre Brive. Gallimard, Paris 1970.

Le Journal de l'impressionnisme, Maria and Godfrey Blunden. Skira, Geneve 1970.

Exhibition catalog *Monet et ses amis, le legs Michel Monet, la donation Donop de Monchy.* Musée Marmottan, Paris 1971.

Monet, Nymphéas, Denis Rouart and Jean-Dominique Rey. Hazan, Paris 1972.

Monet, Sabine Cotte. Henri Scrépel, Paris 1974.

Claude Monet: biographie et catalogue raisonné, (3 vols.), Daniel Wildenstein. Bibliothèque des Arts, Lausanne, 1974. Paris 1979.

Exhibition catalog *Hommage à Claude Monet.* Grand Palais, Paris 1980.

Tout l'œuvre peint de Monet, Luigina Rossi Bortolatto. Flammarion, Paris 1981.

Claude Monet au temps de Giverny, exhibition catalog. Centre culturel du Marais, Jacqueline et Maurice Guillaud, Paris 1983.

Monet, Robert Gordon and Andrew Forge. Flammarion, Paris 1984.

Monet (Les Chefs d'œuvre), Jean-Paul Crespelle. Hazan, Paris 1986.

L'Impressionisme et son époque, Sophie Monneret. Laffont, 1987.

Claude Monet par lui-même, Richard Kendall. Editions Atlas, 1989.

Monet, le triomphe de la lumière, Paul Hayes Tucker). Flammarion, Paris 1990.

Monet, Karin Sagner-Düchting. Taschen, Cologne 1990.

Catalog *Claude Monet-Auguste Rodin, centenaire de l'exposition de 1889,* Musée Rodin, Paris, November 14, 1989 to January 21, 1990.

Les Cathédrales de Monet, Rouen 1892–94, Joachim Pissarro. Anthese, Arcueil 1990.

Blanche Hoschedé-Monet, 1865–1947, une artiste a Giverny, exhibition catalog. Musée Municipal A. G. Poulain, Vernon April 6 to June 2, 1991.

Photograph credits